THE STEAM AND DIESEL ERA IN WHEELING, WEST VIRGINIA

THE STEAM AND DIESEL ERA IN WHEELING, WEST VIRGINIA

PHOTOGRAPHS BY J. J. YOUNG JR.

Edited and with text by

Nicholas Fry, Gregory Smith, and Elizabeth Davis-Young

WEST VIRGINIA UNIVERSITY PRESS • MORGANTOWN 2016

Copyright 2016 West Virginia University Press

All rights reserved

First edition published 2016 by West Virginia University Press

Printed in the United States of America

24 23 22 21 20 19 18 17 16 1 2 3 4 5 6 7 8 9

ISBN:

cloth 978-1-943665-03-7

Library of Congress Cataloging-in-Publication Data is available from the Library of Congress

All photos unless otherwise noted are copyright of E. Davis-Young and West Virginia State Archives

Book and cover design by Than Saffel

Cover image: Original American Freedom Train at the PRR's Wheeling depot in 1946. Photograph by J. J. Young Jr.

CONTENTS

ACKNOWLEDGMENTS

No book is created in a vacuum. There are numerous contributors to the final product, and they all deserve special thanks from authors and readers for their help in bringing the book to the reader. The editors and authors would like to thank the following people and organizations for their support of this project:

J. J. Young Jr. deserves special and primary thanks for his photographs and the initiation of this project shortly before his passing. Without his work, this book would not exist and the documentary record of images of railroading in and around Wheeling would be much poorer.

The family of J. J. Young Jr. for their contributions to the introduction and accounts of his early life. To understand his passion, one must understand the person, and their recollections and contributions were invaluable in this regard.

The West Virginia State Archives, particularly Archives Director Joe Geiger, Assistant Director Debra Basham and former Archives Director Fred Armstrong, who allowed the editors and other members of the B&O Railroad Historical Society to help catalog and identify the J. J. Young Jr. photo and negative collection that had been donated to that institution.

Don Barnes, Bill Hornbrook, John King, Alden Mcbee, James Mischke, and Maria Potter all worked at various times with the editors at the West Virginia State Archives to contribute their time and knowledge to identifying these images, which made this project manageable and possible.

The staff and editors at West Virginia University Press deserve thanks for their enthusiasm and support for what is a first book for all three of these authors/editors. Their patience and guidance has helped this become a better book.

viii

The staff and volunteers of the John W. Barriger III National Railroad Library, B&O Railroad Historical Society, and the city of Martins Ferry, Ohio, for the assistance of their staff and the images they provided from their collections to help us with the book.

Special thanks also go to Ron Goldfeder, Bob Holzweiss, Ray Lichty, Herb Harwood, Bob Cohen, and others who we may have forgotten to mention for their time and contributions as they read over parts of the manuscript while it was being produced. If we have omitted your name, it is our fault alone. Please accept our apologies and know we are very grateful for your help.

Finally, we would all like to thank our friends and families and, individually, each of us thanks our coeditors in this project for their support and cheerleading. It was a long road, but we have finally arrived at the finish line.

Intro

INTRODUCTION: WELCOME TO WHEELING, WEST VIRGINIA

The subjects of this book are the railroads of Wheeling, West Virginia, and the surrounding areas as photographed by West Virginia photographer J. J. Young Jr. (Nobody except his family called him by his first name, John.) Today Wheeling is viewed by most travelers from Interstate 70 as they pass through the town on their way to other destinations. Some do stop to visit family or friends or to tour the city and visit its attractions. Others are there on errands of commerce and drive past the remains of the immense industrial and heavy transportation infrastructure of the region on their way to newer factories and commercial businesses.

What these people may know, but possibly do not, is that they are in an area of rich historical significance. Wheeling was once a great river port on the commercial highway known as the Ohio River. Because of its location and its river access, Wheeling was an important destination for commercial travelers and a lucrative base for new businesses. The importance of the city was only heightened in the middle of the nineteenth century when rich coal deposits were discovered in the region and later when iron ore was found within easy distance of the community. Because of these factors and others, the city saw the National Road pass through in 1818 on its way to the new lands of the West. A suspension bridge would be built in 1847 to carry the road over the Ohio River, and it still is an active crossing to this day.

The natural resources and the industries that developed around them coupled with a transportation revolution taking place in the country put Wheeling in play as a potential destination for the first railroads being built westward from the ports of the Mid-Atlantic. Through some shrewd political dealing in the Virginia legislature and the victory of the Chesapeake & Ohio Canal Company in court, the city of

Wheeling was able to make itself the endpoint of the Baltimore & Ohio Railroad, which completed its main line to Wheeling in 1852.

Other railroads followed, like the Pennsylvania Railroad and the Wheeling & Lake Erie. Each of these lines would also build bridges across the Ohio River near Wheeling or arrange to use other crossings that were already in place. Soon Wheeling saw freight trains come through the city with commodities from across the country. The city's industries were able to tap into national and international markets, and thousands of people passed through the city's passenger stations.

These glory years of industrial and commercial prosperity saw hundreds of steam locomotives and, later, diesel locomotives muscle their trains up the grades to pass through the mountain barrier to the east of the city or creep up heavily engineered trestles to elevate the trains to the track level of the bridges across the Ohio River. These years were not to last forever, and the number of locomotives and trains in the region would begin to shrink.

Today we are fortunate that circumstances brought J. J. Young Jr. into being in that place and that time. J. J. was born in 1928 and came to the hobby of photography in 1936. He had natural skill with a camera and was enamored with railroads. Because of his decision to never drive a car, he was moored to the Wheeling area for decades. These factors combined to give us a wonderful historic record of railroad imagery of one region over nearly thirty consecutive years.

The chapters that follow will provide only the briefest sample of J. J.'s work as a photographer in Wheeling. After he passed away in 2004, his collection of Wheeling and other West Virginia

photographs was donated to the West Virginia State Archives. There are thousands of prints and negatives from nearly seventy years of his life with a camera. Few have captions, but the images are an important record of railroading in Wheeling and in other parts of West Virginia.

Of the railroads featured in this book, the Baltimore & Ohio gets the largest share of space. This is mainly due to the fact that of J. J.'s Wheeling photographs, it is the most photographed railroad. J. J. had an extraordinary amount of access with this railroad, and the images show that he was able to take pictures in places most railfans were not able to go. After the B&O, J. J. shot the Pennsylvania most frequently and then, to a lesser extent, the Wheeling & Lake Erie, the Pittsburgh & West Virginia, the Nickel Plate Road, and the New York Central. One can see in the collection that the farther he had to travel to get the images, the fewer the images in his collection. J. J. was also able to get some additional images of the industrial railroads and the interurban line that served Wheeling, but the number of photos he took of those subjects pale in comparison to the volume of images he took of the major freight and passenger hauling railroads of the area.

Presently Wheeling is still served by the major freight railroads, but the number of trains that pass through town is much fewer than in the era of J. J.'s photographs. The Wheeling & Lake Erie still exists after a rebirth and serves the city. The B&O and Pennsylvania have given way to CSX and Norfolk Southern respectively, and much of their old lines has been torn up and abandoned or turned into recreational trails.[1]

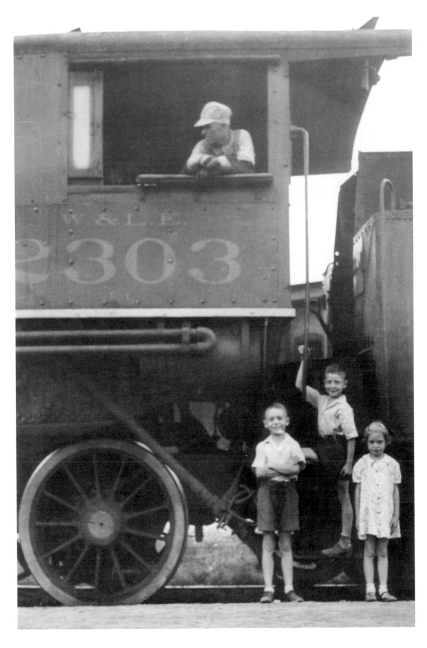

Three of four Young kids with Wheeling & Lake Erie class E 4-4-2 Atlantic at Wheeling in 1938.

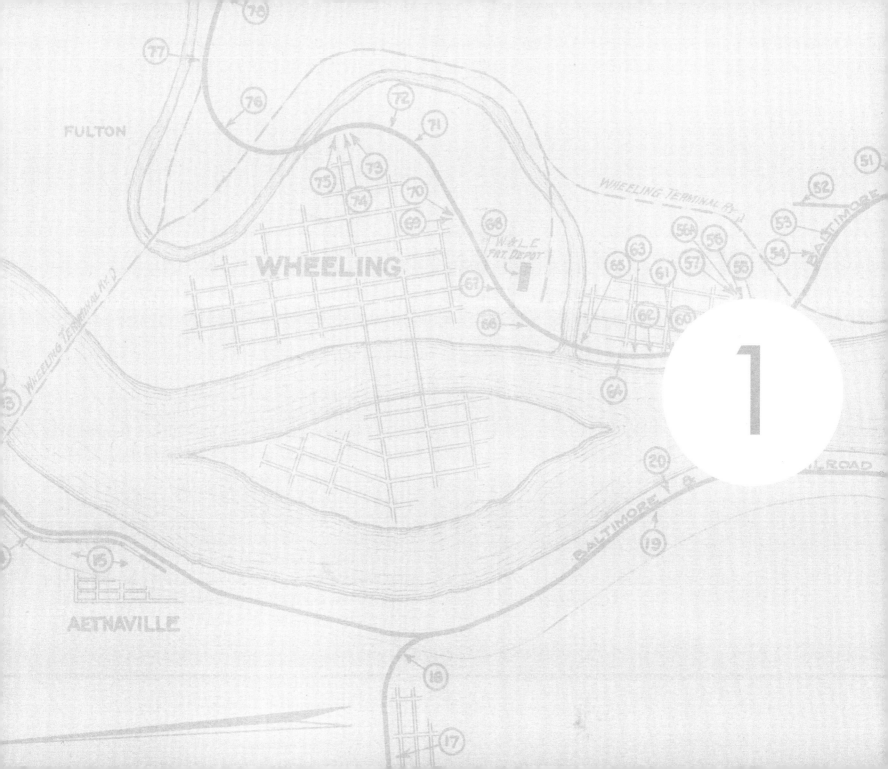

J. J. YOUNG JR

By Elizabeth Davis-Young

Johrn Young Jr. said that his lifelong love affair with trains was born when, at one-and-a-half years old, he was able to pull his chin up to the window ledge of the McColloch Street family home in Wheeling, West Virginia, and watch the gargantuan fire-breathing, cinder-spitting, smoke-enveloped "demons from hell" explode from the inky-black portal of Tunnel No. 1 on the Baltimore & Ohio Railroad line on their in-bound trip from Pittsburgh.

The photographs in this book cover the Wheeling years of John's life, circa 1936 to 1959. During this period of time—from his youth until his move to upstate New York in 1959—John came into his own as the unofficial photographic documentarian of railroads and the individuals who kept those steel wheels rolling.

Today much of the landscape in Wheeling is changed, and dramatically so, from what it was for the boy. Just shy of his seventh year, John, having stealthily snuck his dad's Zeiss folding camera out of the house, used the entire city and its environs as his backyard and recorded on film a world and a time that has ceased to be.

Yes, Wheeling's downtown still sits with its back up against the West Virginia mountains and its face to the Ohio River. But the biggest changes are what's missing, that part of the fabric that *was* Wheeling: the warp and weft of the railroads. Now even the tracks themselves are gone. The two dominant railroads that served Wheeling were the Baltimore & Ohio Railroad and the Pennsylvania Railroad. These railroads transported much of the goods generated in the city and surrounding areas, like steel and steel products, glassware, metal containers, and coal. The raised tracks of the B&O's right-of-way, which once curved through the city from steep mountain to soaring hillside, are now just a photographic

memory. The Pennsylvania Railroad, like the B&O, has become a walking Heritage Trail. Even the location of John's childhood home now only "houses" a support pier for I-70. The city has almost become a mere gas stop on the way to someplace else.

1929 was the year before Wheeling, a gateway city between east and west along the National Pike, officially reached its peak in population of 61,659. At a time when heavy industry, coal, and steel ruled, it was—like its near neighbor Pittsburgh—a teeming, noisy, busy city. As many as 120 trains a day passed through this area traveling to points east and west, north and south. Automobiles were still pretty much a luxury; steam powered passenger trains and electric street cars provided the community with much of their local and long distance freight and travel needs.

John Joseph Young Jr. came into the world May 23 of that year. He suffered major health issues, and his parents were not expecting him to live for very long. Surgery and aftercare corrected most of the problems, allowing this pugnacious individual to grow and take on the world on his own terms. Then, when he was about three or four years of age, John had typhoid fever; he lost all his hair and was very sick. At that time the disease killed many people, adults as well as children, fortunately John survived the experience.

Because of his childhood illnesses, John did not get to play much with kids in the neighborhood, but he certainly found the ways and means to entertain himself. The stone arch viaduct that crosses Wheeling Creek, where Tunnel No. 1 disgorged the thundering giants, was an easy walk, a not too distant location for the lad—a wonderful place where a boy could indulge his fascination with trains and begin saving those times in photographs.

By 1936, with the aforementioned purloined camera in hand, young John began what soon became his vocation and avocation: learning photography and recording images on film of all the rail lines that served the city. His negatives survive from that time, among them the Baltimore & Ohio, the Pennsylvania Railroad, the Wheeling & Lake Erie, and others, as well as images of the major spring flood of that year.

That historic March 18, 1936, flooding of the Ohio River sent waters fifteen feet above flood stage in Wheeling, completely washing away the ballast and underpinnings of railroad rights-of-way in places. During cleanup and repair operations along the rail lines after the flood, John, not yet seven years old, got a boyhood wish fulfilled: a ride in the engine cab of one of those fire-breathing monsters. Years later he could still recount his adventures, as if they happened only yesterday . . .

Watching a Pennsylvania Railroad crew that late spring day from a hillside perch in field close to home and curious as to what the workers were doing, John, without stopping to ask his parents' permission, ran down from the hill. With a child's energetic need to get closer to the action, he scrabbled up the B&O stone viaduct. Clad in short pants, his short, skinny legs barely reached each of the jagged, steep steps of the viaduct's abutment. The climb was made all the more difficult by the bruising railroad ballast slipping beneath his bare knees. To get a better view, the young boy crossed the stone viaduct, climbed down the other side, and traveled a couple hundred feet farther along the Pennsylvania Railroad line for a ringside seat.

John never forgot the name of the engineer of that work train, George Painter, who asked him, "Young fellow, what are you doing?"

"I came over to see what you fellows were doing," the boy replied.

"Come on up," the engineer said, beckoning and smiling.

Somehow, though it seemed twice his height above him, John hoisted himself up the engine's ladder. He stayed the rest of the day, feeling like a king as he sat on the engineer's seatbox while the crew continued with their work.

The oldest of four siblings (with brother Edward and sisters Mary and Elizabeth), John was a self-confessed gadabout, never home if at all possible. John and his family maintained a family garden in a community area at the bottom of their hillside neighborhood. It was Ed's and John's job each summer to till the garden, which was located near the city stockyards and, by happy coincidence, the railroad tracks. When the boys were at work in the garden, locomotive engineers would "inexplicably" slow down their trains and toot their whistles in the boys' direction. Dropping his shovel, John would call out "See ya!" to his much chagrined brother, running to climb aboard the train as the engineer began to ease out on the throttle, regaining track speed.

John's sister Elizabeth remembers a day when, returning from a shopping trip with their mother, their mom almost had a heart attack seeing John standing out on the roof of the family home's third floor, recording the sounds of the engines' steam whistles as they came through Wheeling Tunnel and echoed across the river valley. The roof was about four feet by three feet in size, and the house itself located high on the very steep hillside. The scolding he received was no deterrent, for he would return to the rooftop often.

"We lived in a big house in East Wheeling and it had a huge front porch on it. You could see Tunnel Green [near Tunnel No. 1 on the Baltimore & Ohio Railroad] from the porch, and John would take pictures of the trains coming out of the tunnel all day long," his sister Mary related recently, adding, "When he was about six or seven, his great uncle began to come in from Saginaw, Michigan, each year to visit, and John would always go with his dad and grandfather to pick him up at the B&O train station. I think this is where he got his fascination of trains."

One May afternoon In 1940, John's mother told him to run along, to go watch trains, and that he could worry about his chores later. This was so unlike his mom that he was suspicious, but he wasn't going to pass up a wonderful opportunity, either. Watching trains from atop the portal of Tunnel No. 1 he was also able to see his house, where he soon spotted several of his schoolmates walking onto his front porch. He suddenly remembered that it was his eleventh birthday and figured his parents must have been planning a surprise party for him.

Always the self-professed black sheep of the family and no social animal, John decided to play hooky from his own party. Walking the roughly two-mile distance to the B&O station, he talked himself into a cab ride to Pittsburgh. When he got to Pittsburgh, he purposely called his mother.

"Where are you?" she tersely asked.

"Pittsburgh," was his smug reply. After a long silence, the line went dead.

At the station, upon his return to Wheeling later that same day, John found his dad waiting, who "whipped his [backside] the entire walk back" to the house.

John's familiarity and friendship with those who worked on the railroads opened doors and garnered him even longer cab rides, which led to his infamous and spur-of-the-moment Thanksgiving train trip to Buffalo, New York, when he was about fourteen years old.

Sent by his mother to find a store that would be open that Thanksgiving morning for a couple of much needed items for dinner, John got all the way downtown before he found one that would be open, but not until noon. Already familiar with the schedule of train runs through the city, and rather than walk back home only to have to return, he decided to walk the additional couple blocks of distance to the B&O passenger station at the foot of Tenth Street to see the morning train come in from Pittsburgh. He

was hoping, in the bargain, that he just might be able get a cab ride to Benwood Yard in Wheeling while they turned and serviced the engines.

John knew the engine crew that worked that morning and, unfailingly, was able to ride along while they took the empty train the four miles down the line to the yards at Benwood for turning and servicing the engine. Upon the return trip to downtown, the engine crew made a casual but far-reaching suggestion to the ever-adventurous youngster: a cab ride with them to Pittsburgh.

Knowing train schedules as well as he did, John calculated that if he took the crew up on their offer he would arrive at the Pennsylvania Railroad's Pittsburgh station in time to make it over to the B&O station to take B&O train no. 75 back to Wheeling and still make it home in time for dinner. However, when he arrived at the Pittsburgh B&O station, he had the unexpected fortune of discovering that he knew the engineer on a train ready to depart for Buffalo, New York. When offered the chance to ride along, John threw caution and the shopping list out the cab window.

Upon his arrival in Buffalo much later that day, John thoughtfully called his mother.

"Where are you?"

"Buffalo."

"Buffalo, New York? How did you get to Buffalo?"

"On the train. They do run there, you know."

From then on, John said, whenever he left the house, his mom told him to send her a postcard "when he got there."

John walked many places where he could, sometimes three and four miles at a time, to watch and photograph his beloved trains. As he grew older, friends and other rail enthusiasts helped provide transportation, broadening his geographic "train chasing" area enormously. Never having a driver's license and never owning a car, John used mass transit his entire working life and beyond; he still managed to visit every one of the forty-eight contiguous states and into Canada—just to photograph trains.

In school John excelled. Due to his health issues and with the thought that he should begin school the same time as his brother Ed, John was held back two years from starting school at the age of five. But over the course of his school years, John was advanced by two grades (getting all the As, while his brother confessed to Cs and a couple of Bs) and thereby able to graduate with his peers. While John gravitated to photography professionally, Ed would go on to found a successful business on his own.

After graduating from Wheeling Central Catholic High School in 1946, John's first job as a young adult was with the Wheeling & Lake Erie Railroad as an agent/operator. He had hoped it would be a lifetime career with the line, but in less than three years technology erased his position. He did have the distinction of possibly breaking more order hoops than any other agent/operator on the W&LE,

according to a story he related to the B&O Railroad Historical Society of his travails in getting orders to train crews via wooden order hoops that he just couldn't get the hang of holding on to; somehow the hoops kept winding up under the wheels of W&LE freights.

In those halcyon days of the 1940s and early 1950s, as John got to know the hoggers and the ashcats along the various railroad lines of Wheeling, his presence was also being noticed—by B&O Wheeling Division Superintendent John Sell, an individual about whom John would forever express his abiding thanks and appreciation.

After leaving W&LE, John found work at Wheeling Mold & Foundry, located on the peninsula, a flat tongue of land created by a tight loop in Wheeling Creek. With a draft deferment during the Korean War, John worked molding tank turrets as part of the war effort. "It was rugged and dirty and a challenge and I loved it," John once said. He told me that, unlike many people who would complain of the heat, he did not mind at all the open blast furnace and its temperature of upwards of 2000 degrees Celsius.

One day, in the summer of 1951, John gathered up his nerve and a few photographs and paid a visit to B&O Division Superintendent Sell's office in Wheeling. His goal, in describing his hobby and showing the division superintendent his photographs, was to hopefully obtain longer cab rides and to truly experience railroads. Mr. Sell informed him that, having seen the level of safety John routinely exhibited around the bustling station, he would gladly give the teen his permission. John immediately made arrangements to ride aboard one of the large articulated EM-1 2-8-8-4s that ran from Wheeling to Holloway, Ohio. Years later, he would recall that day, with a smile, and how he was given the opportunity to "fire and water" the engine.

Then, in the late 1950s, a company out of East Chicago, Indiana, bought Wheeling Foundry. John began to notice that the foundry's casting molds were slowly starting to leave the facility via the rail line that serviced the plant. Because of his familiarity with the road crews, he found out that the molds were being moved to the new owners' East Chicago facility, a move that would put 11,000 employees out of work. After eleven-and-a-half years at the plant, and now with a young family to support, John was again seeking employment.

John by this time had become so enamored by the process of photography that he made the decision to use his photographic skills to earn money. Answering an ad that was listed in the *Wheeling Intelligencer* for a photo processor/finisher in a little place called Binghamton, New York, John moved in the spring of 1959. For the next thirty-two years, John worked at Broome Community College, eventually retiring as an instructor in photography.

John never owned a suit, preferring to wear jeans and a windbreaker out in the field. He carried his cameras in double paper bags, often surprising other railfans with this practice when they met him.

He also eschewed color film as others embraced it in the 1960s. He experimented with it briefly in the 1950s, but found the results to be unsatisfactory to his goals as a photographer and remained a black-and-white photographer for the rest of his days. John's belief that a photograph's quality derived from the photographer's familiarity with their subject made him concentrate on railroads that were local to him, wherever he happened to be living at the time. This was reinforced by his refusal ever to apply for a driver's license. Being limited to foot travel, friends and colleagues who had cars, and public transportation forced him to work within a limited geographic area. While this could be said to have restricted the breadth of his photography, it certainly increased the depth of his coverage of a specific area.

The following pages of this work will attest to the depth of John's coverage of the railroads of Wheeling. The Baltimore & Ohio has the largest number of images in this work mainly because John had more access to this railroad than any other line in Wheeling. In his collection at the West Virginia State Archives, the B&O makes up a greater percentage of his photographs than any other railroad. The Pennsylvania will come in second as it was the second most dominant railroad in Wheeling, and John was able to catch its frequent trains in the area. The Wheeling & Lake Erie, Pittsburgh & West Virginia, and Nickel Plate are all combined for third place in number because they had such a close relationship to one another and eventually were all merged together under the auspices of the Norfolk & Western Railway. The New York Central makes a brief appearance in this work due to its access to the Ohio coalfields in the area around Dillonvale, Ohio. John was able to catch some of New York Central's trains while he was in the area that also saw plenty of Wheeling & Lake Erie and Pittsburgh & West Virginia traffic. Finally, the book has a selection of industrial and interurban lines of the Wheeling area. These small and now long gone railroad companies provided short haul service to industries and passengers respectively in the Wheeling area.

Some of these images may seem familiar. John was never shy about sharing his work with those who asked. His photographs appeared in *Trains* magazine when the legendary David P. Morgan was editor. He also liberally supplied images to other authors such as Alvin Staufer and the Central Electric Railfans Association for book projects on the B&O's locomotive fleet, the Pennsylvania locomotive fleet, the New York Central's locomotive fleet, and the Traction and interurban lines around Western Pennsylvania and West Virginia. John contributed articles on railroading in Wheeling to the B&O Railroad Historical Society's magazine, the *Sentinel*, and was a frequent guest at railroad conventions and seminars in the area as well.

Even after he moved, John would return to Wheeling to visit family and always brought his camera with him. Unfortunately his old friends, the railroads, were all starting to change, and Wheeling was seeing the beginning of an industrial decline that was affecting the nation as a whole. Mergers and

new technologies changed what railroads were in the region and decreased the number of trains and railroad workers in the area. The construction of Interstate 70 through the city changed the railroad landscape as tractor-trailers were now able to take freight off the rails and onto the roads, which altered the city's neighborhoods forever.

John visited the city that was the setting for so many of his images in 2002. He came back one last time for the 150th Anniversary of the arrival of the B&O Railroad in the city and was feted with a banquet in his honor. Four years earlier he had donated 400 prints of his to the West Virginia Northern Community College for display. They were appropriately exhibited in the old B&O station that now houses part of the college's facilities. John was recognized by the state of West Virginia as a "West Virginia Hero" in 1998 and received his proclamation from then Governor Cecil Underwood for his work in recording an important part of the history of railroading in West Virginia, much of which has since vanished from the landscape.

After his passing in 2004, John continued to give. He willed his photographic collection of black-and-white images of West Virginia to the West Virginia State Archives for continued preservation and availability to the people of West Virginia and scholars and researchers seeking a visual record of railroads in the Mountaineer State. His contributions to the cultural record of his home state of West Virginia and the state of New York earned him honorary resolutions from both states' legislatures, and his work continues to live on in libraries across the world in issues of *Trains* and other magazines that featured his photographs.

This book is something of a time capsule—a series of images taken during the life of one man focused on one subject in one geographic area. Some of the captions are ones that John had written down himself as he was preparing this project shortly before he passed. John had a phenomenal memory and carried almost all of his captions in his head. Unfortunately, he was unable to complete this book before he passed away. The editors and numerous collaborators reconstructed most of the captions by looking at the images and making use of the research material available at this time.[2]

16

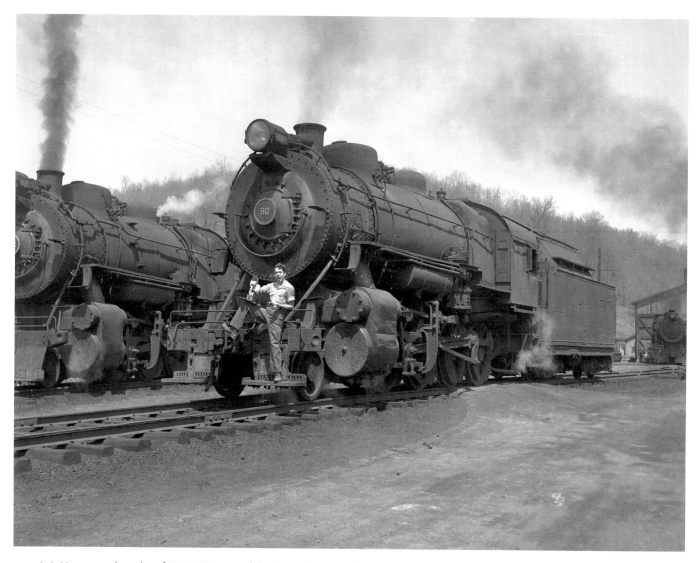

J. J. Young on the pilot of PRR #90, one of the Pennsylvania Railroads's former H-10s built in the early twentieth century for Pennsylvania Lines West. This pair is now working for the Western Allegheny Railroad (WARR). The PRR took control of this line in the early 1950s and the road ceased operations in 1996. This scene is at the yard in Kaylor, PA.

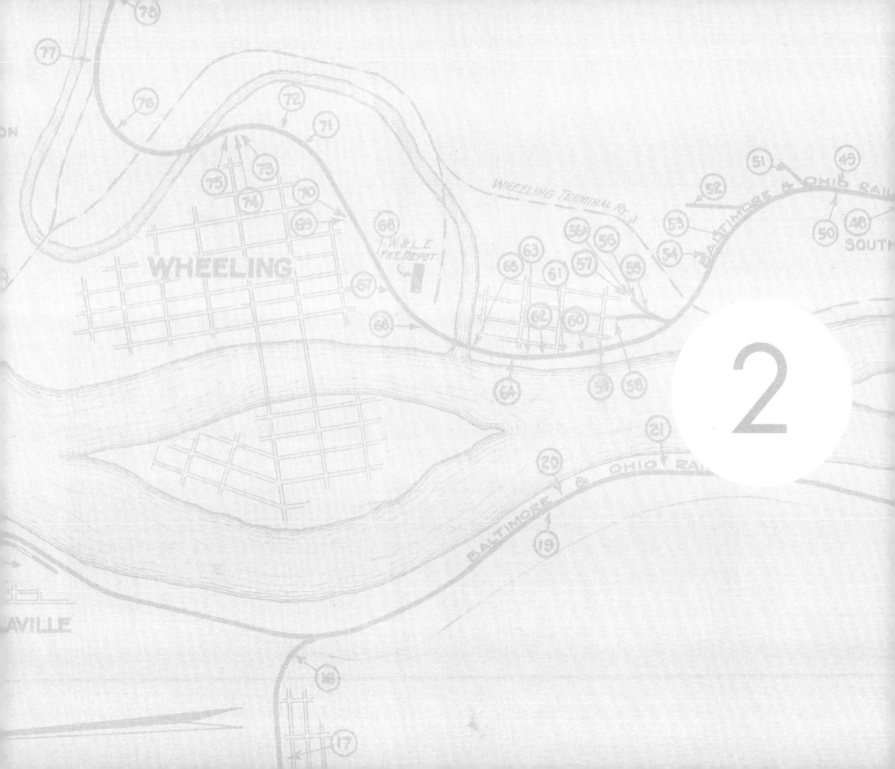

THE BALTIMORE & OHIO RAILROAD

T he Baltimore & Ohio (B&O) had the distinction to be the first common carrier railroad in America, meaning it took freight and passengers from all customers. It also had the distinction of being the first railroad to reach Wheeling, West Virginia (at the time, Virginia), and through service became possible when the main line was completed in 1852 at Roseby's Rock in Marshall County, north and east of Wheeling. The merchants and manufacturers of Wheeling now had direct access to an ocean port without having to use the National Road to reach Baltimore or Philadelphia, or the Ohio and Mississippi Rivers to reach New Orleans. Because of its early arrival in the city, the B&O was the dominant railroad in the Wheeling area for nearly the entirety of its existence. This commanding position only began to slip when the customers that provided the revenue and traffic for the railroad began to disappear or move away from Wheeling itself. Happily, while J. J. Young Jr. was in Wheeling, the B&O's trains were numerous and varied, and they became frequent subjects for the young photographer's camera. Of all the railroads in Wheeling, J. J. took more photos of the B&O than any other, only stopping when he moved to New York State to teach photography professionally. Still, he would occasionally return to Wheeling, and the B&O would continue to find a place in his camera's viewfinder.

How the B&O reached Wheeling is something of a saga unto itself. Originally, the company wanted to run its railroad line along the Maryland bank of the Potomac River and connect with the Ohio near Pittsburgh, Pennsylvania. At the time, Pittsburgh was a major inland port and shipbuilding center for riverboats on the Ohio-Mississippi-Missouri system. Unfortunately for the B&O the Chesapeake & Ohio Canal was able to legally secure the Maryland side of the Potomac for its own designs from Harpers

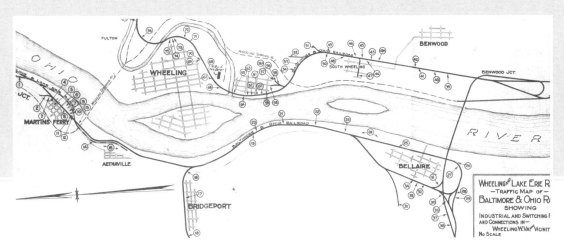

Ferry, West Virginia (then Virginia), to Cumberland, Maryland. The B&O was forced to appeal to the state of Virginia to use its side of the river to build the railroad. The state agreed, on the condition that the railroad's terminus on the Ohio River be located in Virginia. Further lobbying from the city of Wheeling secured a mandate that Wheeling be the terminus, despite the railroad's preference for Parkersburg.

The B&O soon was able to back a separate railroad, the Northwestern Virginia, that connected to the B&O near Clarksburg, Virginia, and enabled it to reach its preferred Ohio River port of Parkersburg and thence cross the river via ferry to the developing lines in the state of Ohio and points west. Wheeling became a secondary terminal for the B&O for the rest of its days, but the company was able to maintain its position as the dominant railroad in the city and the metropolitan area. Even as a secondary city, Wheeling was home to extensive yard and maintenance facilities for the company and saw a significant amount of coal, steel, iron ore, and merchandise traffic originate and arrive in its yards, factories, ware-houses, and stations.

The steel and coal industries were the primary drivers of these traffic volumes on the B&O, and J. J.'s photos show numerous coal trains and trains of empty coal hoppers moving through the region. Much of this coal was considered metallurgical coal that was turned into coke and then combined with iron ore to make steel. Some of this coal went to Pittsburgh via the B&O, which by the 1880s had built a branch known as The Pike that connected the two cities through the mountains of Western Pennsylvania. The Pike line never really lived up to the expectations of its planners, but it remained in use well into the twentieth century.[1]

This map of Wheeling was made by the Wheeling & Lake Erie Railroad to show the layout of the B&O Railroad's tracks in and around the city. J. J. Young would spend a significant amount of his time in Wheeling along these tracks, notably near the B&O Railroad station (point 68 on the map) and the area in and around Benwood, WV, and Bellaire, OH. (Used with the permission of B&O Railroad Historical Society Archives.)

19

In spite of its status as a secondary terminal on the B&O, Wheeling did receive a beautiful and large passenger station. As a division point for three separate divisions of the B&O, it was an important interchange for passengers, mail, and express shipments on the railroad. As such, it merited the large structure with multiple platforms that one sees in J. J.'s photographs. Happily, the building has survived to the present day. Now part of the West Virginia Northern Community College, it has been home to an exhibition of railroad photographs of Wheeling taken by J. J. Young Jr.[2]

Although J. J. never owned a car, he was able to travel extensively via friends with driver's licenses who shared his passion for railroad photography and, in the case of the B&O, via the excellent relationship he built with John J. Sell, superintendent of the Wheeling Division. Mr. Sell provided J. J. with a special pass that allowed him to ride any train on the division, and J. J.'s relationship with friendly railroaders allowed him to ride in the cab of many locomotives. Being well-known and well-liked enabled J.J. to range along much of the Wheeling Division and its neighboring divisions on the B&O system. As such, this section and the sections on the other railroads of Wheeling will include images from both sides of the Ohio River and areas outside of Wheeling itself.

The major B&O facilities in the area that J. J. photographed included the Benwood yard and shop facilities south of Wheeling along the Ohio River, and the town of Martins Ferry, Ohio, home to a small yard and some local freight facilities. A notable landmark in many of these images is the Bellaire to Benwood bridge over the Ohio River. The original bridge was built in 1871 with a split on its western side. The north leg takes trains to Holloway, Ohio, a major marshaling yard for mine trains, and thence to the Lake Erie ports and a connection with the railroad's Chicago main line. The south leg of the bridge heads to Newark, Ohio, and Columbus, Ohio, and a junction with the B&O's St. Louis main line. Because of space restrictions on the West Virginia side of the river, it was necessary to build a loop to raise the right-of-way to the proper elevation to cross the bridge and allow river traffic to travel unimpeded on the river below.

Locomotive power in this section is quite varied: The Wheeling and Ohio Divisions saw many steam engines come in from other divisions as they switched to diesels. Common motive power that J. J. saw and photographed were 0-8-0 switch engines, 2-8-0 Consolidation and 2-8-2 Mikado road freight engines, 4-6-2 Pacific passenger locomotives, and 2-8-8-4s (also known as EM-1s) that were articulated heavy-hauling freight locomotives. Diesel switch engines start to appear more frequently through the 1940s and 1950s, as do F3, F7, and GP9 class diesel locomotives built by General Motors' Electro-Motive Division (EMD). Many of these locomotives were pulling trains to the ports along Lake Erie, and it was not uncommon to see long trains of coal hoppers going around the loop at Benwood, West Virginia, to cross the Ohio River on their way to places like Lorain, Cleveland, or Toledo, Ohio.[3]

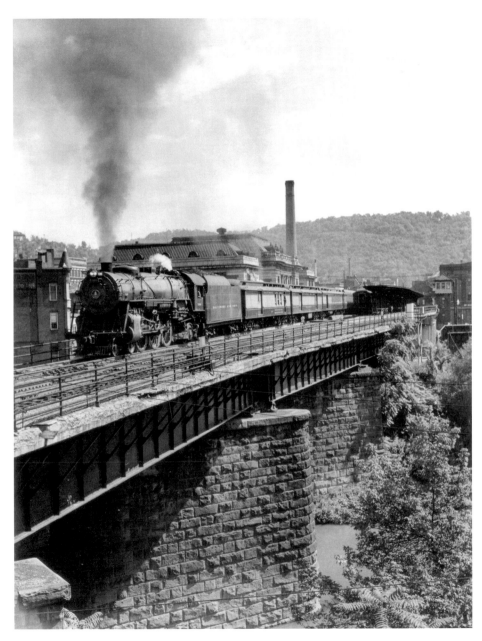

P-7 Pacific #5300 leaves Wheeling depot with train no. 33 in 1950 en route to Cincinnati, OH.

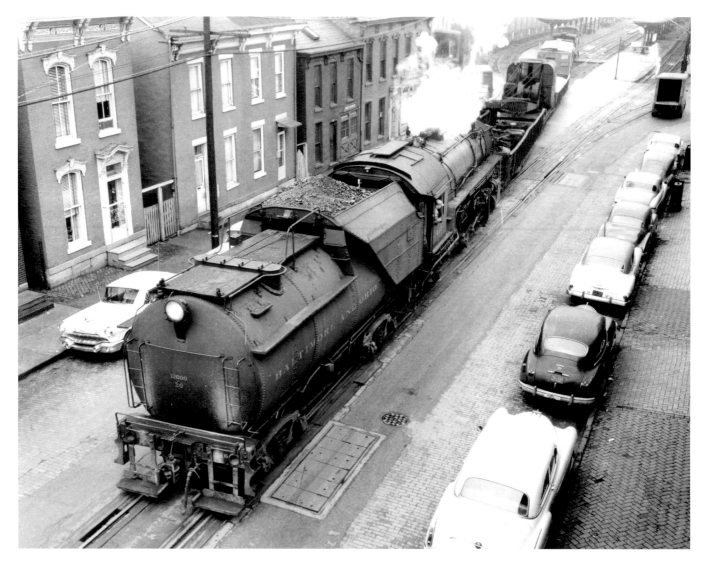

Q-4b Mikado #416 is backing a train through Wheeling Station trackage onto Seventeenth Street en route to Tunnel No.1 to do excavating work in 1957.

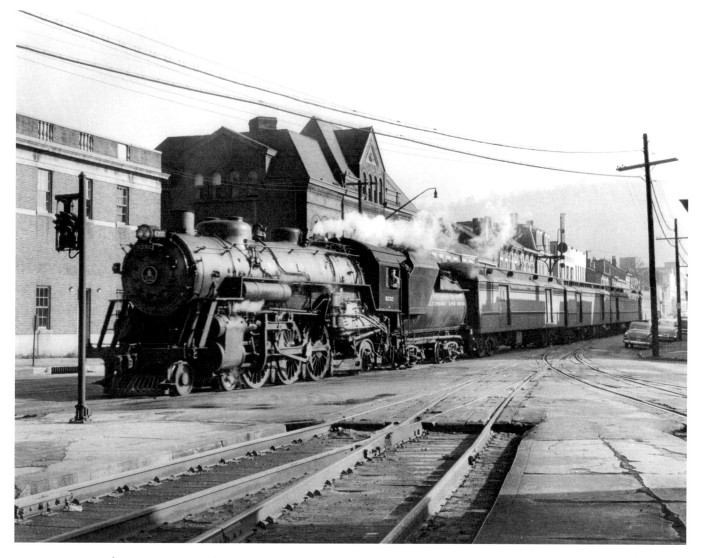

P-6a Pacific #5232 coming down Seventeenth Street and entering Wheeling Station trackage in 1950. Note the dwarf signal on the mast on the left hand side.

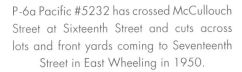

P-6a Pacific #5232 has crossed McCullouch Street at Sixteenth Street and cuts across lots and front yards coming to Seventeenth Street in East Wheeling in 1950.

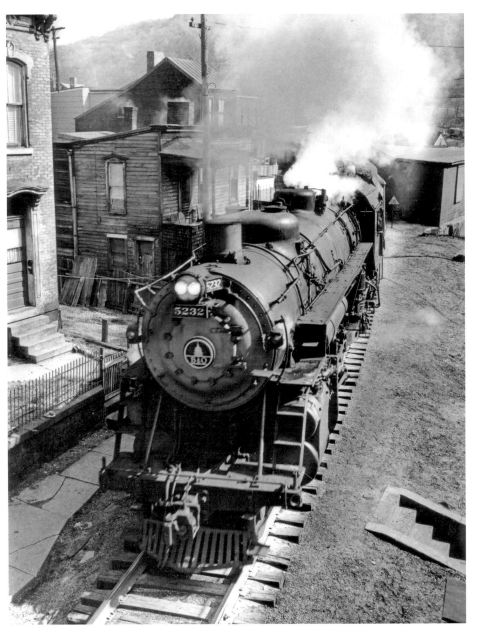

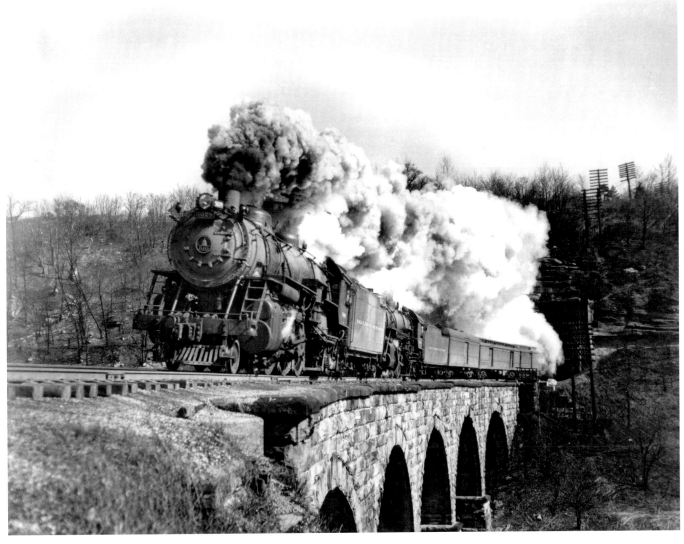

P-1aa Pacifics #5078 and #5059 lead train no. 33 out of Tunnel No. 1 and cross Wheeling Creek in East Wheeling in 1950.

26

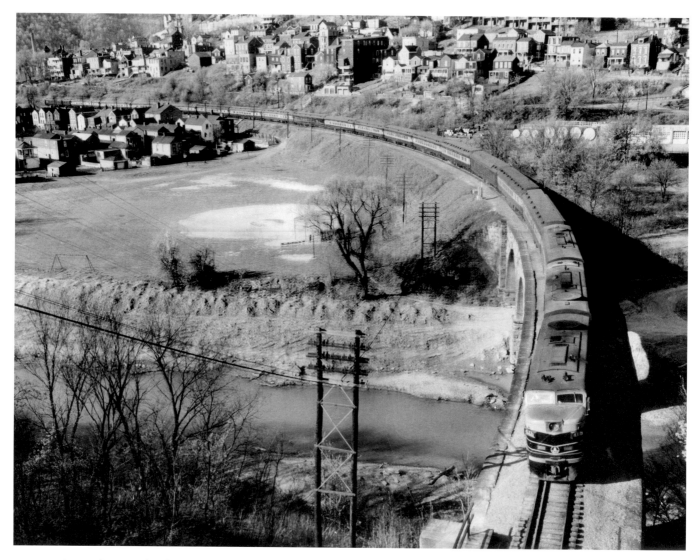

A trio of ALCO diesels get some special work hauling an eastbound passenger extra across Wheeling Creek and are about to enter Tunnel No. 1 in 1950.

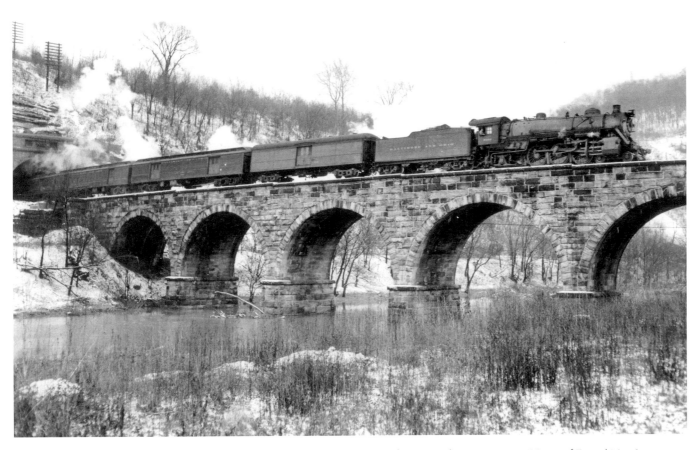

A light snow has fallen on this winter day of 1949, and P-1aa Pacific #5082 brings train no. 33 out of Tunnel No. 1 across Wheeling Creek. The train is heading toward Wheeling from Pittsburgh with a final destination of Cincinnati. In Wheeling, this train will pick up several cars to add to its consist for Cincinnati.

28

Class D-30 0-6-0 #383 has exited Tunnel No. 1, crossed over the Pennsylvania Railroad river terminal branch, and is crossing Wheeling Creek with Goosetown on the left and East Wheeling on the right. Bringing up the rear is an I-16 caboose.

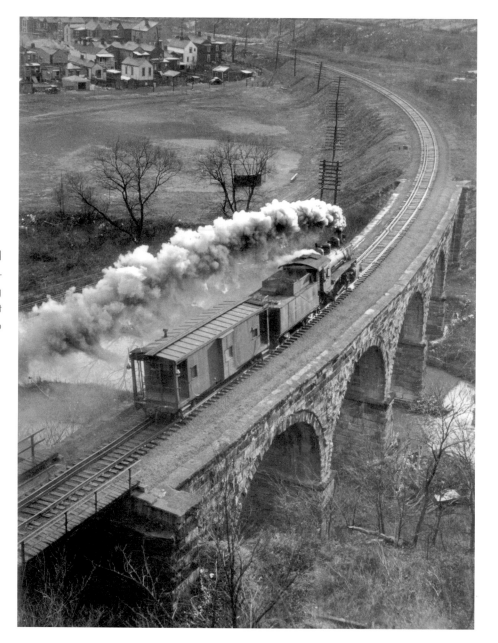

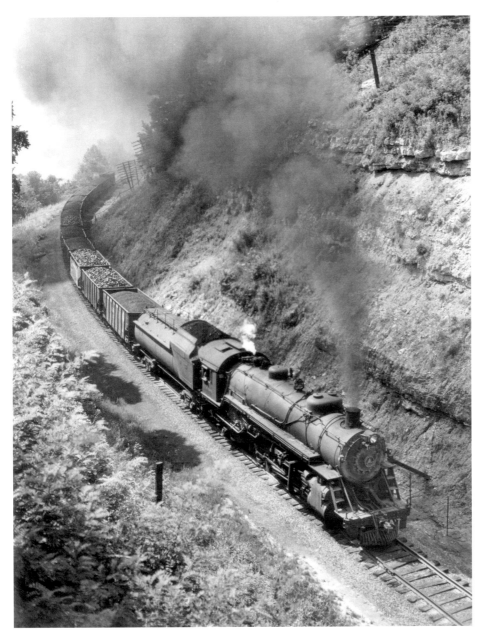

Q-4b Mikado #4469 in the cut at Mount De Chantal in Wheeling en route to Benwood, WV, with a mine run in 1941.

30

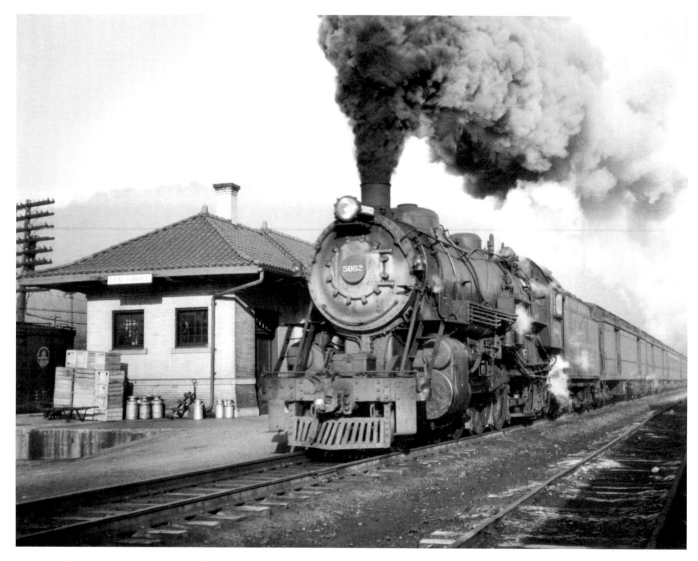

Elm Grove, WV, Depot with train behind P-1aa Pacific #5082 in 1940. The train is heading to Wheeling from Kenova, WV.

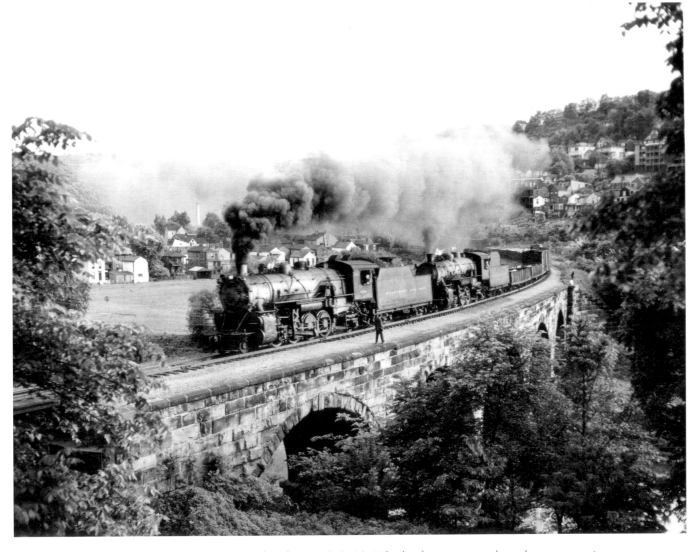

A pair of ex-Buffalo, Rochester & Pittsburgh (BR&P) Q-10 Mikados brings an eastbound tonnage train across Wheeling Creek en route to Pittsburgh in 1947. These locomotives came into the service of the B&O after the BR&P was bought and merged into the B&O Railroad during the Great Depression.

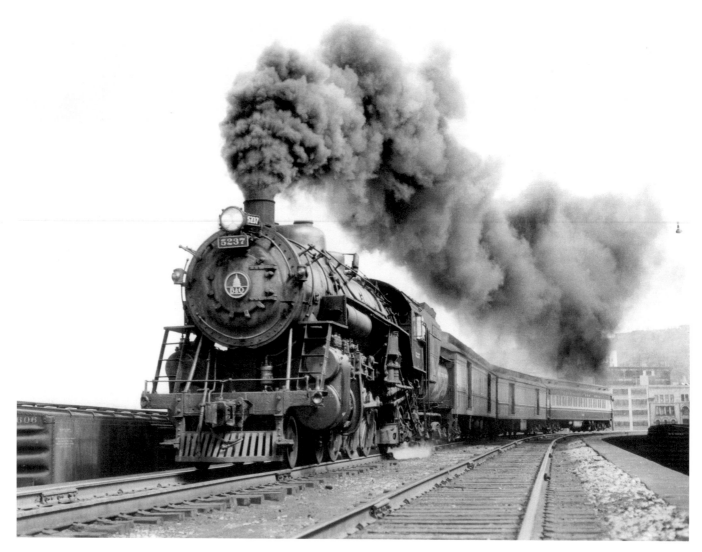

P-6a Pacific #5237 is leaving Wheeling with train no. 73 in 1951.

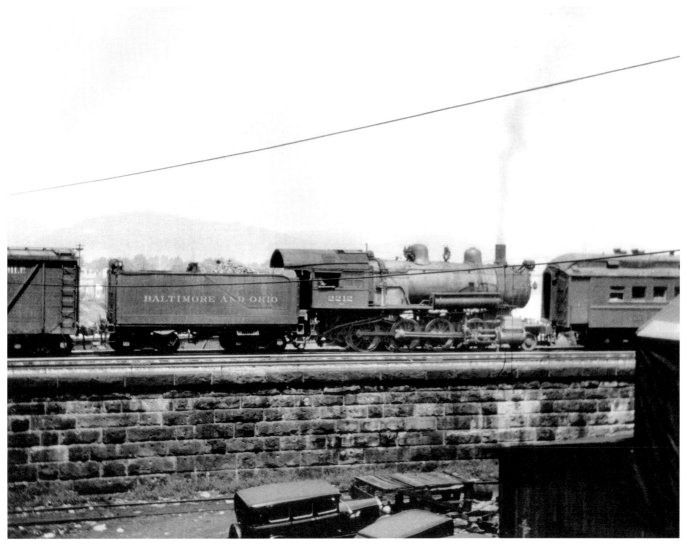

E-24 Consolidation #2212 switching at the Wheeling passenger depot in 1937. Note that this E-24 still has slide valves on its cylinders. This is probably one of J. J.'s earliest shots—note the classic cars in the foreground.

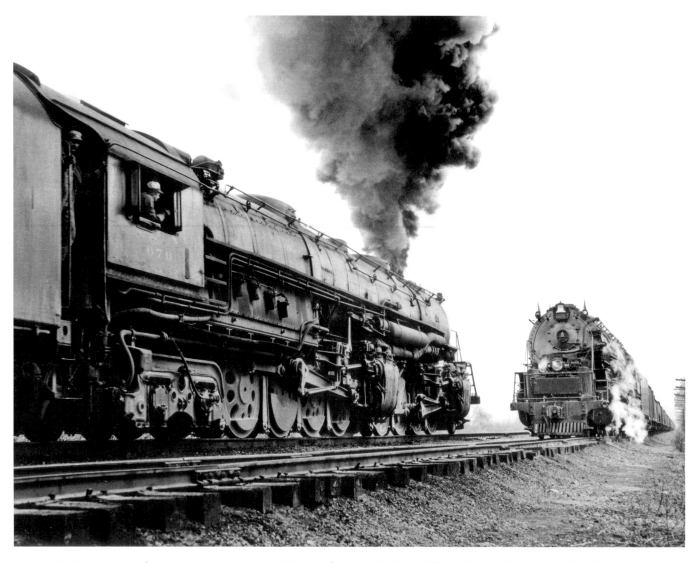

EM-1s #676 and #665 meet at SW Tower in McMechen, WV, in 1957. These locomotives, along with the rest of the B&O's steam locomotive fleet, were given three-digit numbers in 1956 as part of a system-wide renumbering that saw the newer diesel locomotives get four-digit numbers previously held by the steam locomotive fleet.

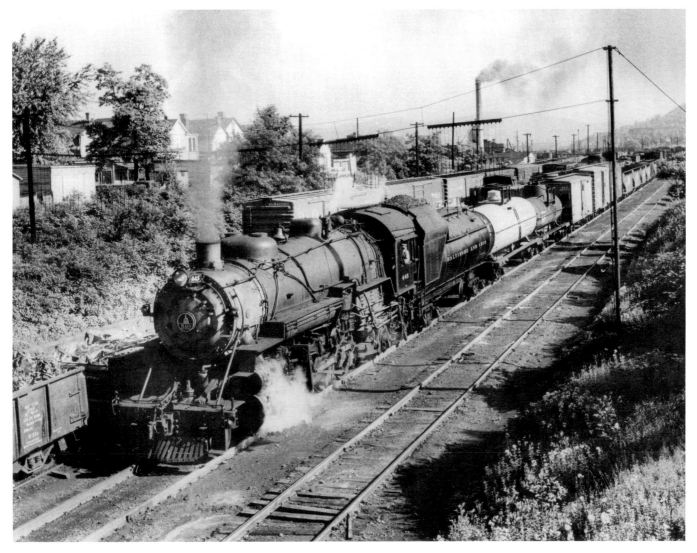

Q-4b Mikado #445 brings a Parkersburg manifest freight into Benwood Junction, WV, in 1957.

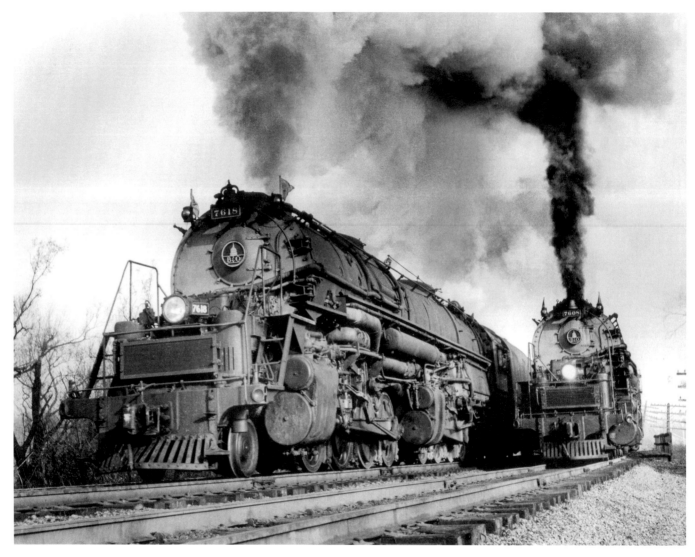

EM-1s #7618 and #7608 at SW Tower in McMechen, WV, in 1954.

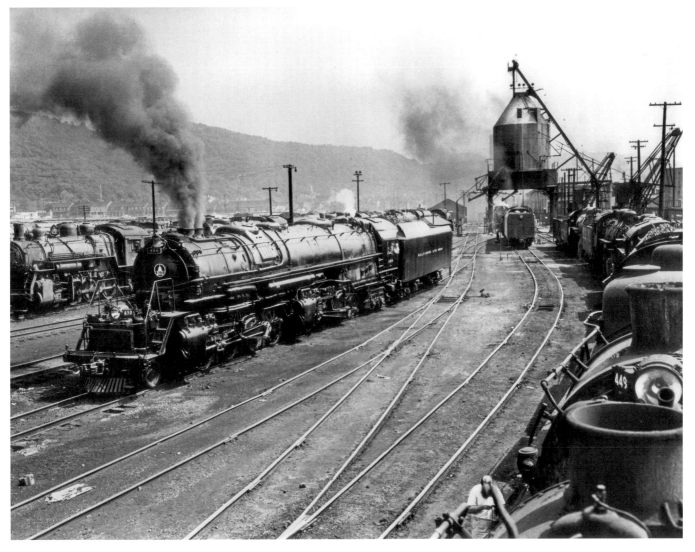

EM-1 #650 (originally #7600) and several other EM-1s being serviced at Benwood Junction, WV, in 1957. To the left of the EM-1, L-1a #807 works the yard, and on the right, Q-4a Mikado #449 (ex-#4449) sits in the dead line.

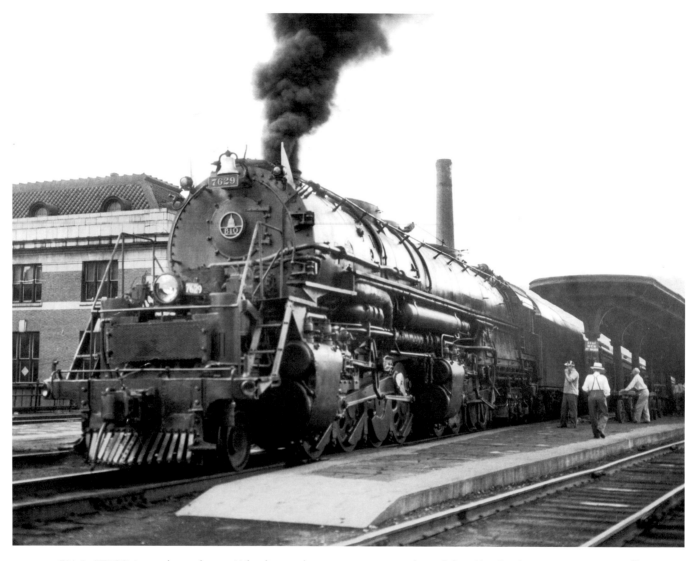

EM-1 #7629 is ready to depart Wheeling with a passenger extra bound for Cleveland, OH, in 1950. In all likelihood this was a railfan excursion.

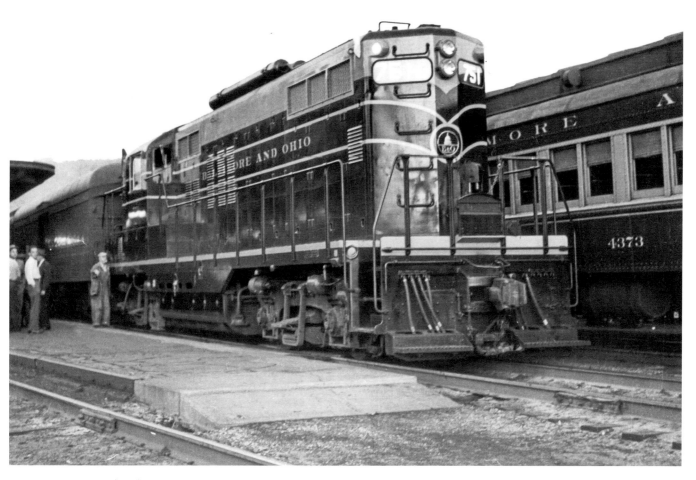

Passenger diesel GP-9 #751 on a passenger extra ready to depart Wheeling in 1955. This engine runs today on the South Branch Valley Railroad out of Moorefield, WV.

EM-1 #659 shoves a Holloway turn out of Benwood, WV, as Q-4b Mikado #482 is ready to depart with a Parkersburg train in 1957.

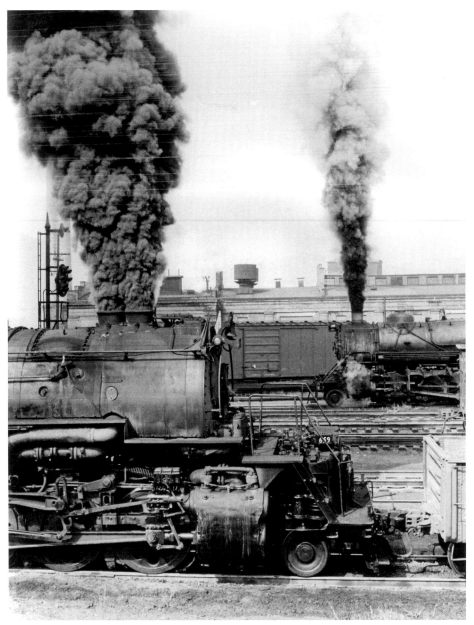

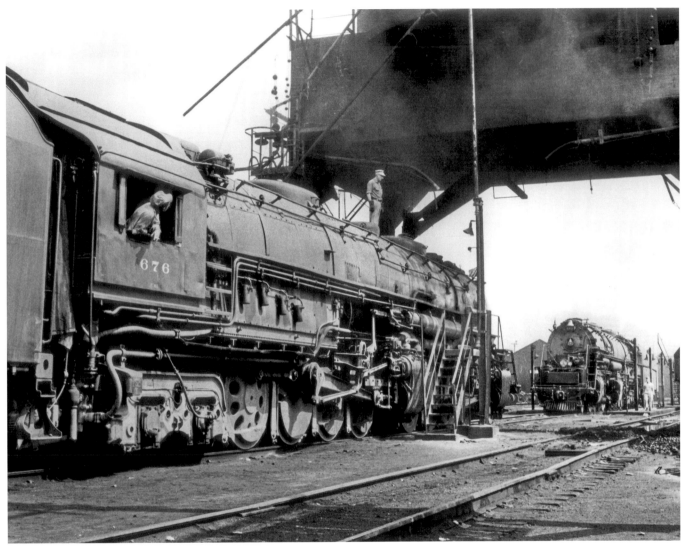

A pair of EM-1 2-8-8-4s are serviced at Benwood Yard, WV, in 1957.

42

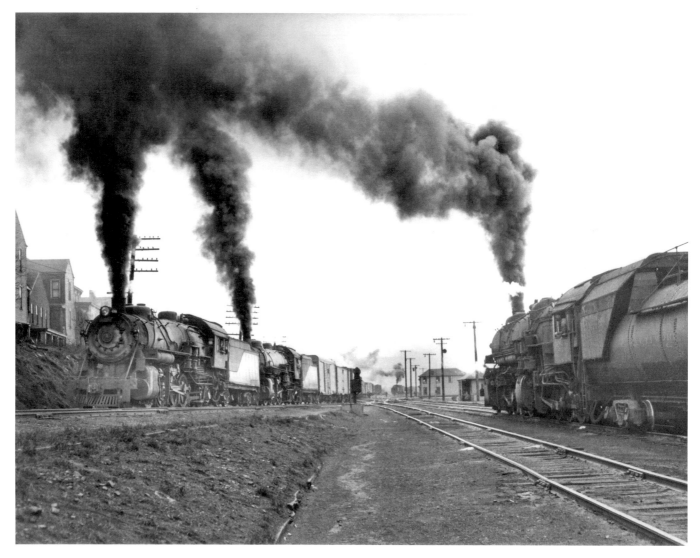

Typical Benwood action as a pair of Q-1 Mikados led by Q-1c #4306 gets a Newark, OH, manifest freight on the move. An L-class 0-8-0 switches near the yard office (center of shot), and an EL-5a, #7156, brings a Piker into town.

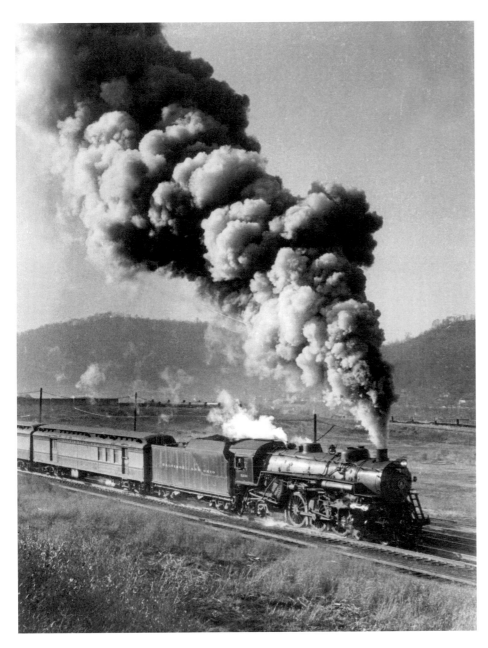

P-6a Pacific #5231 at Benwood Junction, WV, with a P-1d tender in 1952.

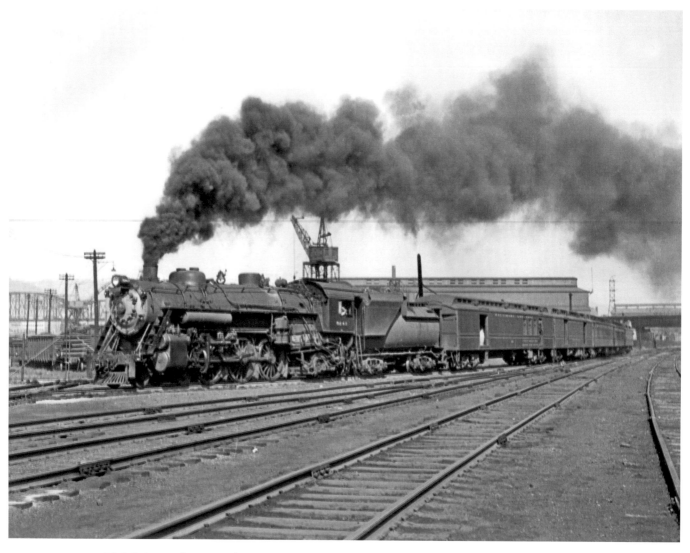

B&O P-6a Pacific #5243 brings train no. 33 onto the loop at Benwood Junction, WV, in 1952.

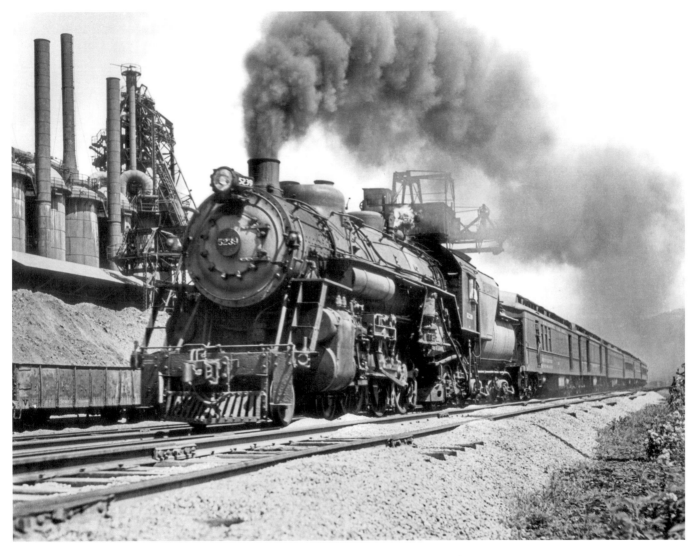

B&O P-6a Pacific #5239 rolls past Wheeling Steel's Benwood Blast Furnace in 1947.

Engineman Prestley Hill sounds an EM-1's hoot whistle on a humper en route to Holloway, OH, in 1953.

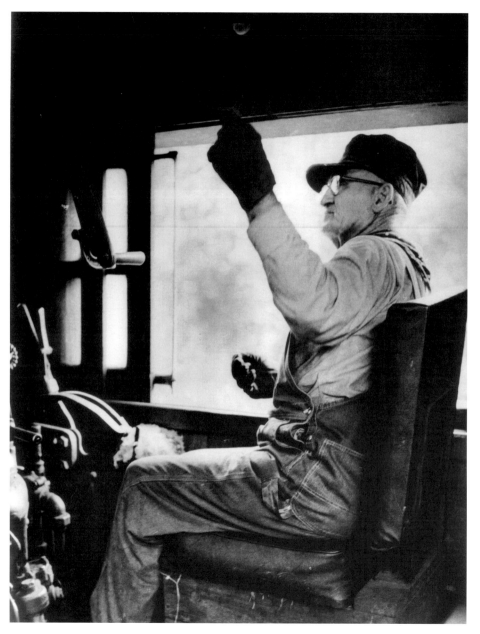

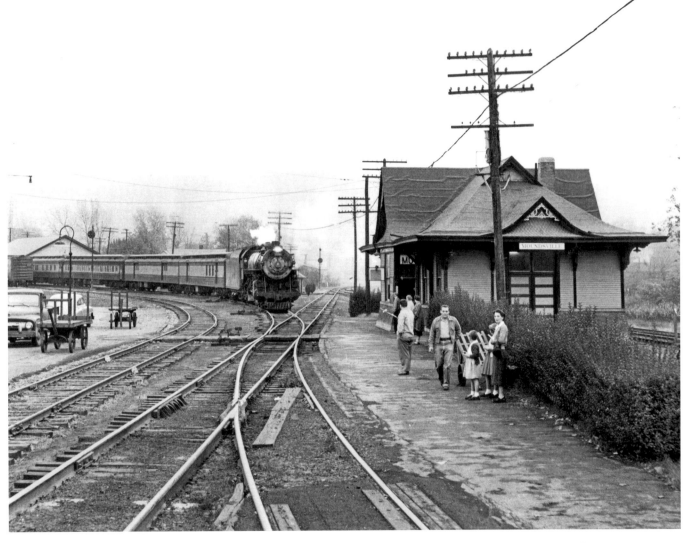

P-7 Pacific #5300 comes off the old main line from Fairmont, WV, at Moundsville, WV, as Paul Maxwell prepares to hand orders to the crew. This depot portrayed the fictional Glory, WV, depot in the film *Fools' Parade* based on David Grubb's novel of the same name. Much of this film was shot on location in and around Moundsville.

48

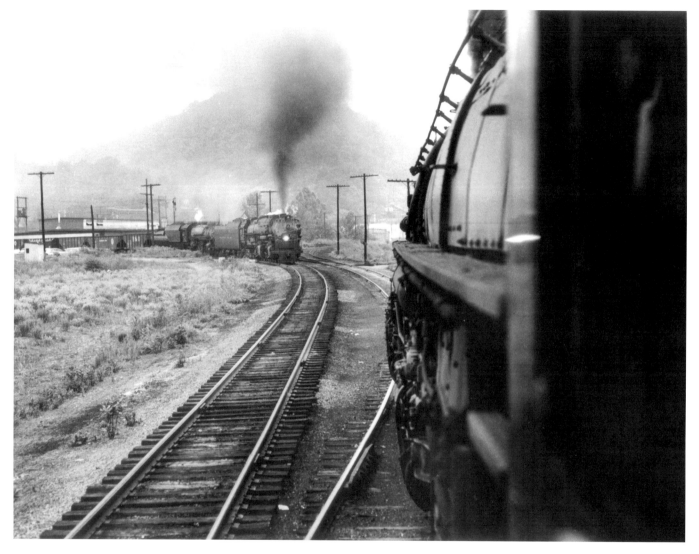

J. J. is aboard an EM-1 on a Holloway Humper departing Bridgeport, OH, and meeting an EM-1 and Q-4 Mikado duo with an inbound Holloway, OH, manifest freight in 1952.

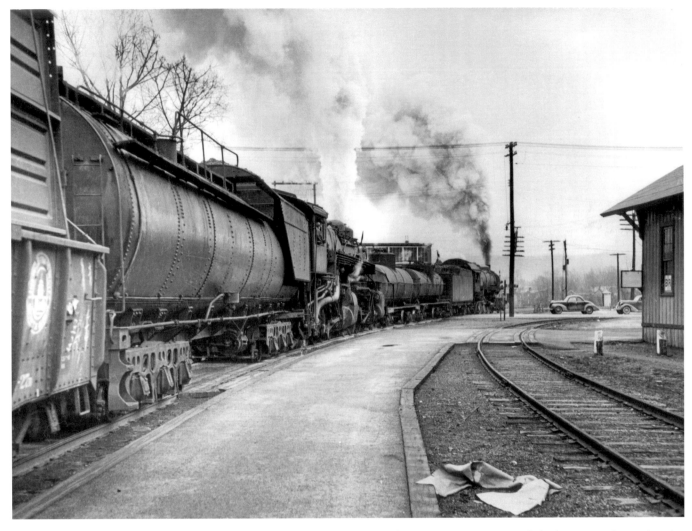

Q-1aa Mikado with a pair of water bottles and ex-SAL EL-6 2-8-8-0 at Bridgeport, OH, in 1949. With the long-term plan to dieselize the railroad underway after World War II, the B&O began to remove infrastructure along the Wheeling Division that supported steam locomotives, mainly water facilities. The reduction in water availability caused the B&O to assign tank cars to water service, and larger tenders that were saved from scrapped articulated locomotives were assigned to trains operating along this division. This allowed these trains to travel further between water stops without endangering the safe operation of the locomotive due to lack of water.

50

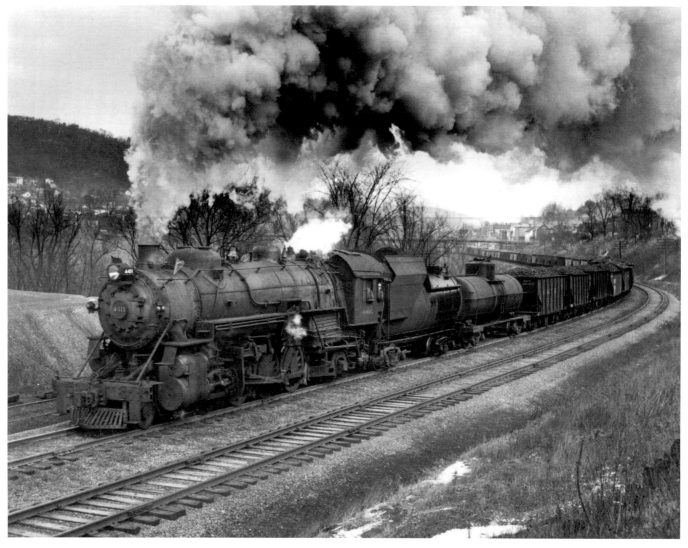

Holloway Humper behind Q-4 Mikado #4411 with a water bottle at Boydsville, OH, in March 1948.

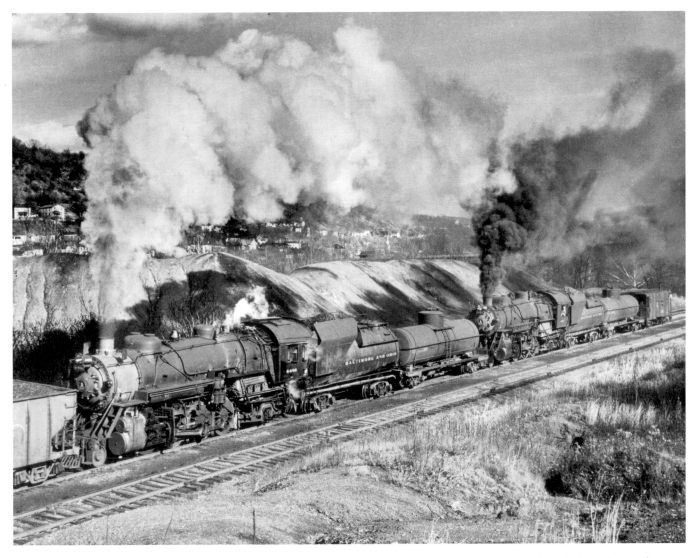

Hind end of same train in the previous shot with a pair of Q-4 Mikados led by #4486—a Q-4b Mikado with over-fire jets—followed by a Q-4b Mikado without over-fire jets; each has a spare water bottle with it. An I-12 caboose brings up the rear. The over-fire jets were designed to improve the efficiency of the steam locomotive firebox by increasing the airflow to the fire. Some crews did not like them because of the extra noise they produced while in operation.

SW Tower Operator Paul Maxwell at work
in February 1957.

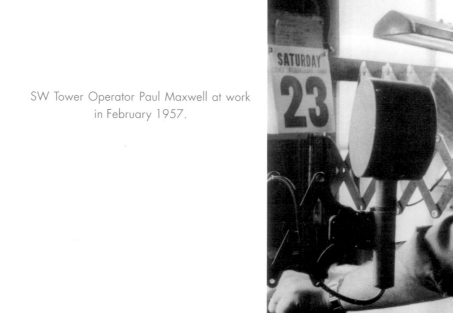

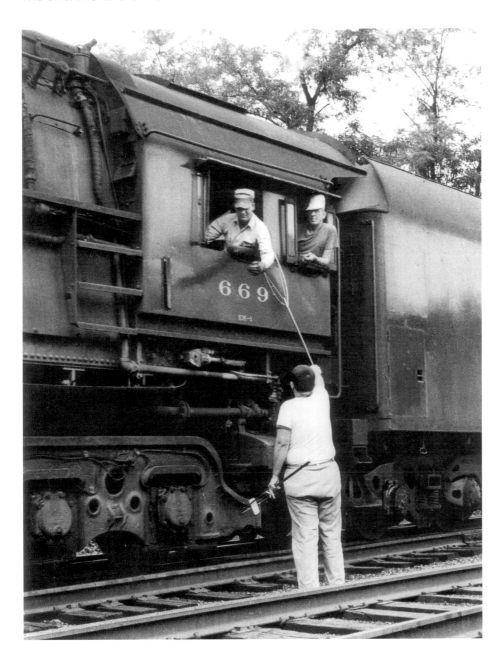

SW Tower Operator Maxwell hands orders to crew of EM-1 #669 at McMechen, WV, in 1957.

Operator Maxwell hands orders to the
hind-end crew of the same train.

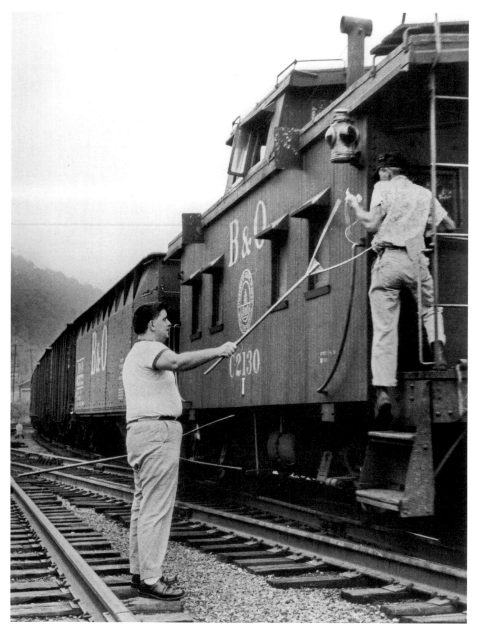

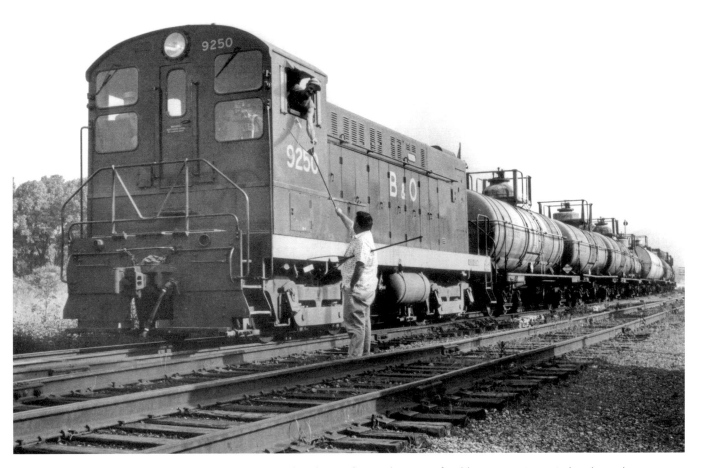

Operator Maxwell again, now in the 1960s, handing orders to the crew of Baldwin DS-4-4-1000 diesel switcher #9250 with a string of LPG cars.

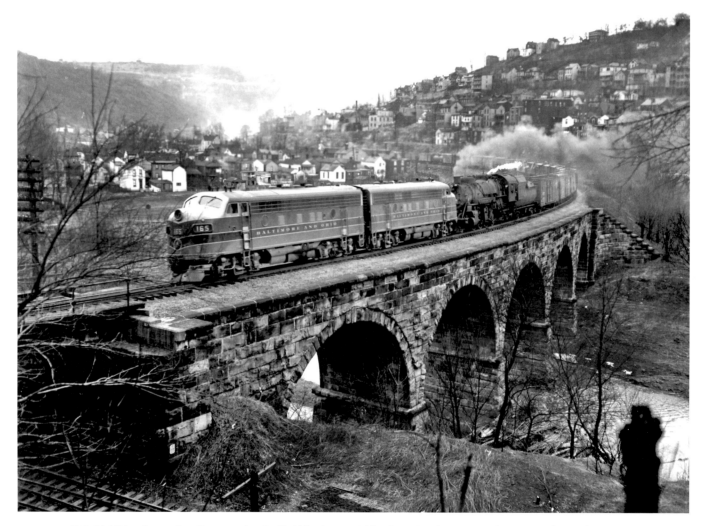

F-3 #165 leads another F-unit and a Q-4b Mikado over Wheeling Creek into Tunnel No. 1 in the early 1950s.

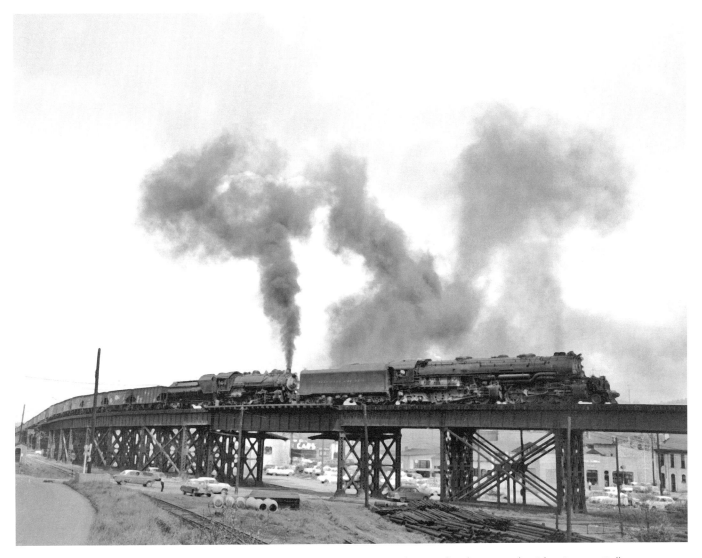

EM-1 and Q-4b Mikado lead a Holloway Humper toward Benwood, WV, after they cross the Ohio River at Bellaire, OH, in the mid-1950s.

58

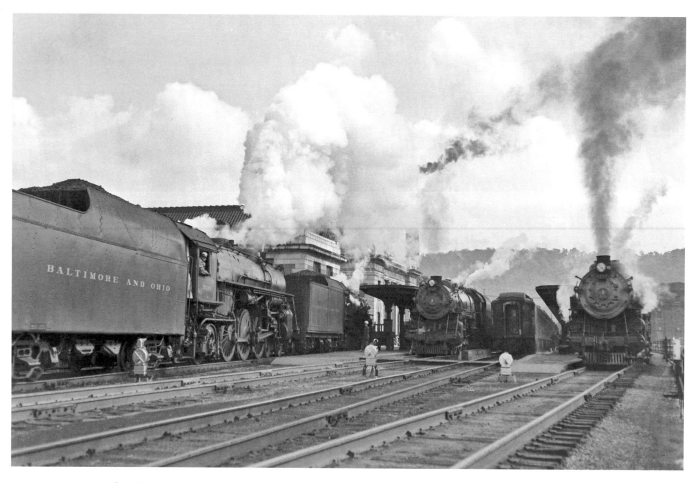

A quartet of B&O power at Wheeling's B&O passenger station. From left to right we see P-7 Pacific #5318 behind an unidentified B&O steam locomotive, P-7 Pacific #5320, and P-6 Pacific #5237.

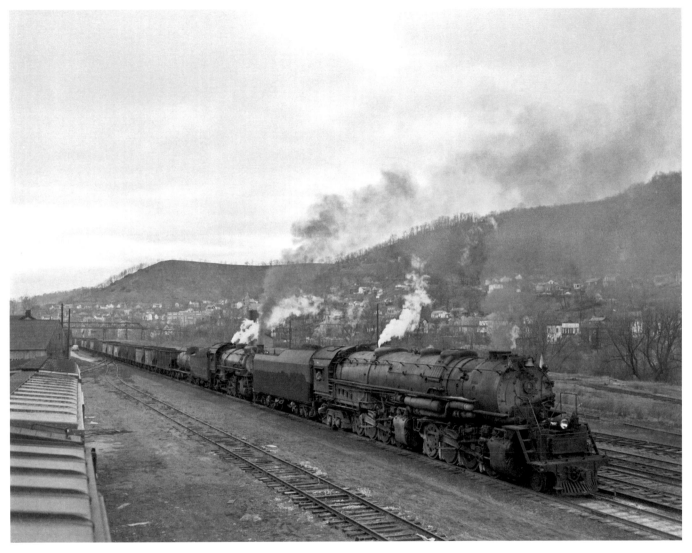

EM-1 and Q-4b Mikado lead a Holloway Humper westbound toward Holloway, OH.

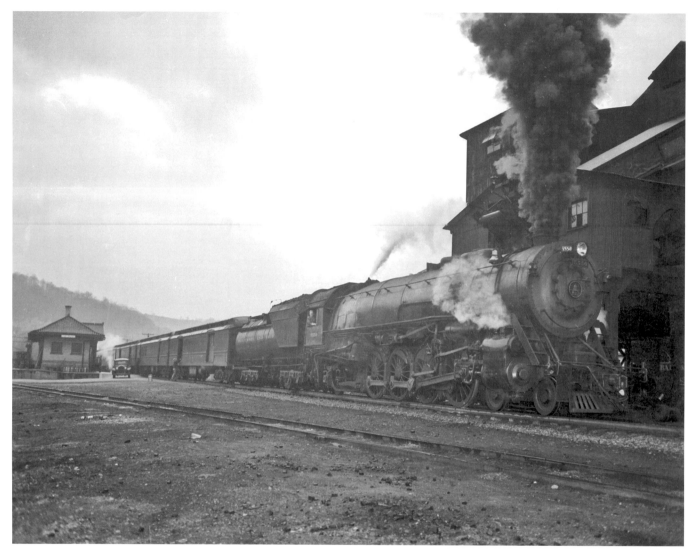

In Elm Grove, WV, T-2 Mountain #5550 has stopped at the station and is getting underway toward Wheeling passing Jean Mine.

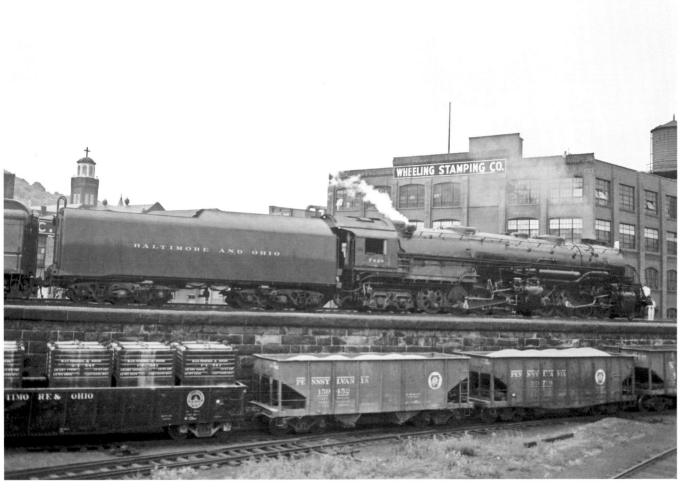

An EM-1 leading a passenger train waits to depart Wheeling. Below it sits a B&O O-27 gondola with containers (probably containing dolomite for fluxing at a steel plant) and Pennsylvania Railroad hoppers.

62

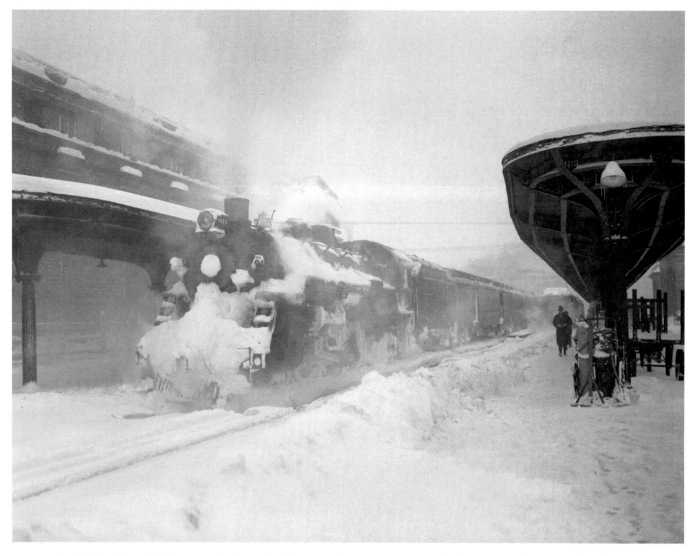

Brr! P-4 Pacific #5133 has been fighting the elements to bring its train into Wheeling on a cold, snowy day. This shot had to be taken before 1951 since this locomotive was retired in that year.

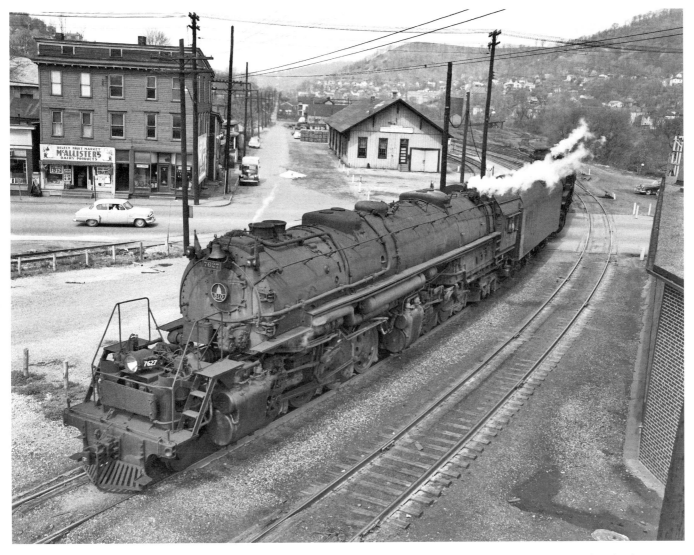

EM-1 #7627 has just passed the Bellaire, OH, freight house on its trip out of Martins Ferry, OH, heading back to Benwood, WV. There is another locomotive behind it, but the steam obscures any means to identify it. The shot appears to be from the mid-1950s based on the car and the fact that #7627 still has its four-digit number.

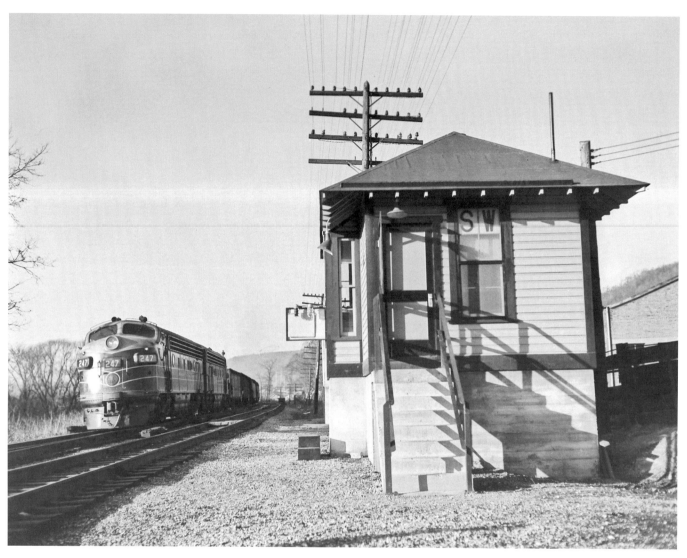

B&O F-7 #247 leads a freight eastbound past SW Tower in McMechen, WV.

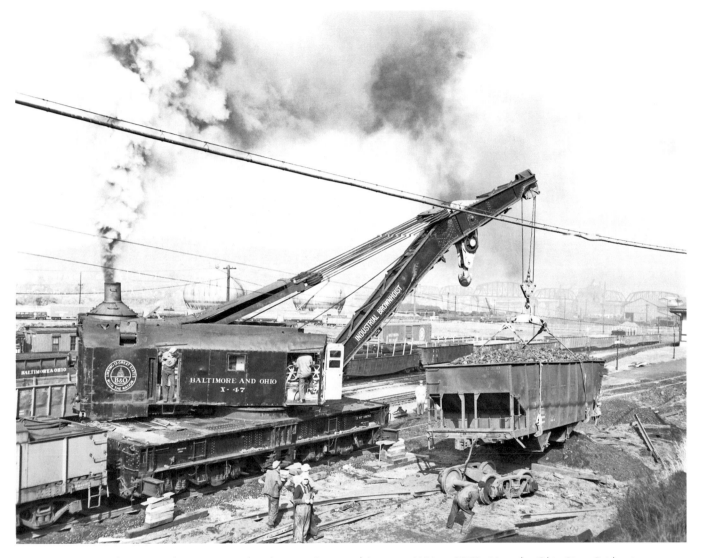

Steam Hook X-47 is cleaning up a derailment at Benwood Junction, WV, in 1951. Note the Ohio River Bridge in the background on the right.

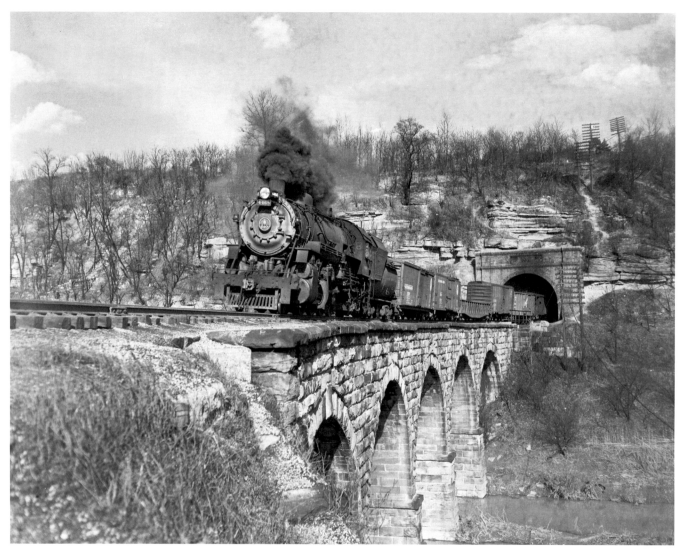

Q-4b Mikado #4468 leads a train out of Tunnel No. 1 and over Wheeling Creek in this winter shot.

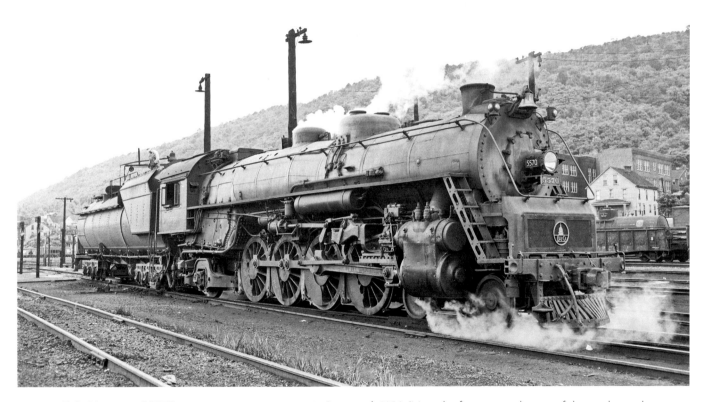

T-3t Mountain #5570 is preparing to get water in Benwood, WV. (Note the fireman on the top of the tender and the hatch open.) It was built at Mount Clare Shops in Baltimore, MD, in 1944. In 1957 it was renumbered to 712.

68

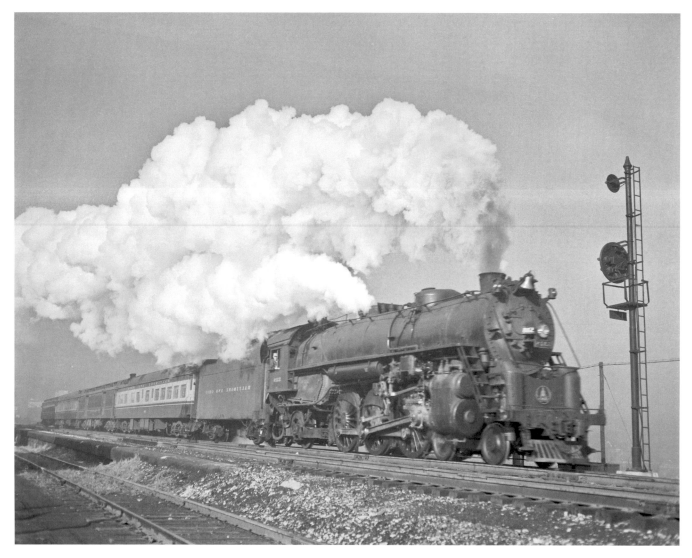

P-7c Pacific leads a passenger train (probably train no. 33 to Cincinnati) past Benwood, WV, station and is approaching the Ohio River Bridge in this pre-1951 shot.

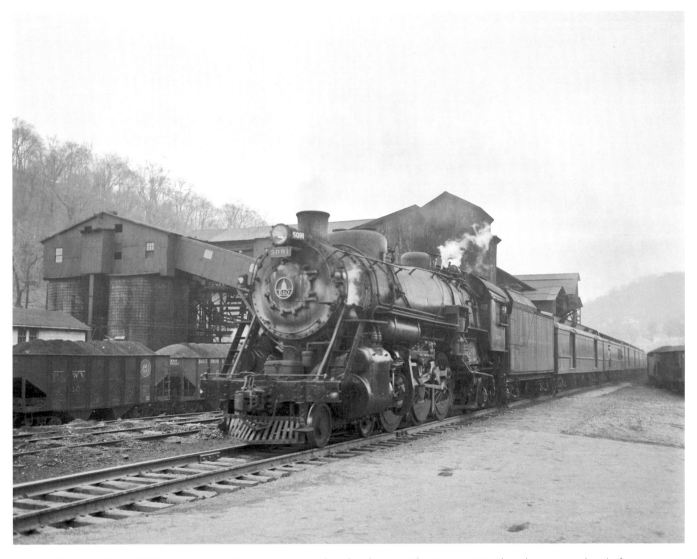

P-1d Pacific #5091 passes Jean Mine as it approaches the depot in Elm Grove, WV. This photo was taken before 1955, the year this locomotive was retired.

70

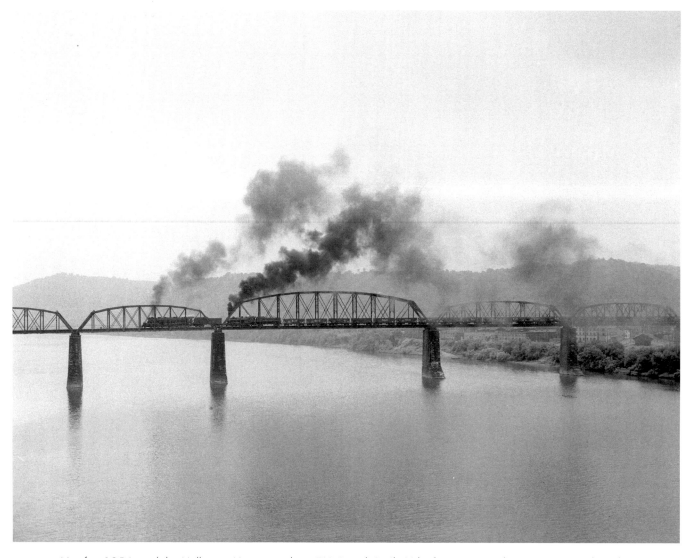

It's after 1954, and the Holloway Humper with an EM-1 and Q-4b Mikado power combination crosses the Ohio River. The Holloway Humper was a frequent target of J. J.'s camera as it regularly moved coal from Wheeling to Holloway, OH, and then on to the Lake Erie ports. Because the trip involved traversing several significant grades, it usually was assigned a significant amount of power.

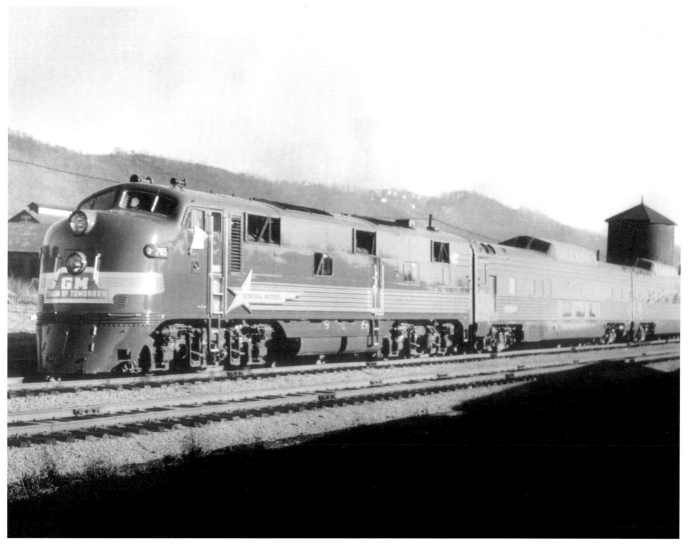

GM's Train of Tomorrow led by an EMD E-7 in South Wheeling in 1946. The train was a promotional tool designed to showcase the new postwar railroad equipment coming from General Motors and Pullman.

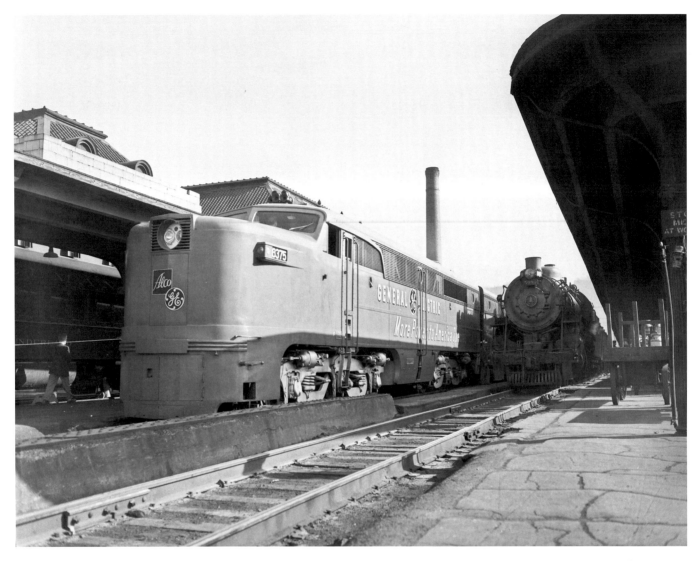

The ALCO-GE "More Power to America Special" has stopped in Wheeling with B&O P-1d #5092 sitting on the track next to it. In early 1950, a set of PA-1/PB-1s returned to ALCO for upgrades to PA/B-2s. They went on a fifteen-month tour to promote ALCO's power for tomorrow.

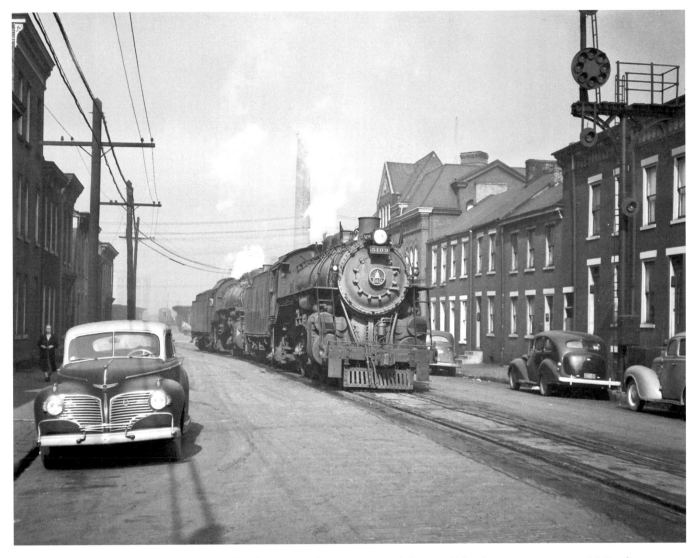

B&O P-3 Pacific #5109 leads another locomotive down Seventeenth Street in Wheeling past a signature B&O color position light signal on the right.

74

An L-2 0-8-0 steam switch engine and a Baldwin switcher lead a mixed freight from Martins Ferry, OH, into Benwood, WV, via the Ohio River Bridge.

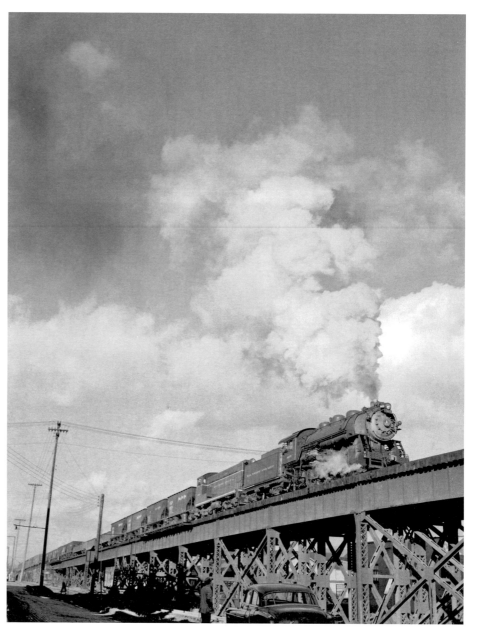

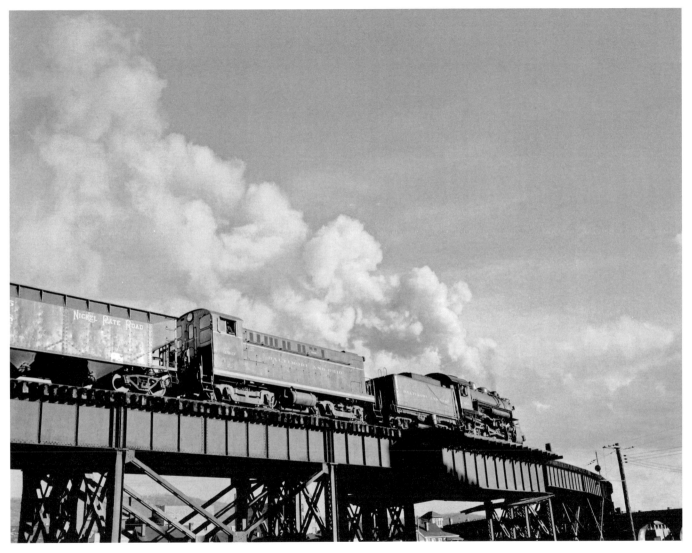

The L-2 0-8-0 and Baldwin make the curve to begin their descent to ground level in Benwood, WV.

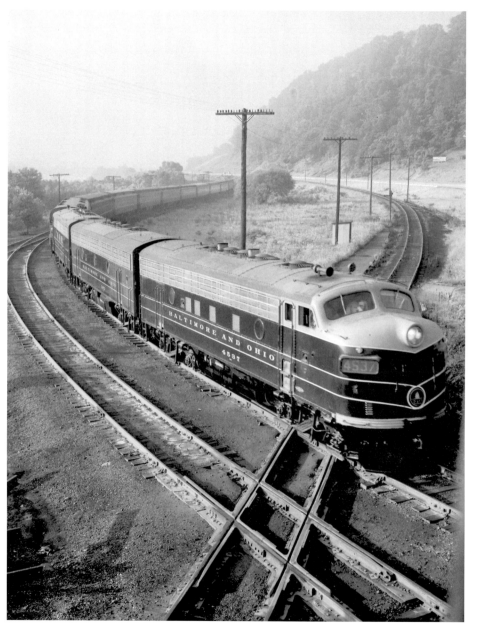

F-7 #4537 leads two more Fs and a string of passenger cars on an excursion run over the Pennsylvania Railroad tracks at the diamond south of Martins Ferry Yard in Ohio.

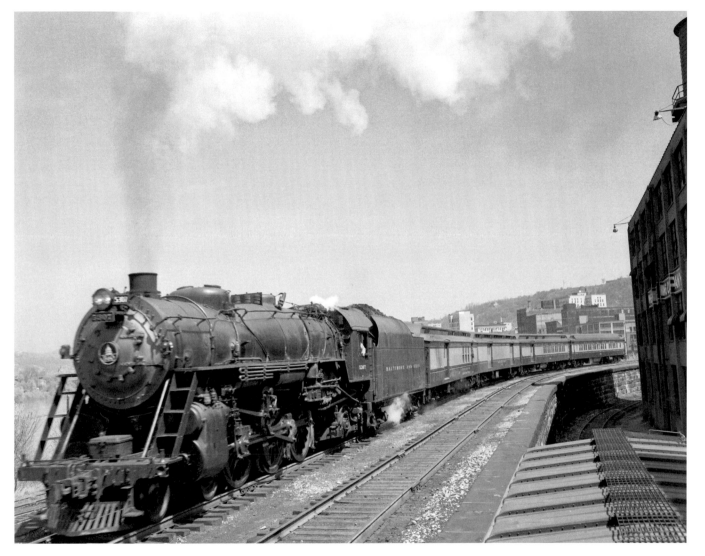

P-7 Pacific #5307 leads train no. 233 out of Wheeling to Columbus, OH, and Cincinnati, OH.

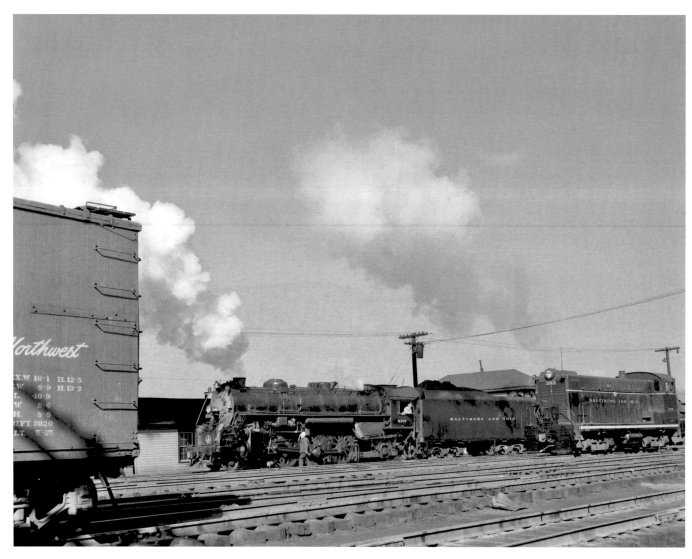

P-7C Pacific #5314 and Baldwin DS4-4-1000 Switcher #382 at Benwood, WV.

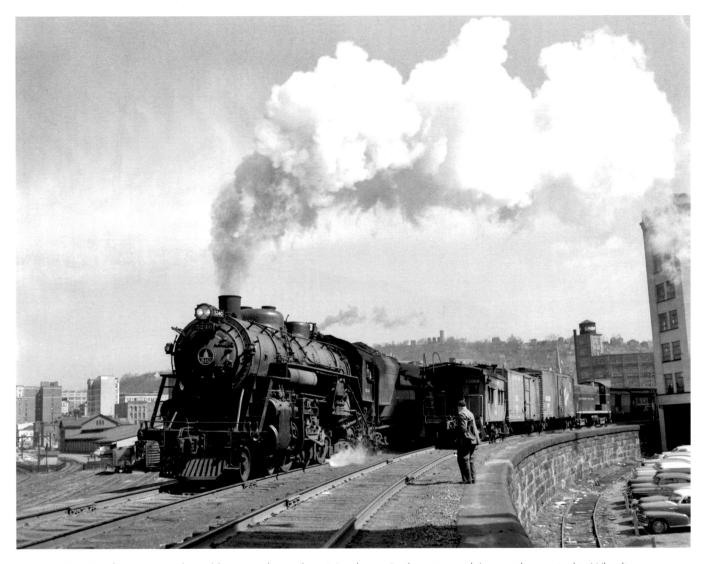

P-6a Pacific #5240 and a Baldwin switcher with an I-1 caboose (without its cupola) are at the terminal in Wheeling.
The Baldwin and the caboose are working a transfer job inside the terminal.

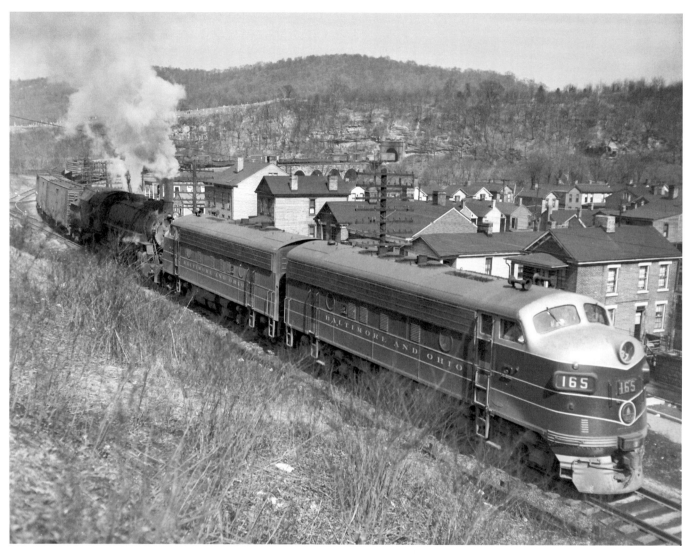

A pair of F-3s led by #165 and a Q-4 Mikado lead a freight train out of Tunnel No. 1, over Wheeling Creek, and around East Wheeling as they make their way into Wheeling Terminal.

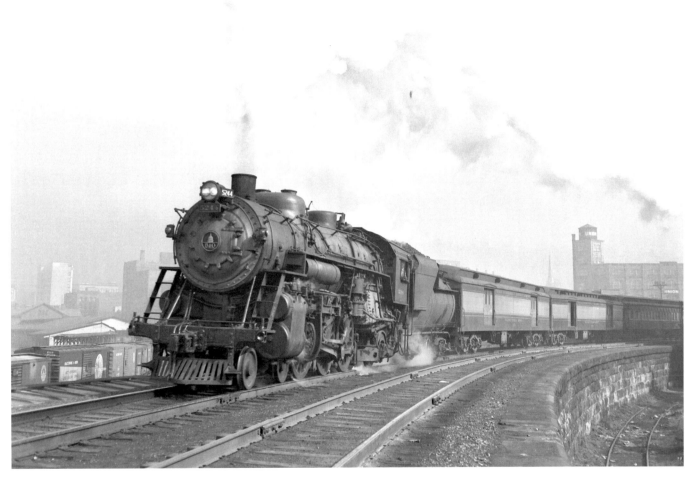

P-6 Pacific #5244 leads a train out of Wheeling Depot. Note the B&O Time Saver boxcar painted in the "comet scheme" in the lower freight yard on the left.

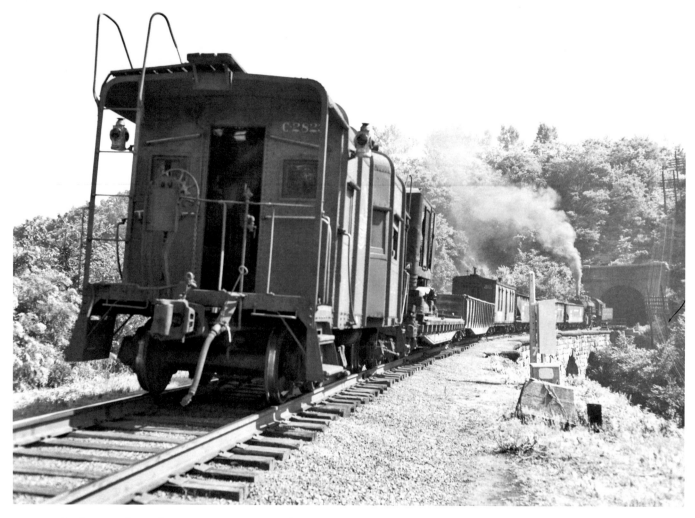

On the rear of a work train, I-12 Wagontop caboose #2825—built in 1945 and named for its curved roof—is pulled into Tunnel No. 1.

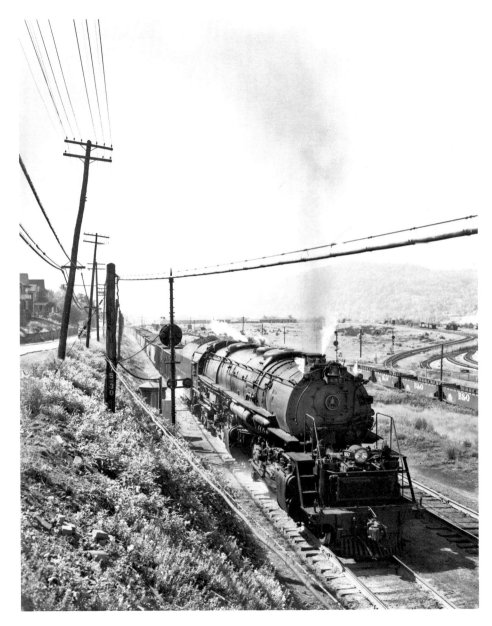

EM-1 #657 is going over the hump to approach the Ohio River Bridge in this 1957 shot.

84

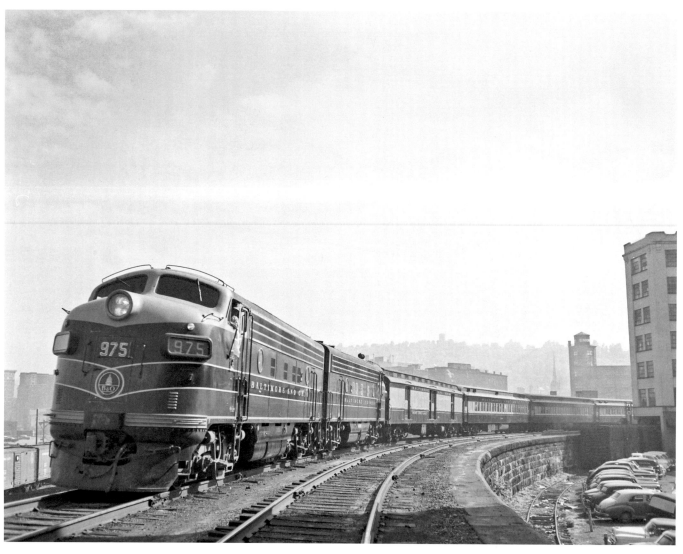

Freight F-7 #975 with a horse car and several coaches heads out of Wheeling in the summer.

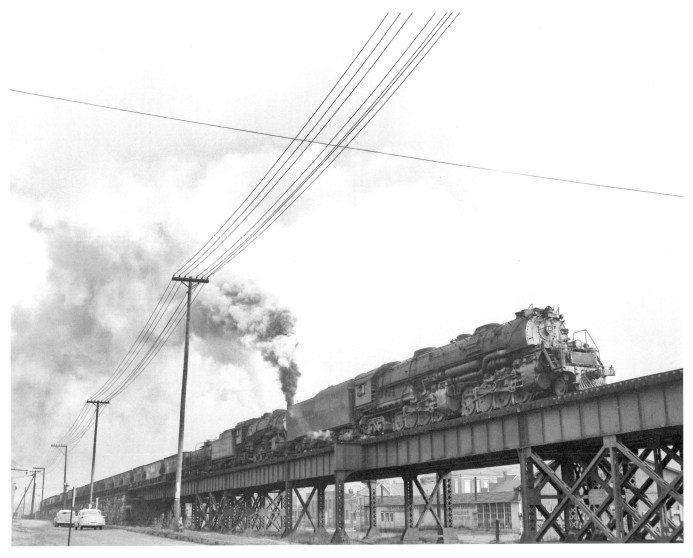

An EM-1 and Q-4b Mikado pair on the Holloway Humper are going to West Virginia over the Ohio River Bridge in this post-1954 shot.

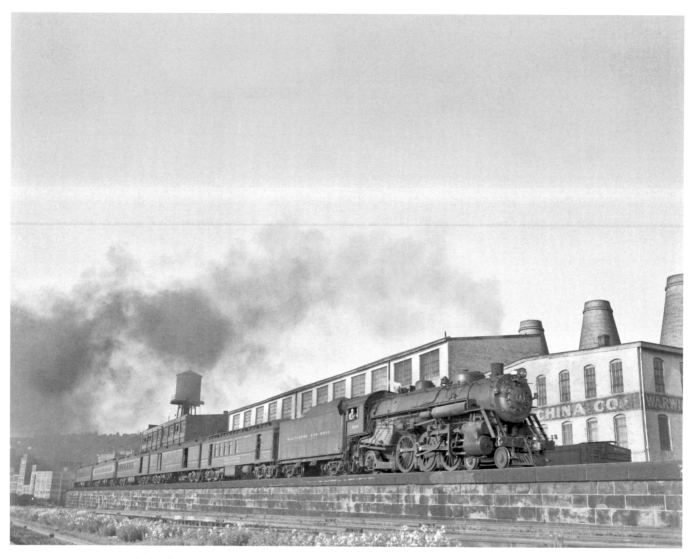

A P-7 Pacific leads train no. 73 heading to Kenova, WV, in this shot near the mouth of Wheeling Creek.

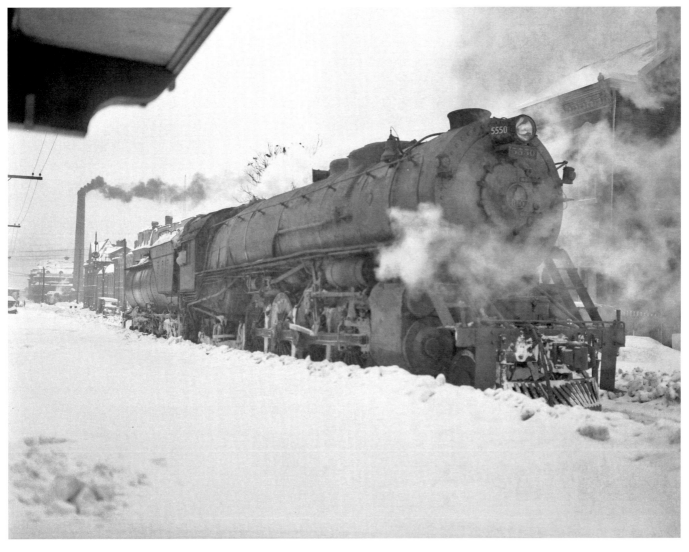

The locomotive in this scene is a class T-2 4-8-2 Mountain. Number 5550, shown here on a cold, snowy day, is making a switching move at Wheeling Station. The T-2 was built by Baldwin Locomotive Works and had a sister—T-1—of the same dimensions with one difference: the T-1 #5510 had a water-tube firebox, thus giving it a different class designation. Comparison studies were done on both to see the efficiency of water-tube locomotives. Locomotive #5510 retired in 1951, and this locomotive was retired in February 1953.

T-2 Mountain #5550 leads a train down the street as it passes the grade-crossing flagman on Seventeenth Street.

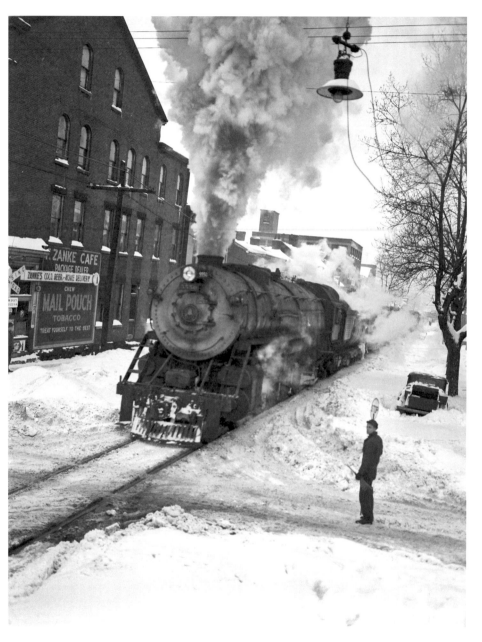

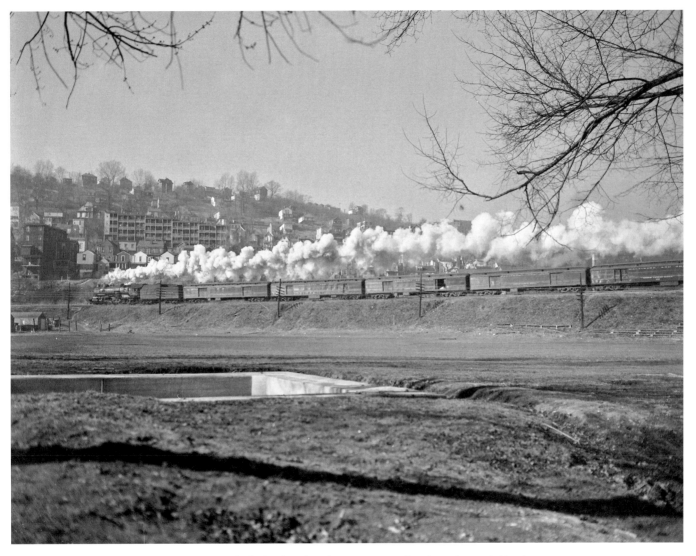

A rare consist of all blue head-end equipment makes this a later-1940s shot.

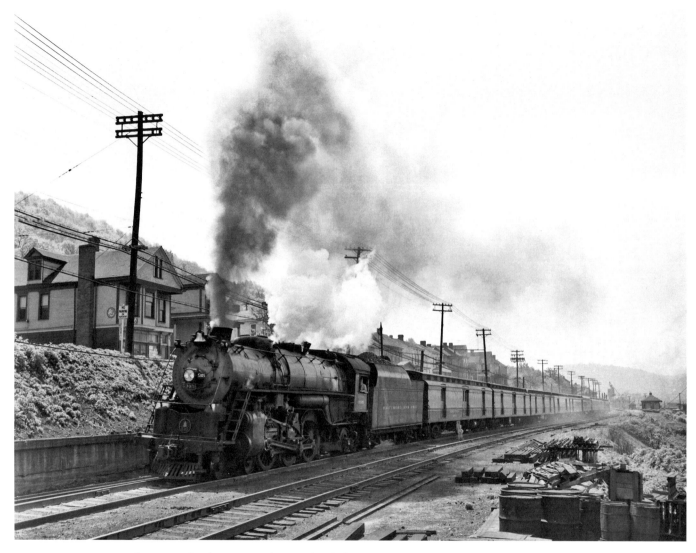

B&O P-7c Pacific #5305 leads a racetrack special with three horse cars past Benwood, WV, en route to Wheeling.

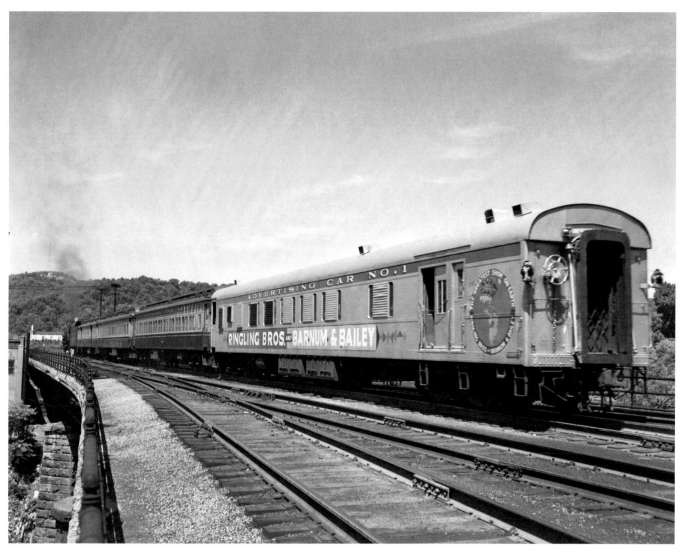

Ringling Brothers and Barnum & Bailey Circus Advertising Car No. 1 brings up the rear of a B&O train as it leaves Wheeling. While the circus no longer uses single advertising cars to promote itself, it does still travel by rail.

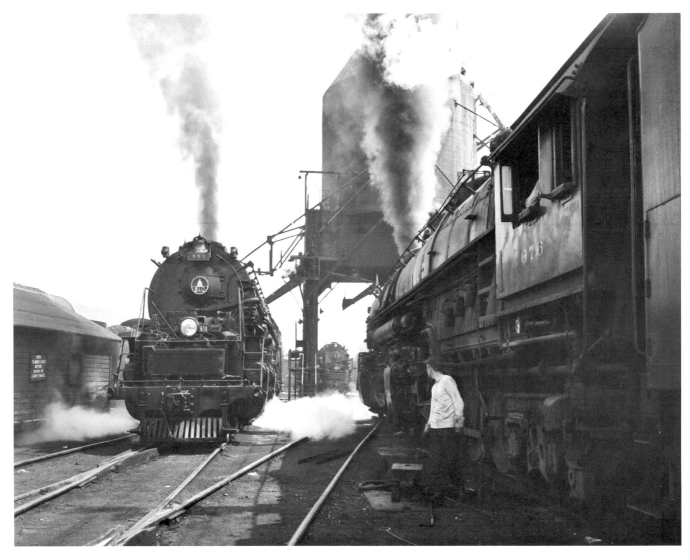

Circa 1957, Benwood, WV. Ready track with three EM-1s: #650 on the left, #676 on the right, and another in the distant middle.

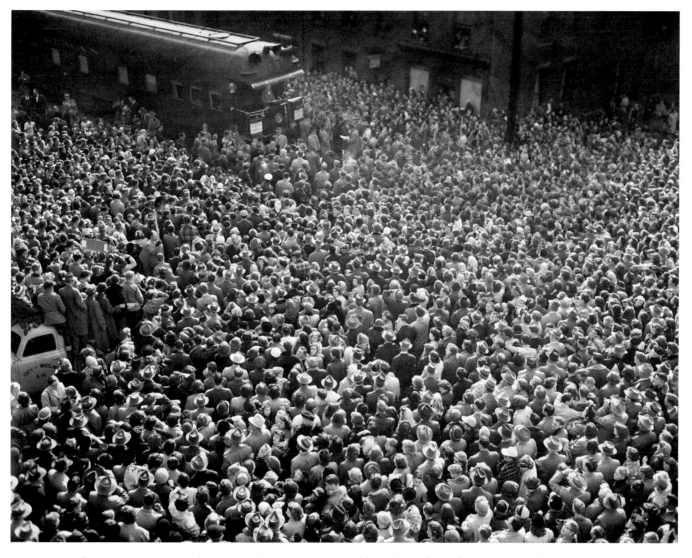

President Harry Truman speaks to a standing-room only crowd from the platform of Presidential Rail Car US No.1, the *Ferdinand Magellan*. We believe that this is from a 1952 campaign swing through Wheeling to support Democratic nominee Adlai Stevenson.

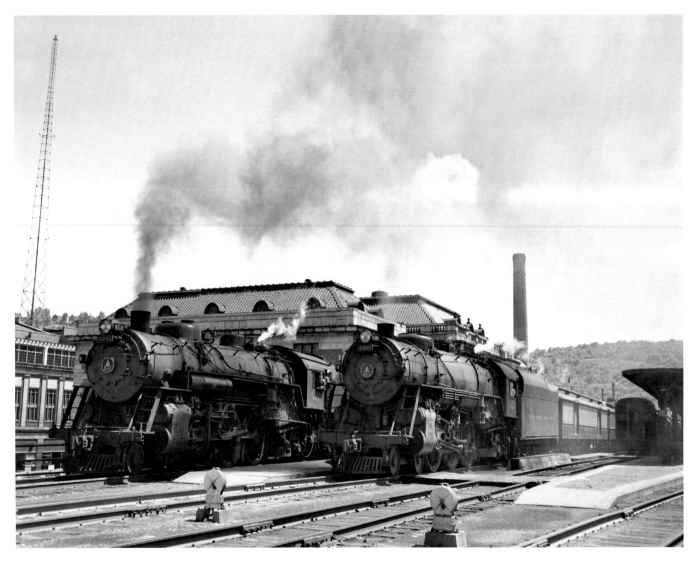

Wheeling Station is hosting three passenger trains at once. This was done to provide passengers a quick transfer to other trains going in different directions. The locomotives are two Pacifics, P-6a #5234 and P-7 #5300. In the distance you can see the rear of a third train, which is headed to Pittsburgh.

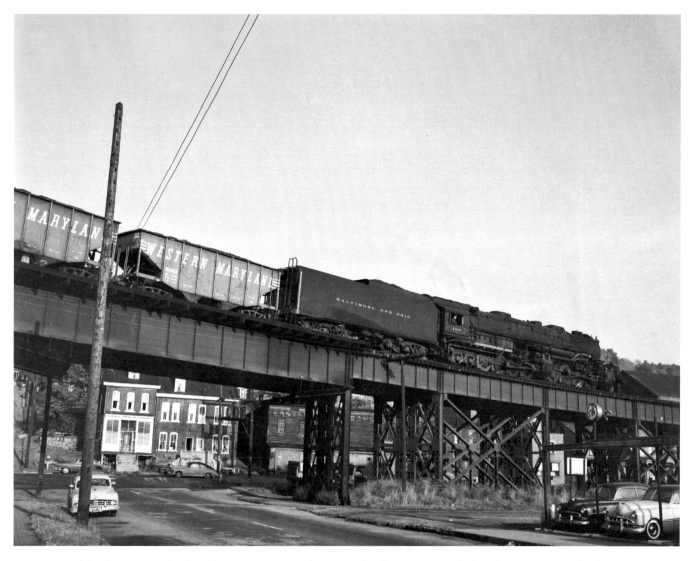

Coal for the Great Lakes lead by EM-1 #7607. The town of Bellaire, OH, sits below the massive iron bridge that supports trains traveling across here frequently each day.

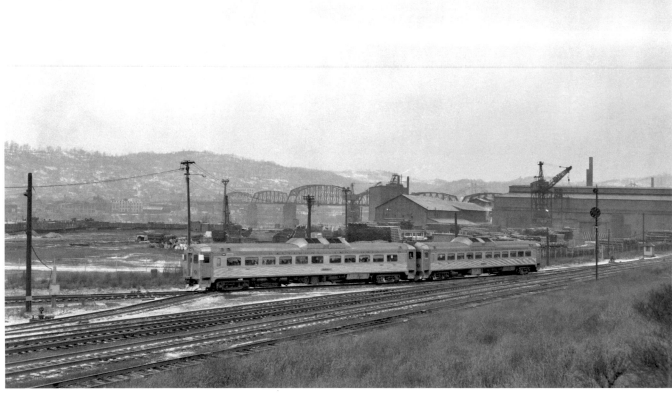

A pair of RDC-1s is about to enter the Benwood Loop to ascend the grade to reach the Benwood bridge approach and cross the Ohio River. Since RDCs were not assigned to this division, this must be a special run.

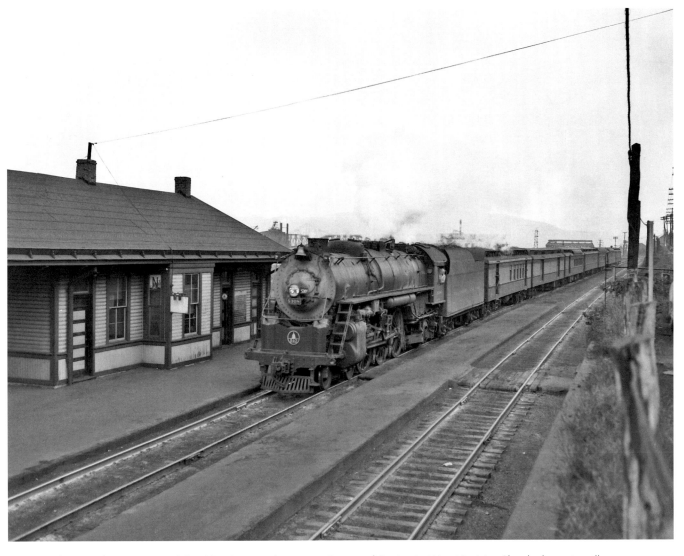

This train has just crossed the Ohio River and is now at Benwood Station in West Virginia. Shortly the train will enter Benwood Yard and transverse the loop to change directions to enter Wheeling headfirst. Engine #5308 is a P-7c Pacific.

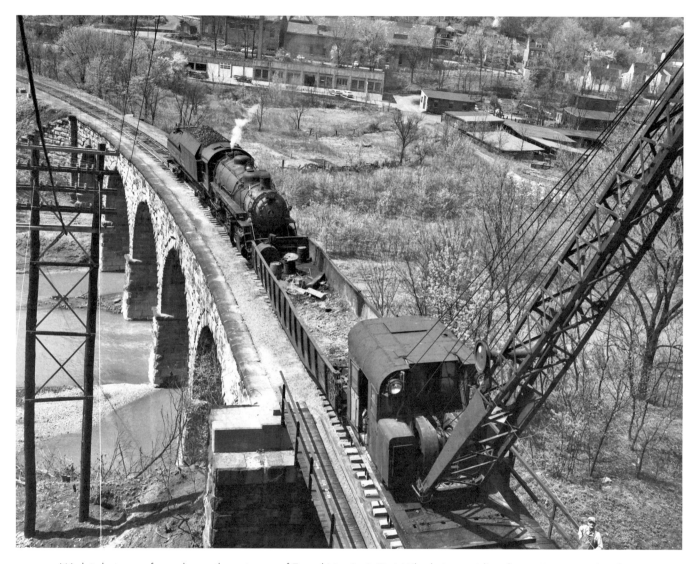

Work is being performed near the entrance of Tunnel No. 1. A Q-4 Mikado is providing the motive power this day. Wheeling Creek is below; the tracks leading to the upper left head toward downtown Wheeling, and the tracks in front of the crane lead to Elm Grove.

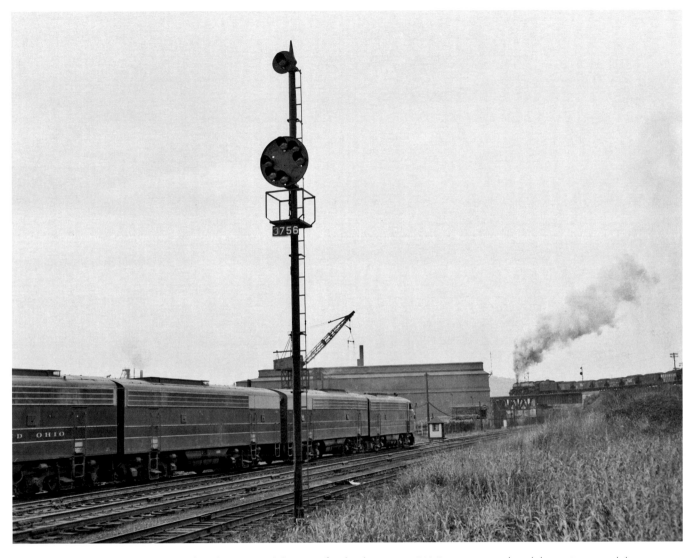

A set of B&O A-B-B-A FTs head up toward the city of Wheeling as an EM-1 crosses overhead the main toward the
Ohio River Bridge and then north to the Great Lakes.

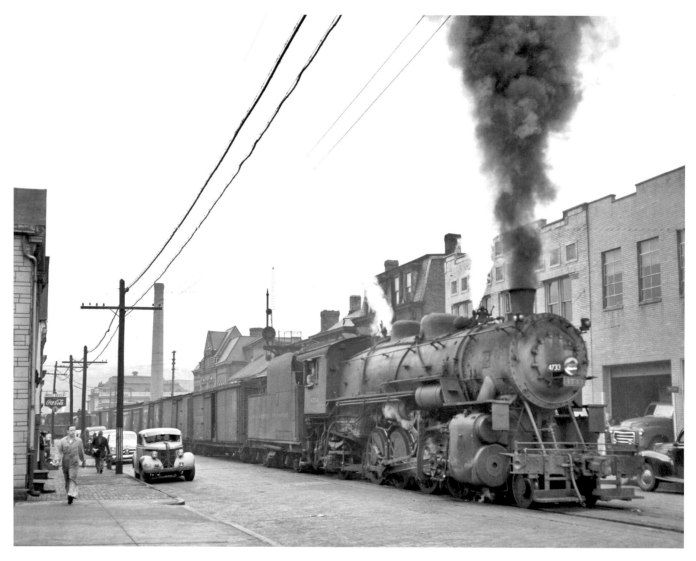

We see ex-BR&P now B&O Q-10a Mikado #4733 working a freight through Wheeling and headed to Pittsburgh.
The Q-10 classes were all retired by 1954.

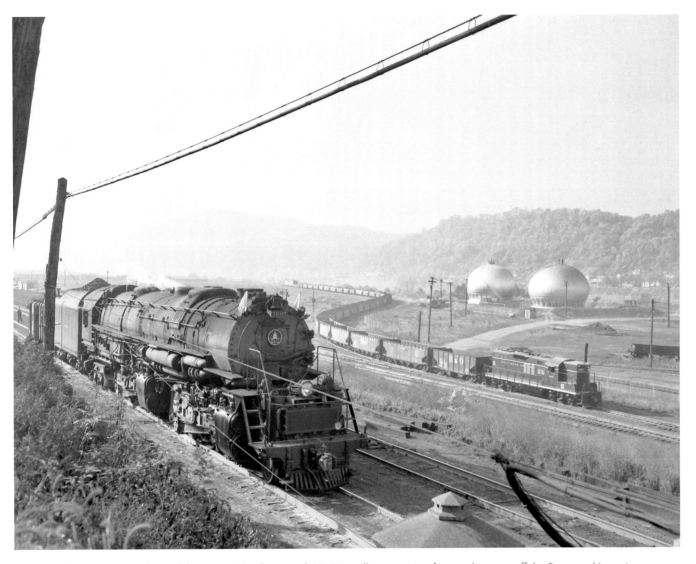

The writing is on the wall for steam. Newly arrived GP-9 is pulling a string of empty hoppers off the Benwood Loop in West Virginia. EM-1 #7607 with an I-12 caboose is on the lead to the Ohio River Bridge and on this day is probably on helper duty. The first freight GP-9s arrived on the B&O in April 1955.

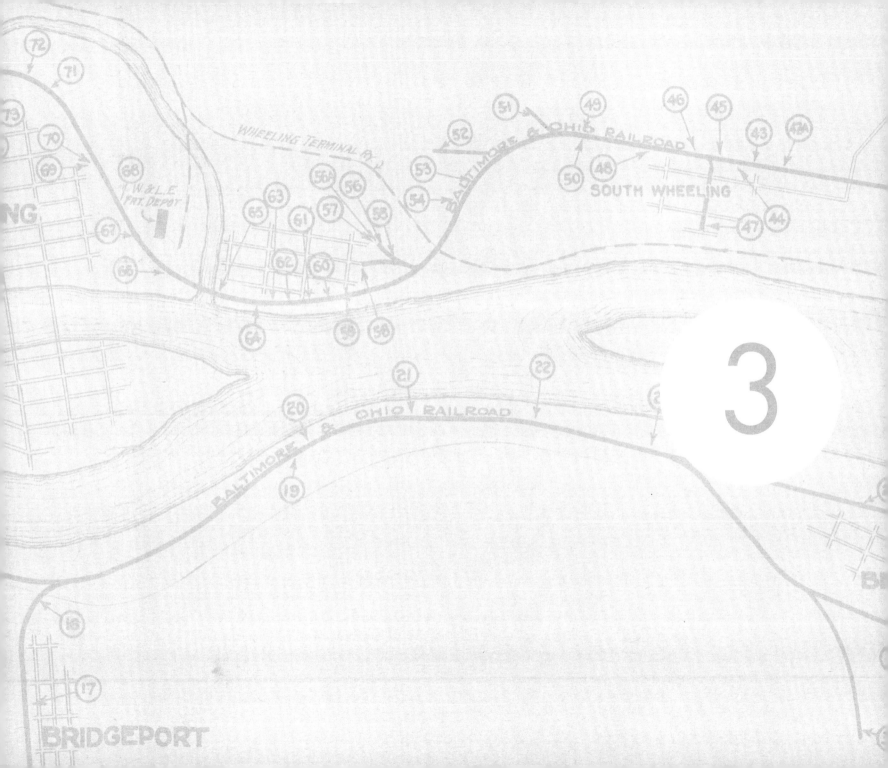

THE PENNSYLVANIA RAILROAD IN WHEELING

While the Baltimore & Ohio Railroad was the first railroad into Wheeling, it would not be the only railroad to serve the city. Few railroads allowed competitors to have exclusive access to markets; in the case of the B&O, it's most tenacious competitor, the Pennsylvania Railroad (PRR), saw the potential for invading the Wheeling market and acted to slice off a portion of the revenue that was feeding the B&O's coffers.

The first railroad that became affiliated with the Pennsylvania Railroad to reach Wheeling was the Cleveland & Pittsburgh Railroad. Originally chartered by the state of Ohio in 1836, it began construction south from Cleveland to the Ohio River. It reached Bellaire, Ohio, in 1856. In 1871 the entire railroad was leased to the Pennsylvania Railroad and eventually became part of the PRR's system of lines west of Pittsburgh. The Cleveland & Pittsburgh never crossed the Ohio on its own, relying on the Wheeling Terminal and the Panhandle Route to reach points east.

After the Civil War, the Pennsylvania Railroad sought to consolidate the control it exercised over other lines that were owned or financially controlled by the Pennsylvania Company (a PRR-based holding company) or individuals who were employed or affiliated with the PRR. To facilitate the construction of the line to Wheeling, the Panhandle Railroad Company was incorporated in 1868 and construction began in 1872. (Also known as the Pittsburgh, Cincinnati, Chicago & St. Louis Railroad, the Panhandle Railroad is not to be confused with the Panhandle Route.) Its original charter had been modified to allow the company to build a railroad along the Ohio River into Kentucky and tap the rich coalfields in that state. The railroad didn't see a train until 1878. In this case, the B&O Railroad was

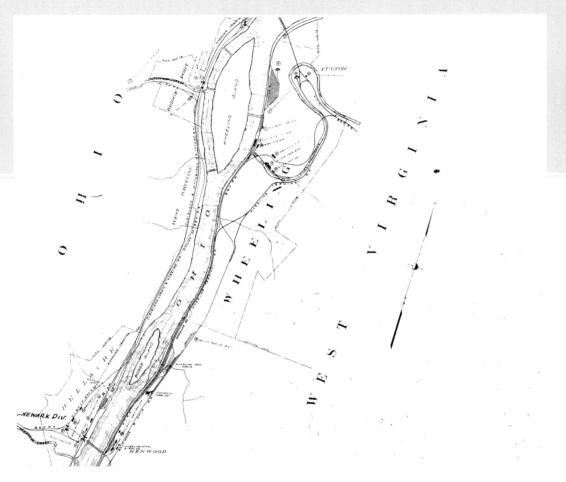

A 1905 Map produced by the Pennsylvania Railroad showing their lines in and around Wheeling. Despite coming into town in second place, the Pennsylvania Railroad aggressively sought to link the city and its industries with their main line at Pittsburgh and take traffic from the Baltimore & Ohio Railroad. (Isabel Benham Collection, John W. Barriger III National Railroad Library, University of Missouri, St. Louis.)

able to delay construction to keep the line from going past Benwood, West Virginia, and no further work was done to extend the railroad to Kentucky.

The Panhandle Railroad's line to Wheeling began at Steubenville, Ohio, along the Pittsburgh, Cincinnati, Chicago & St. Louis line and followed the west bank of the Ohio River, its right-of-way paralleling the main line of the Wheeling & Lake Erie. At the midpoint of this route between Steubenville and Wheeling was a community called Mingo Junction in Ohio. Here the PRR established an engine

terminal with a twenty-four-stall roundhouse and yard tracks to coordinate and classify traffic coming into and going out of the Wheeling area.

In 1890 the PRR increased the amount of track it owned in the Wheeling area with the construction of the Wheeling Terminal Railway. This line connected the PRR line on the west bank of the Ohio River with the Panhandle Railroad property on the east bank of the Ohio River via a steel bridge that crossed between Martins Ferry, Ohio, and Wheeling.[1]

Although the PRR made an impressive show of trying to capture Wheeling traffic, it was in the unusual situation (for the PRR at least) of being too late to the party. Whereas the PRR controlled Pittsburgh, the B&O controlled Wheeling and had long-standing relationships with most, if not all, of the major customers in the region. As such, PRR traffic on the Wheeling Terminal and Panhandle Railroad lines never really was a threat to the B&O's dominance of the area.

The PRR maintained a modest passenger station in Wheeling, and the lines saw a variety of motive power assigned to freight and passenger trains, mainly in the form of 2-8-2 Mikados and the PRR's distinctive 2-10-0 decapods. Much of it was power that was being sent away from other more active divisions of the PRR as newer and more efficient locomotives arrived. One notable visitor to this area, but only on the main line near Steubenville, was the famous T-1 4-4-4-4 duplex steam locomotive. J. J. was able to capture this uniquely streamlined locomotive many times as it plied the rails between Pittsburgh and points west.

Whereas the B&O was running nearly a dozen passenger trains in and out of Wheeling in the early 1950s, the PRR was only running two. Train nos. 702-66 and 67-701 ran every day between Wheeling and Pittsburgh and back, with through sleeping car service to and from New York. By 1964, these trains had been discontinued; any passengers who wished to ride the PRR had to get to Steubenville or Pittsburgh on their own to catch one of the shrinking number of passenger trains traversing its rails.[2]

The PRR-controlled Wheeling Terminal Railway was allowed to maintain its separate corporate identity for most of its existence, and J. J. was able to capture some of its locomotives switching customers around the city. The Wheeling Terminal Railway was not frequently photographed during its lifetime, and J. J.'s photos are a nice window into the company's operations during the 1940s.

With the Penn-Central merger in the 1960s and later conversion to Conrail, the PRR's Wheeling line—called a branch even as far back as the 1949 company corporate history—was put up for abandonment. The collapse of the steel industry in the United States helped to drive down traffic as potential customers went into bankruptcy, shut down, or drastically decreased their production. This made the line less attractive to potential buyers, especially given the existing web of other railroad lines in the area that served or could serve the remaining customers. The Martins Ferry to Wheeling bridge was abandoned in 1982 and torn down in 1993.[3]

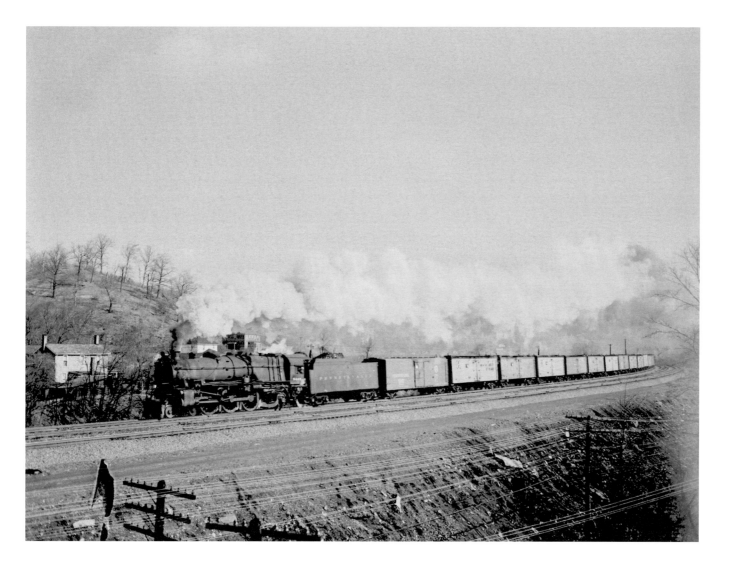

PRR class K-4 Pacific pulling a reefer express on the Panhandle Route somewhere near Mingo Junction, OH.

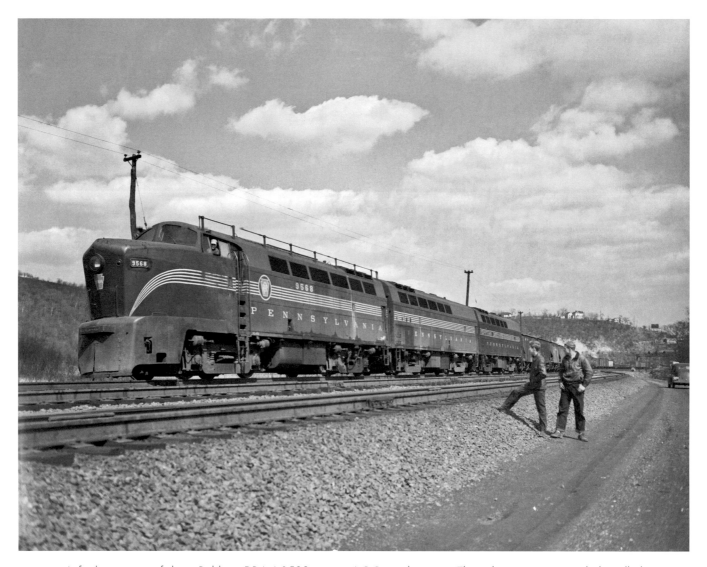

A fairly new set of three Baldwin DR4-4-1500s in an A-B-B combination. These locomotives, popularly called Sharknoses because of the similarity of the design of their nose to that of a shark, were rated at 1500 hp per unit, so this consist totaled 4500 hp. The lead unit, #9568, was delivered in early 1947. These units were initially assigned to Renovo, PA. All of its class were retired by 1964.

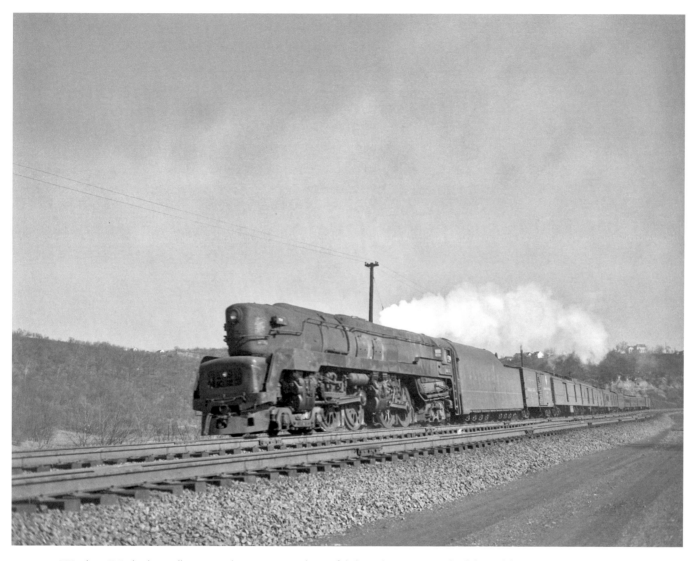

PRR class T-1 duplex pulling a mail express on a beautiful day. The T-1s were built by Baldwin Locomotive Works in Eddystone, PA, in 1946 as the Standard Railroad of the World made one last attempt with steam. These locomotives were known to be fast but slippery, and at times their undersize boiler could not make enough steam. Since they could not match the efficiency of diesels, they were retired in 1953.

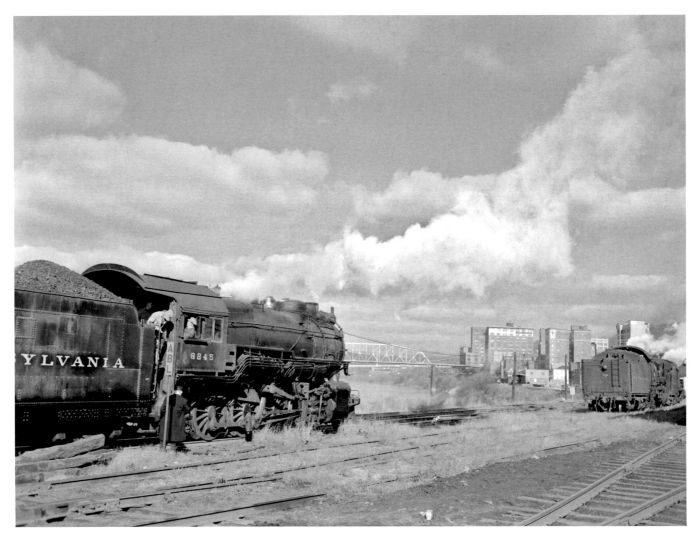

A consolidation class H-10 is in the freight yard waiting to depart. This type of locomotive is usually given freight assignments, but today it will be pulling a passenger special. Built by Baldwin in 1915, it was sold by the PRR in 1960.

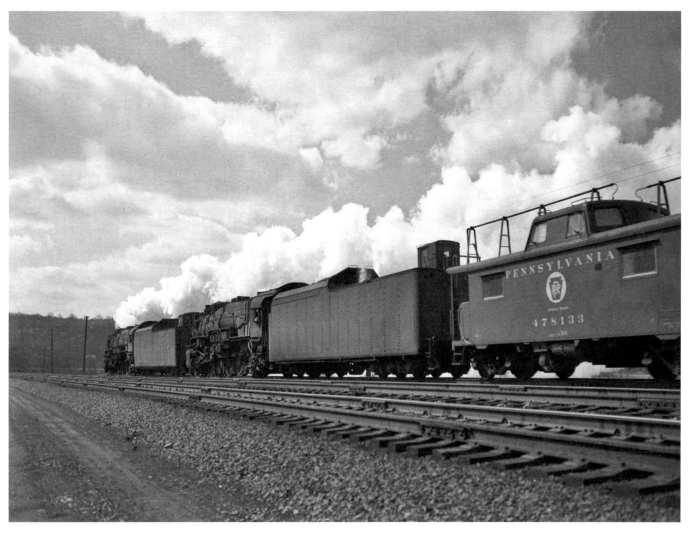

A pair of M-1 Mountains are leading a class N-8 cabin—PRR's name for a caboose. The state of Ohio and a few other states required that the head-end brakeman have a seat for safety reasons. While some railroads extended the locomotive cab to provide a seat, the PRR preferred doghouses on the tenders. Dirty, smoky, hot in the summer, and cold in the winter, doghouses were not the best accommodations for a crewman; the best they did was keep someone dry. The cabin car has train phones, which were an early system for train crews to communicate with dispatchers. Train phones were used from 1944 to 1966 when quality radios replaced them. The circle keystone herald on the side of the cabin indicates that this picture was taken between the mid-1940s and mid-1950s.

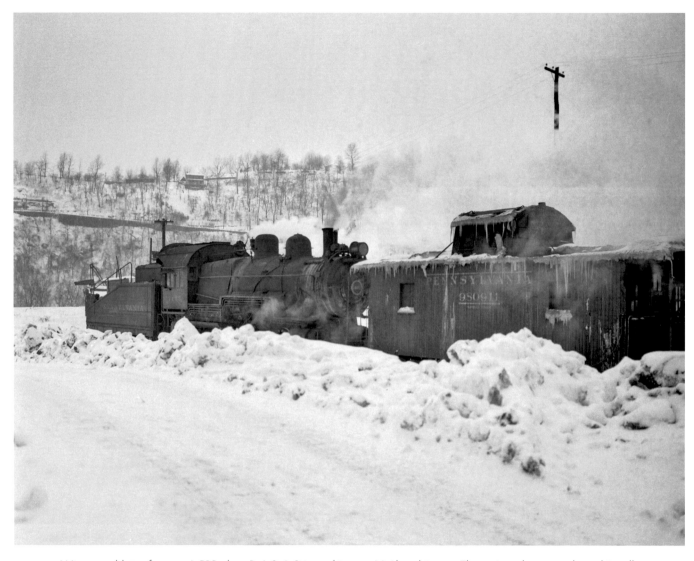

Winter and lots of snow. A PRR class B-6 0-6-0 is pushing an N-6b cabin car. The paint scheme on the cabin tells us that this is possibly in the 1940s.

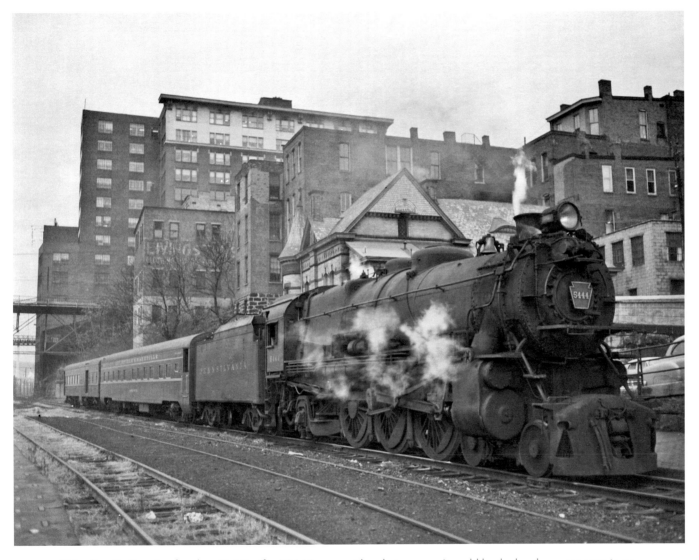

Wheeling Station stop for class K-4 Pacific #5444, seen with only two cars. It could be the local passenger train no. 702 from Steubenville. This early 1950s shot signals the coming end to passenger service in the near future because of improving highways. The locomotive is a product of Baldwin Locomotive Works in 1927 and was scrapped in early 1956.

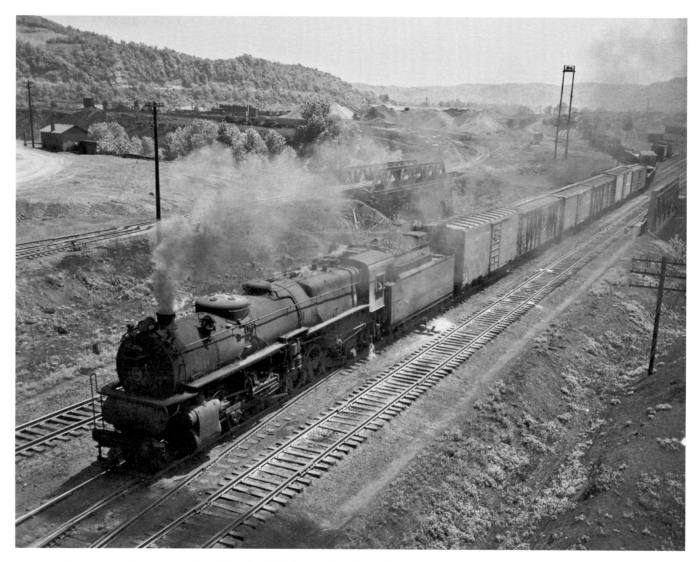

Here we see a Pennsylvania Line West class N-1 decapod 2-10-2 pulling a string of cars at Mingo Junction, OH. The N-1s were built by Baldwin and ALCO just before the United States Railroad Administration took over the nation's railroad in 1919 during World War I and most stayed west of the Ohio River. Slow, with a top speed of 35 mph, N-1s were usually assigned coal and ore trains to and from the Great Lakes. Most of them disappeared by 1950.

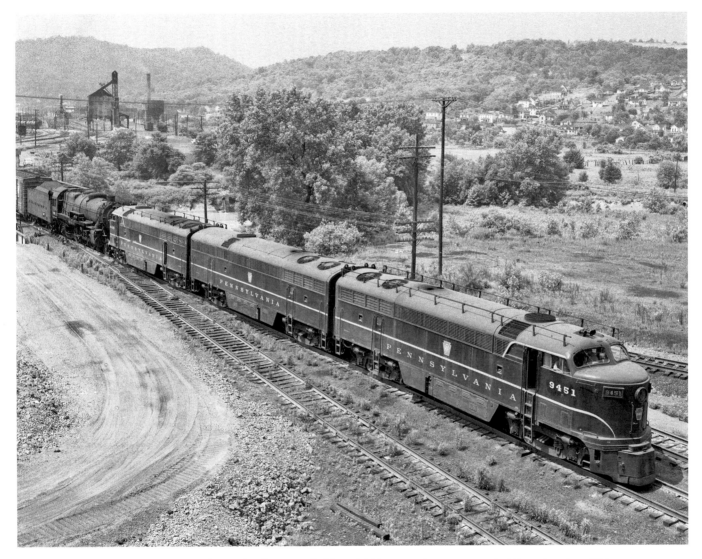

A trio of C-Liners built by Fairbanks Morse led by #9451 is seen here just outside Mingo Junction, OH.

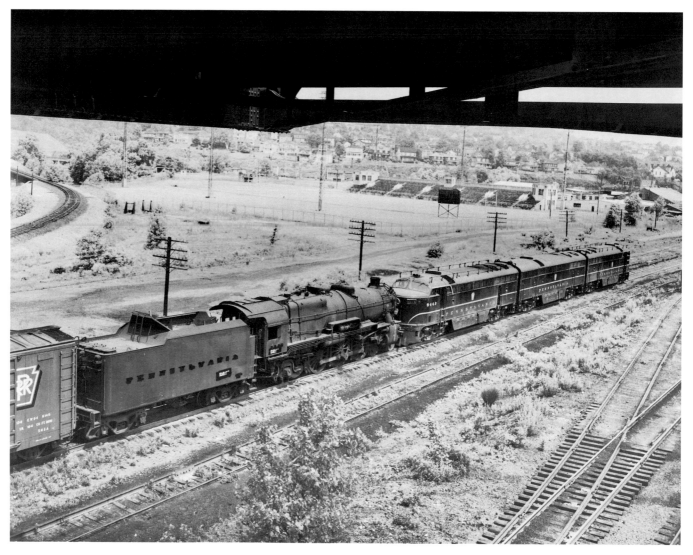

A trio of Fairbanks Morse C-Liners is pulling a K-4 Pacific to its final resting place, the scrapper. Looking at the shadow keystone herald on the boxcar, we can surmise that this is the mid-1950s. Delivered in late 1950, these units were rated at 1600 hp and were assigned to the Pittsburgh, Panhandle, Eastern, and Lake Divisions, but by the end of 1951 moved to the Pittsburgh and Lake Divisions.

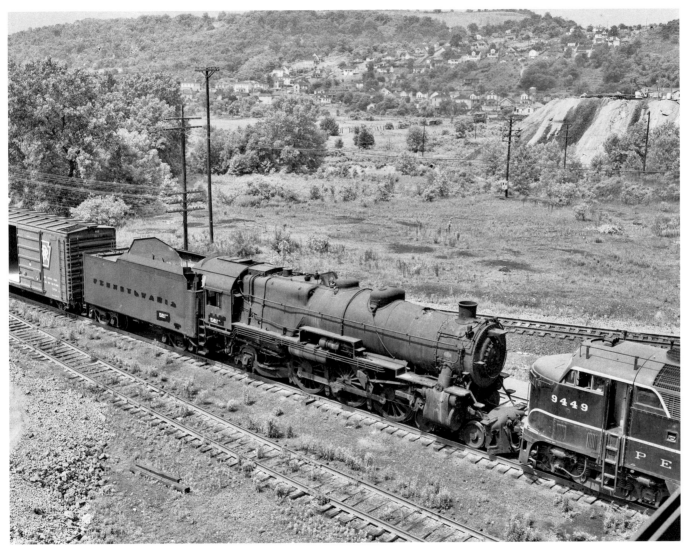

Another view of the K-4 Pacific headed to the scrapper. Here we see the nose of the FM C-liner #9449.

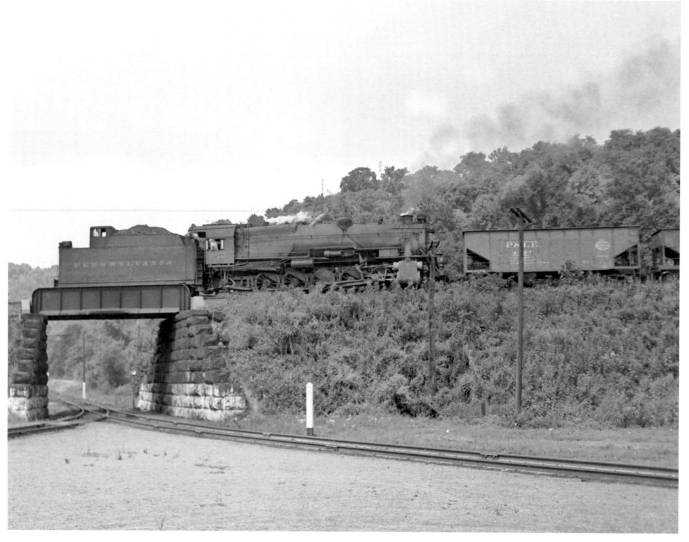

A PRR class 1-1sa Hippo locomotive working a string of hoppers over the Wheeling & Lake Erie Railroad near Jewett, OH.

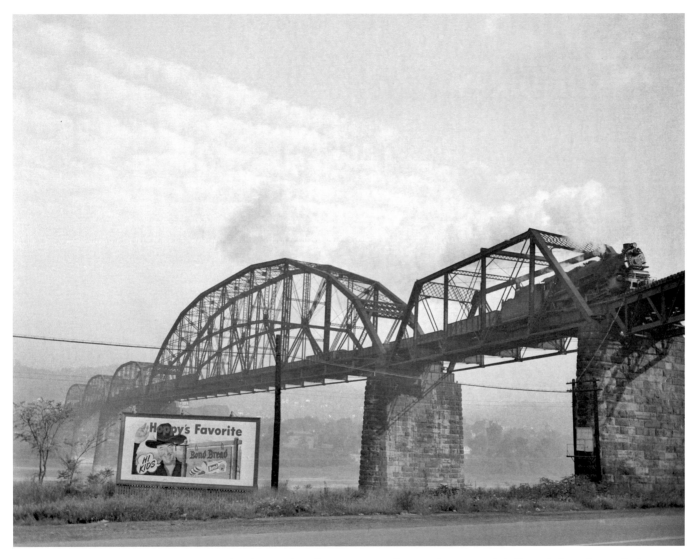

A PRR Mikado, class L-1, working a freight over the Ohio River. Note the Hopalong Cassidy billboard along the roadside.

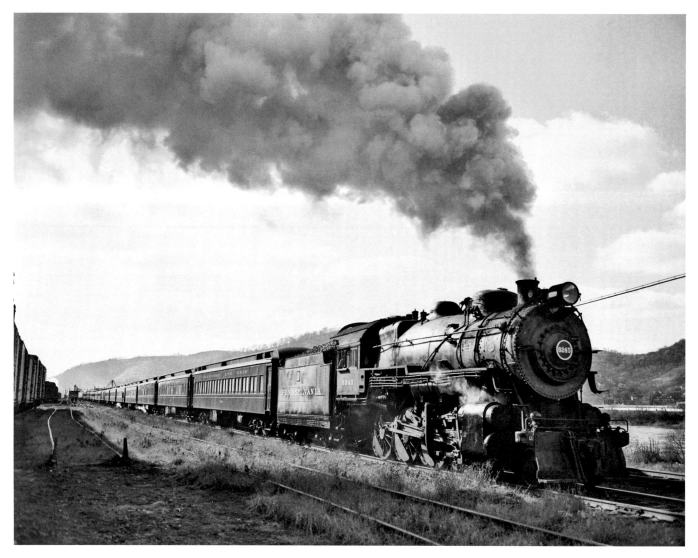

A Consolidation 2-8-0, PRR class H-10, is seen here pulling a passenger special along the Ohio River.

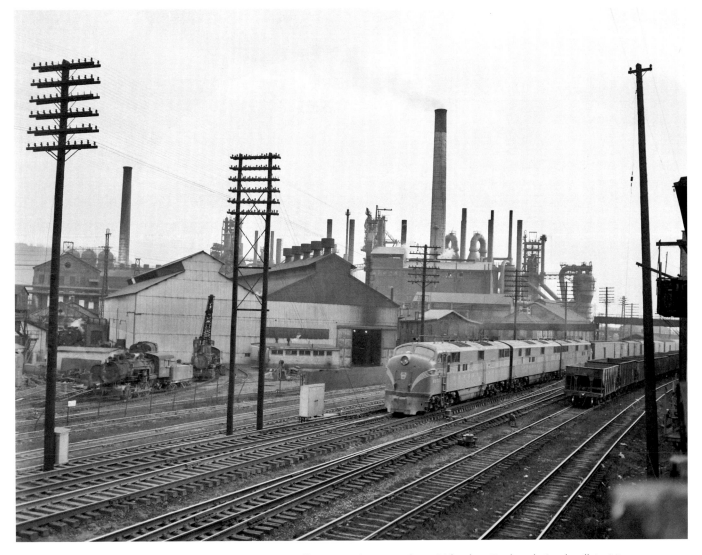

A set of EMD E-7s (in A-B-A arrangement) pulling a mail express by a Wheeling-Pittsburgh Steel mill in Mingo Junction, OH. The PRR had forty-six E-7A and fourteen E-7B units on their roster. The first E-7s arrived in 1945 and the last in 1949. The PRR's E-7s started to retire in 1964, and a dozen were around in 1971 on Penn Central. The only surviving E-7 from any railroad is the PRR unit in the Pennsylvania Railroad Museum in Strasburg, PA.

122

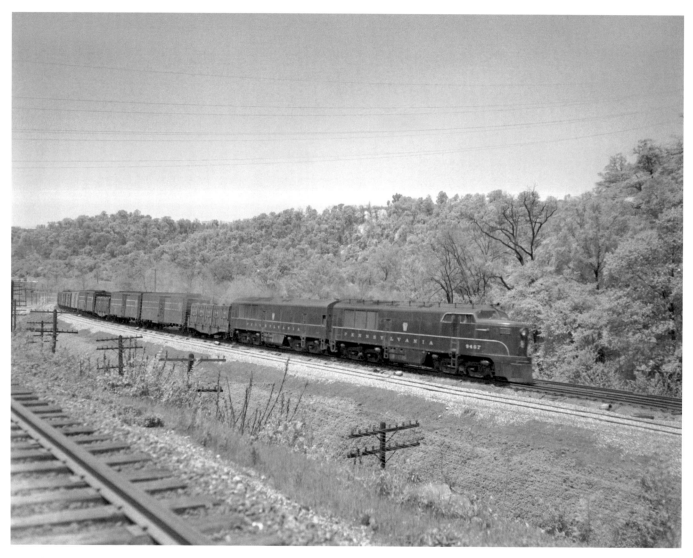

Seen here are Fairbank Morse Erie-built C-liners led by #9467 pulling an express train on the Panhandle Route (PCC&STL). Built in 1948, these locomotives were not popular with many railroads due to the difficulties in maintaining the opposed piston engines that were designed for submarines. The PRR had the largest fleet of these locomotives produced by Fairbanks Morse. Numbering forty-eight strong, the Erie-built C-liners were rated at 2000 hp, and some were geared for 100 mph. All were gone by 1964.

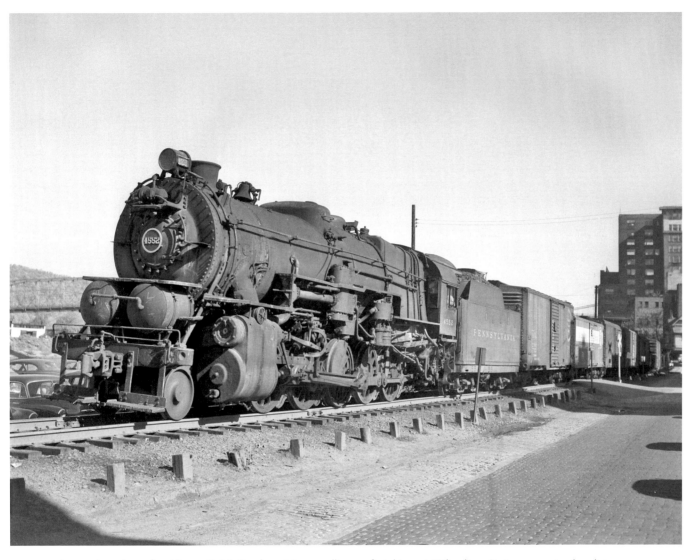

A morning shot of a Hippo 2-10-0, class I-1sa, pulling a freight past Wheeling Station seen in the distance. Locomotive #4552 was built by the PRR's Juniata Shops in Altoona, PA, in 1923 and rebuilt in July 1944. It was scrapped by the railroad in 1960.

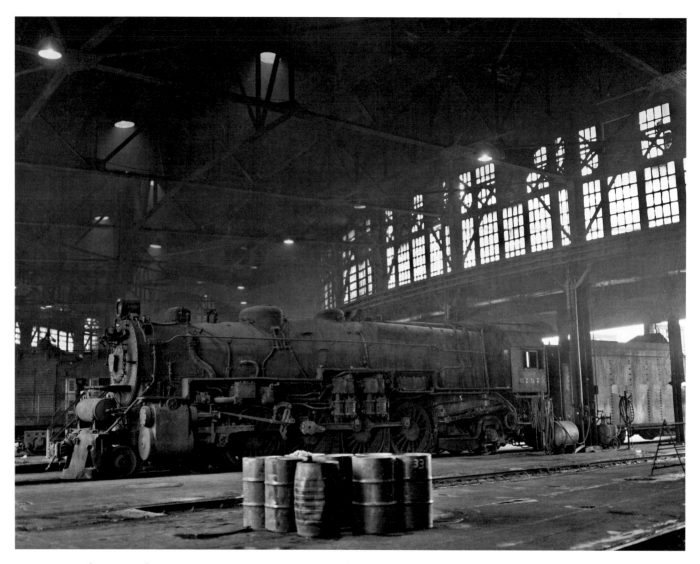

Time for service for M-1a Mountain #6747 as it sits at the Mingo Junction, OH, roundhouse. Built in 1930, these Mountain-class locomotives were used in dual freight and passenger service.

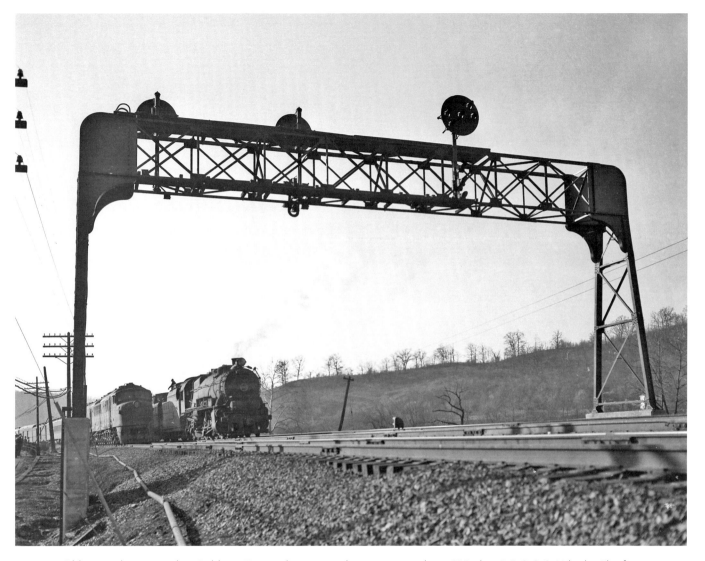

Old meets the new with a Baldwin Centipede next to what appears to be a PRR class L-1 2-8-2 Mikado. The first Centipede set arrived in the spring of 1947 and the rest in 1948. Originally intended for passenger and road service, they spent their later years as helpers outside Altoona on both slopes of Cresson, PA. All were retired by 1962.

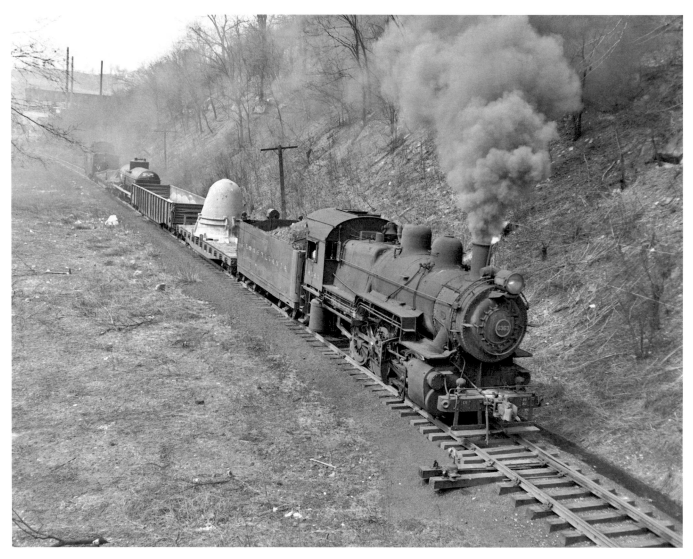

PRR B-6 0-6-0 #6362 with local switcher in East Wheeling on the river terminal branch in 1945.

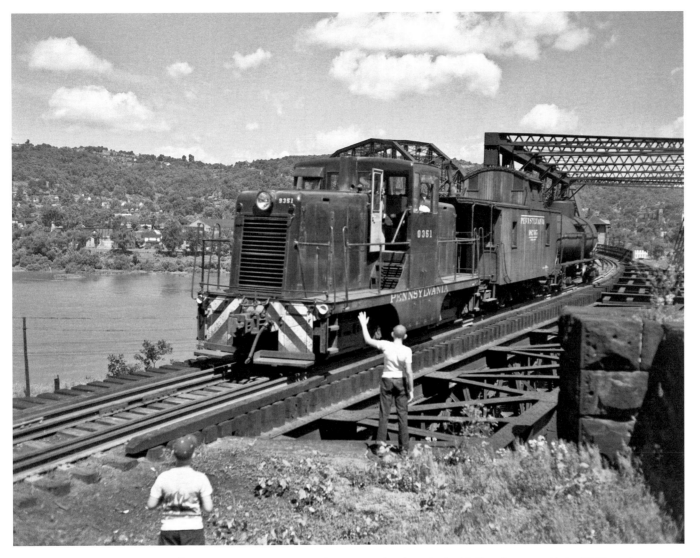

A General Electric switcher, type 44 tonner, is seen doing some local work. An N-6b cabin car with its 1940s style PRR lettering scheme is in the middle of the consist. Locomotive #9351 was built in 1949 and retired in 1964.

128

A Baldwin RT-624 transfer unit leads a coal drag at what appears to be a crossing of PRR and W&LE tracks. The Ohio River is seen to the left, and these two railroads parallel each other for many miles between Mingo Junction, OH, and Martins Ferry, OH. Lead unit #8957 was one of four units of this type that were assigned to Mingo Junction. Each locomotive is rated 2400 hp, and the first arrived on the PRR in 1951. The last of this class of diesels was retired by Penn Central in 1969.

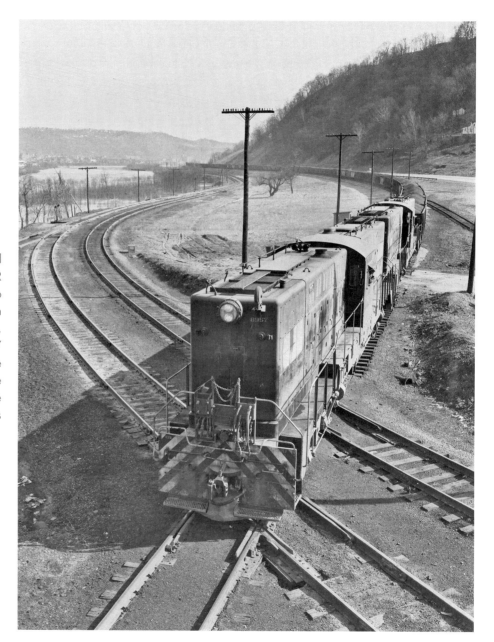

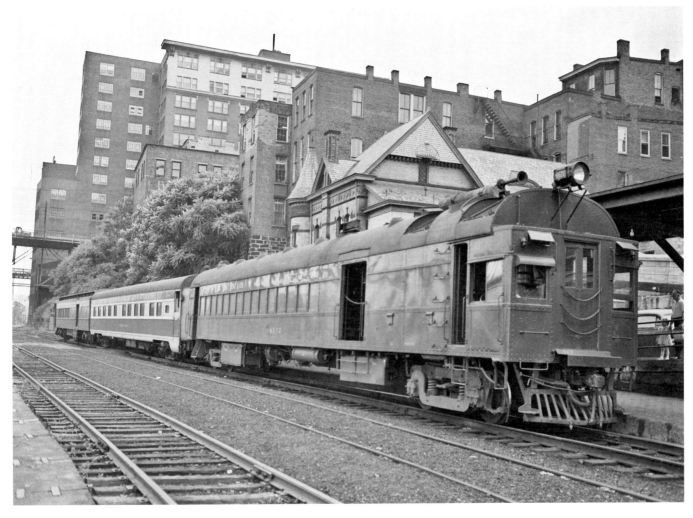

We see PRR combination doodlebug with two additional cars stopping at Wheeling Station. This self-propelled passenger car was one of five built by the Brill Co. in 1930. This is train no. 702, which came from Weirton Junction, WV. This image is unusual on two counts: first is the number of cars behind the doodlebug—normally these units only pulled one car—and second is that the first car behind the doodlebug appears to be in Missouri Pacific livery. This may be a car that was originally in run-through service to St. Louis but owned by the Pennsylvania Railroad. After the service was terminated, it was used in its original paint scheme for some time until it was repainted into the standard PRR scheme.

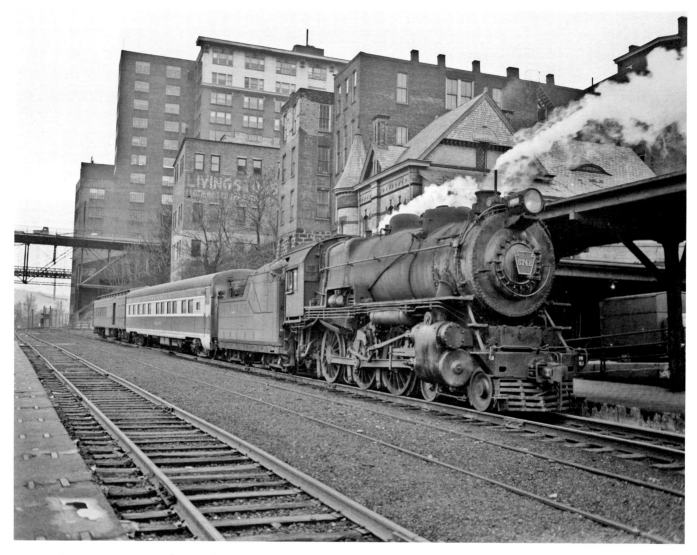

Train no. 702 is seen here at the Pennsylvania Railroad Station in Wheeling. The G-5s 4-6-0 Ten-Wheeler #5712 was built in 1924 and was one of ninety built in this class and scrapped in 1949.

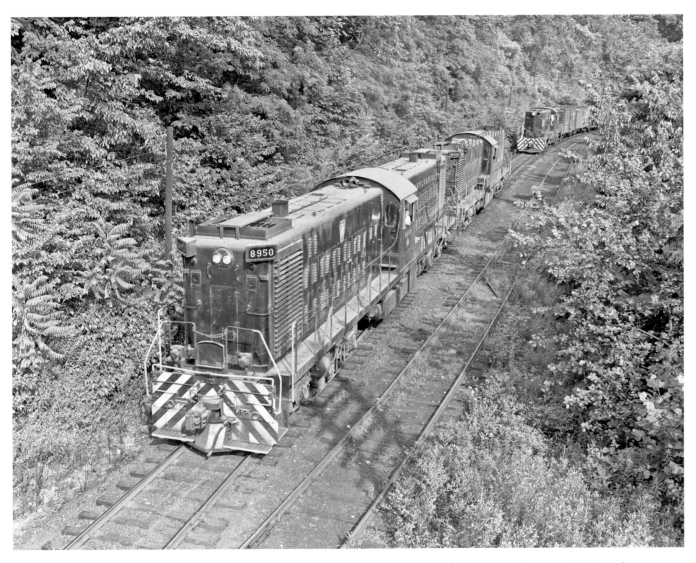

A pair of Lima transfer units is being used as helpers somewhere along the Ohio River. Lead engine #8950 and its sister behind it were assigned to Mingo Junction, OH. The PRR had a total of ten assigned to Mingo Junction of the only twenty-two built by Lima. Rated at 2500 hp, the first ten were not multiple-units capable and were delivered in mid 1951; the rest came later in 1951. All units of this class were retired by 1966.

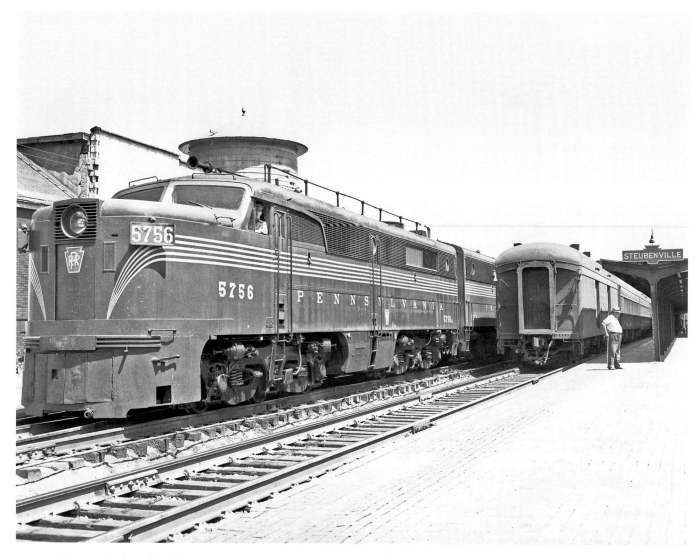

Here at Steubenville, OH, we see an ALCO PA-1, #5756—one of ten built for the PRR. All ten were A-units delivered in late 1947, and all these PA-1s met retirement by the third quarter of 1962.

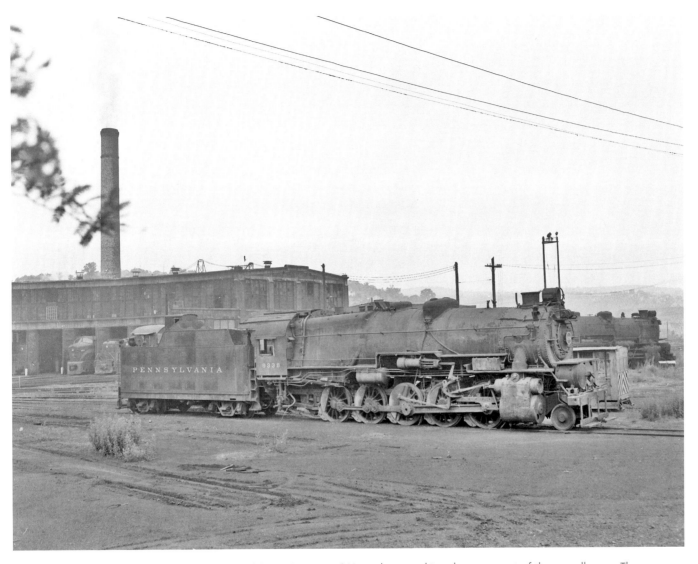

Diesels are taking over operations at Mingo Junction, OH, and are pushing the steam out of the roundhouse. The I-1sa decapod appears to be a parts queen, for the bell, headlight lens, and generator have been removed.

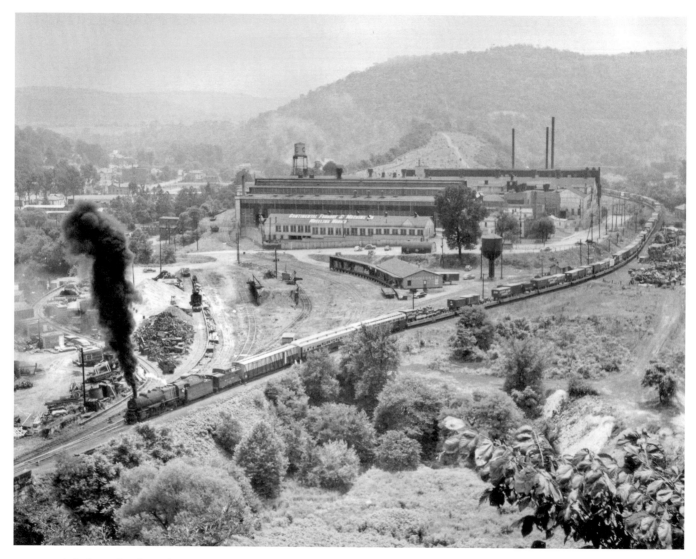

A Cetlin and Wilson Shows train about to depart Peninsula Yards in Wheeling, WV, behind L-1 Mikado #780 in 1947.

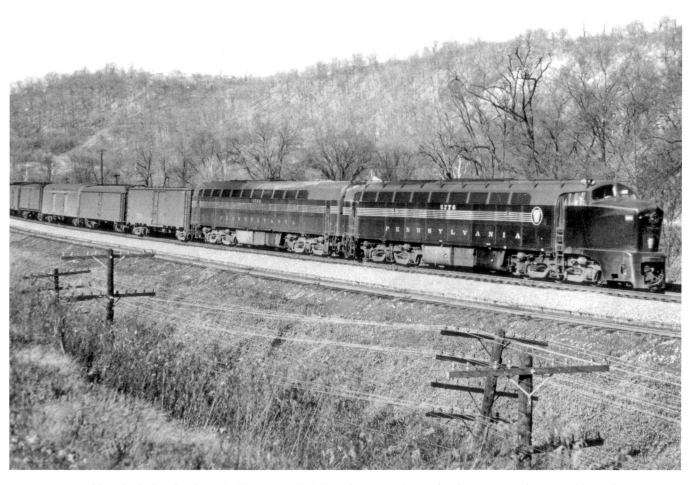

PRR Baldwin-built diesels, class BP-20 (A-Unit #5776 and B-Unit #5778), lead train no. 6 down Gould's Hollow, OH, in February 1952.

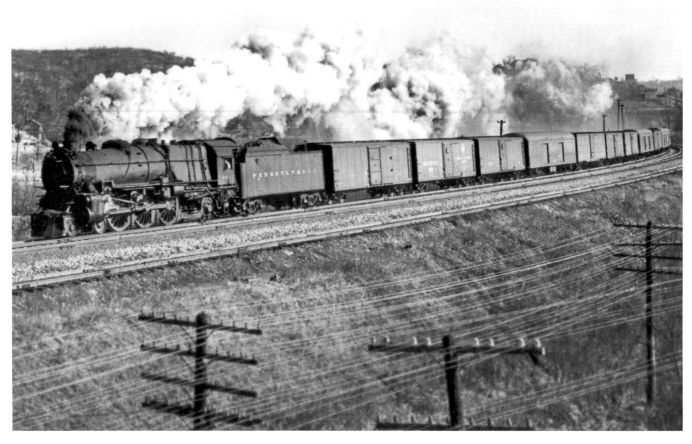

PRR K-4 Pacific #951 takes train no. 205 up Gould's Hollow out of Mingo Junction, OH, in 1952. There are ten head-end cars visible in this show, making this a high-value train to the PRR.

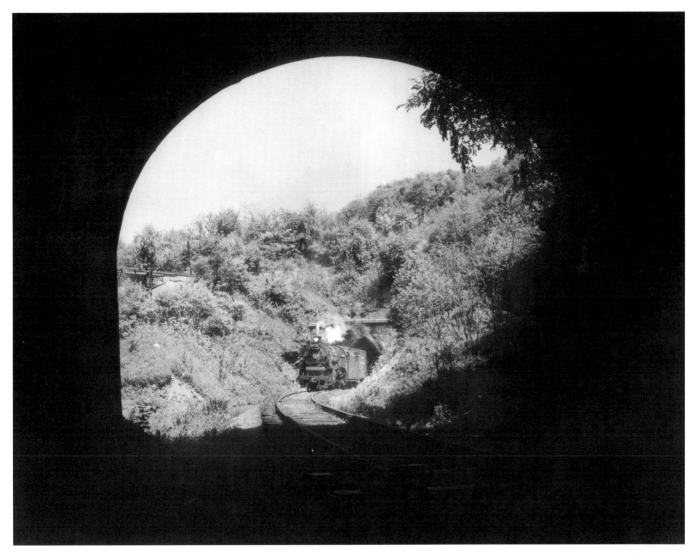

L-1 Mikado #731 exits the Ohio River Tunnel and is about to enter the Wheeling Hill Tunnel en route to Benwood, WV, in 1946.

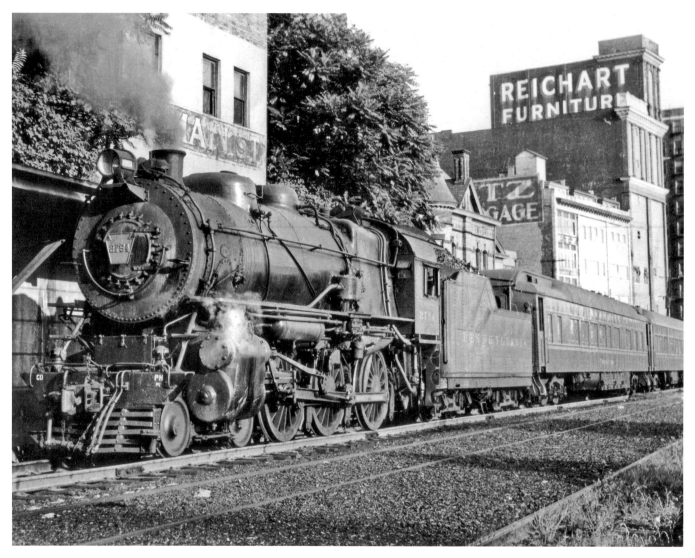

PRR G-5 Ten-Wheeler #3754 ready to depart Wheeling with train no. 702. The depot is visible above the engine's tender in 1946.

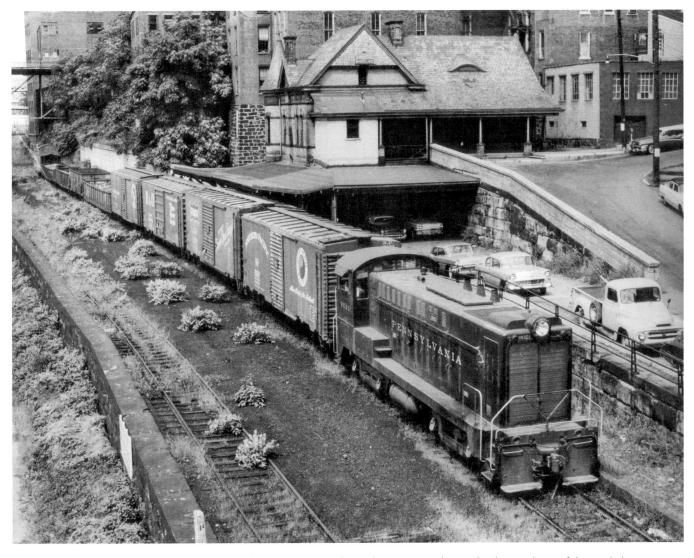

Baldwin VO-1000 #9021 passing Wheeling Depot in the mid-1950s. It's obvious by the condition of the track that the passenger service to Wheeling has been abandoned and that maintenance of the track is less of a priority than it was in the past.

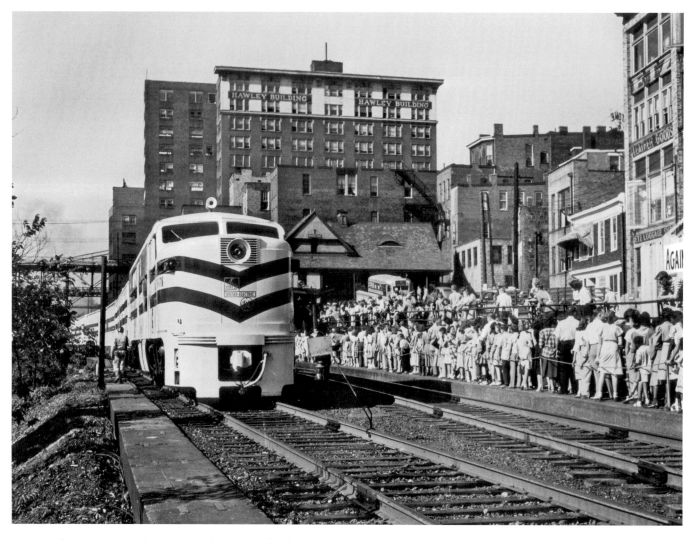

Original American Freedom Train at the PRR's Wheeling depot in 1946. This was the first iteration of the Freedom Train and was born from Attorney General Tom Clark's idea to "to re-establish the common ground of *all* Americans." The proposal found wide corporate support, and General Electric provided the motive power to the project. The idea would be reintroduced during the bicentennial, and steam locomotives would be used to power the train on its tour across the country.[4]

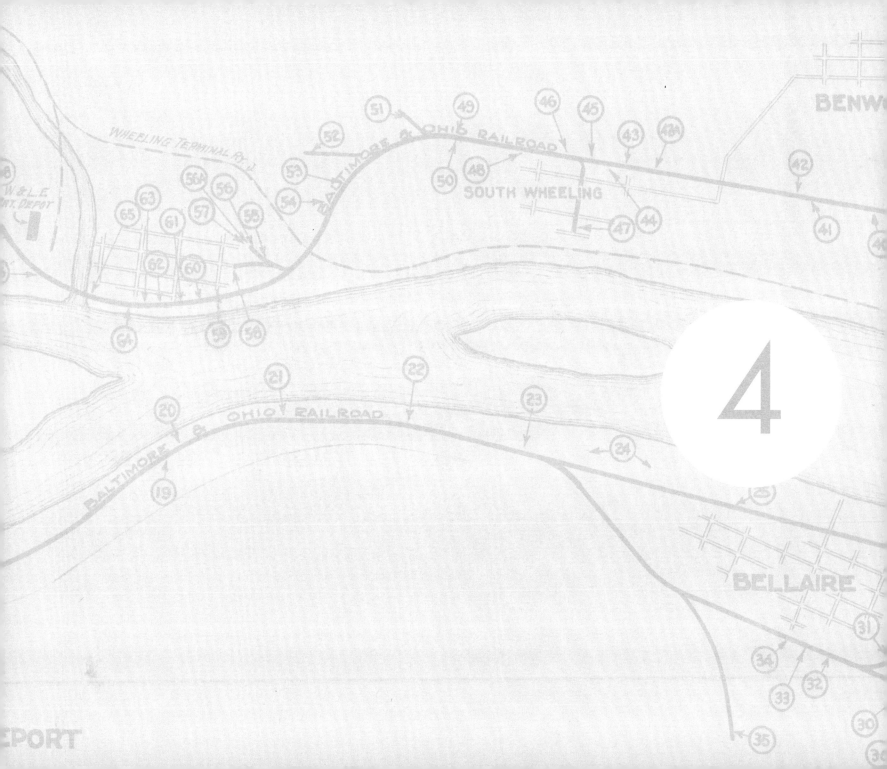

THE WHEELING & LAKE ERIE RAILWAY, THE PITTSBURGH & WEST VIRGINIA RAILWAY, AND THE NICKEL PLATE ROAD

The Wheeling & Lake Erie (W&LE) Railway, Pittsburgh & West Virginia (P&WV) Railway, and Nickel Plate Road are included together in this section because they had historical business relationships and would eventually be merged together with the Norfolk & Western Railroad. Each of these lines found itself to be a pawn in the hands of well-funded railroad financiers and outside interests and never really had a chance to develop as locally controlled companies for very long. J. J. had a special place for the W&LE in his heart: It was the first railroad company that he photographed, and he would eventually work for the company very briefly as a tower operator before going into photography as his vocation.

The Wheeling & Lake Erie started as a three-foot narrow gauge line to connect the coal mining region of southeastern Ohio with the Lake Erie industrial region. The road was one of many narrow gauge lines built after the Civil War on the premise that these railroads could be built cheaply and in places that did not already have rail service or had been too expensive for standard gauge railroads to reach. Unfortunately, like nearly all of these nineteenth century narrow gauge projects, the W&LE went into financial insolvency early in its life without laying more than a dozen miles of rail. At that point,

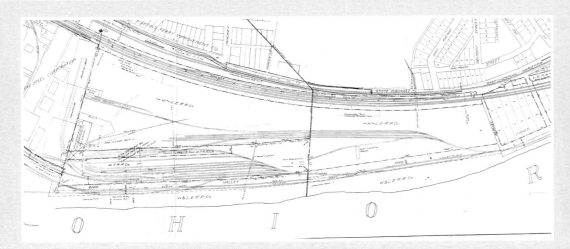

This map shows the extensive track of the W&LE near Wheeling Steel in Martins Ferry, OH.

again like other railroads, its charter was snapped up by a new owner, in this case George Gould, son of Jay Gould, who poured capital into the line and planned to use it for a greater purpose.

George inherited his father's goal to create a single transcontinental railroad under his control. He needed to fill in a gap between the Western Maryland Railway and the Wabash Railroad and utilized the W&LE to do part of that. He took control of another failed line called the Pittsburgh & Mansfield Railroad to bridge the gap between the W&LE and the Western Maryland. Gould began construction on the line in 1900 and by 1904 it had been reorganized and renamed as the Wabash Pittsburgh Terminal Railroad.

Unfortunately for Gould, his entire scheme fell apart thanks to the Panic of 1907. By 1916 both the W&LE and the Wabash Pittsburgh Terminal had been sold off. The W&LE kept its name, but the Wabash Pittsburgh Terminal was renamed the Pittsburgh & West Virginia Railroad and this road eventually came under the control of Cleveland industrialist Frank Taplin.[1]

In the 1920s, the Nickel Plate was under the control of Cleveland investors Oris and Mantis Van Sweringen. They were looking to create a fifth system of railroads to compete with the major eastern lines and had to fight for control of the W&LE from Taplin. After a bruising fight in the courts and the

143

financial markets, the two brothers took control of the line to add to their portfolio and move their rail empire incrementally eastward to the Atlantic and the profitable steel traffic of the Ohio River Valley.[2]

The P&WV stayed in Taplin's hands until 1929 when, one month before the stock market crash, he sold his interest for a tidy profit to Pennroad, a PRR-controlled holding company. Pennroad controlled the ownership of P&WV but did not exercise direct control of the company's operations. As far as the PRR was concerned, this was a defensive move to keep another competitor out of the Pittsburgh region.

This ownership arrangement with Pennroad allowed the P&WV to be a "neutral" during the consolidation push of the twentieth century and for a not un-friendly connection with the Nickel Plate Road (New York, Chicago & St. Louis Railroad) to connect with the W&LE and the P&WV as now all three roads were either under the control of the Van Sweringen brothers or were not overtly hostile to the Van Sweringen interests. Each of the Van Sweringen roads also began to see upgrades in their motive power as standardized designs, notably the 2-8-4 Berkshires, began to replace a hodge-podge of worn out and underpowered locomotives that were used by the then under-funded railroads.[3]

In a second case of horrific timing, the Van Sweringen empire was itself hit by the stock market collapse of 1929 and the Great Depression. The brothers had heavily leveraged their properties to fund other acquisitions, and once the stock market began to fall, these leveraged properties and securities began to decrease in value; the entire structure collapsed onto itself. It was during this era of financial uncertainty and economic distress that J. J. began to photograph these lines.[4]

Despite the problems of the 1930s, both the P&WV and W&LE survived and became profitable regional carriers during the Second World War and into the 1950s, in large part due to their location along the industrialized Ohio River Valley and the eastern Ohio coalfields. They also provided neutral access to the eastern Ohio coalfields for the other eastern trunk lines (B&O, PRR, and New York Central.)

The smaller P&WV traversed rugged mountainous territory like the W&LE, but thanks to the Gould funds used to build the line in the early twentieth century, the grade was quite gentle. To accomplish this, there were numerous bridges and tunnels along the route between Connellsville, Pennsylvania, and Pittsburgh Junction, Ohio. It was apparent that Gould had lavished capital on the road's construction and was preparing it to carry a significant amount of traffic. The bridges themselves were quite spectacular, helping to give the railroad its nickname, the Hi-Line. As one will see in this section, the bridge across the Ohio River near Mingo Junction, Ohio, was a favorite location for J. J. to shoot the P&WV and later the Nickel Plate.

The Van Sweringen brothers' Alleghenny Corporation maintained control of W&LE line throughout the Depression as the Van Sweringen empire imploded with the financial collapse of the securities that supported it. In 1949 it was leased to the Nickel Plate Road after a stock swap between the Nickel

Plate and the Chesapeake & Ohio. The C&O received Pere Marquette Railway stock from the Nickel Plate, and the Nickel Plate received W&LE stock from the C&O. This change in leadership was short-lived as both the Nickel Plate-W&LE combination and P&WV would be merged into the Norfolk & Western in 1964. By 1967 the P&WV was reorganized as a real estate trust and a new Wheeling & Lake Erie Railway—a regional line spun off by Norfolk Southern in 1990—leased the right-of-way and still uses the line to connect Toledo and Cleveland, Ohio, to Connellsville, Pennsylvania.[5]

The W&LE and P&WV also had fame as part of the Alphabet Route. This was a marketing name for traffic agreements between eight railroads—Western Maryland, Reading, Pittsburgh & West Virginia, Wheeling & Lake Erie, Nickel Plate, Wabash, New Haven, and Akron, Canton & Youngstown—to provide through freight routing between the Midwest and the East. The line became known for "Alpha Jets" of priority freight in the 1950s and 1960s, but there are schedules of these trains going back into the 1930s. In addition to these special freights, the W&LE ran unscheduled coal trains and other scheduled freights from Steubenville, Ohio, or Mingo Junction, Ohio, to Brewster, Ohio, and thence on to Toledo.

Although J. J. had moved by the time these fast diesel freights were seen on the W&LE line over the Ohio River, he was able to photograph the W&LE and the P&WV coal drags, and later the P&WV Fairbanks Morse diesels, as they carried freight trains through the northern panhandle of West Virginia to and from Connellsville, Pennysylvania, and the line's connection with the Western Maryland Railway and other points east.[6]

One glaring vacancy in J. J.'s images in this section is photographs of passenger trains. Neither the Nickel Plate, W&LE, nor P&WV invested in entering the passenger service. They came into the primary markets late, and their backers had built them to serve freight customers, not to go into the passenger business. As such, the steam locomotives here are large and powerful, but slow: 2-8-2 Mikados, 2-8-0 Consolidations, and 2-6-6-2 articulated Mallets. It's not until the Nickel Plate merger that the modern 4-8-2 Mountain class and improved 2-8-4 Berkshire class locomotives arrive in the area, but both are soon replaced by diesels.[7]

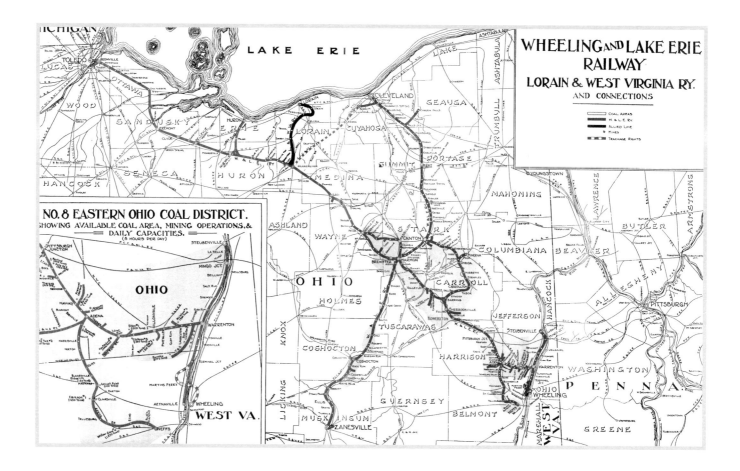

This map of the Wheeling & Lake Erie Railway shows the railroad in relationship to the eastern Ohio coalfields. It is very apparent that the line was essentially a conveyor belt for coal from these fields to the Ohio ports of Lake Erie.

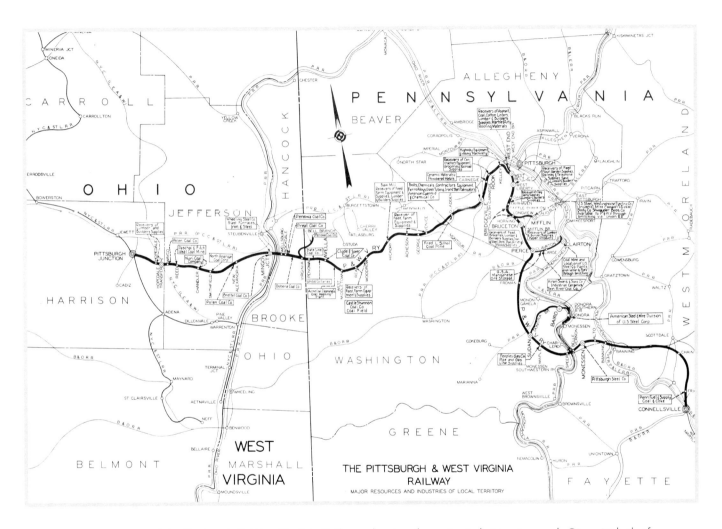

Here is a map of the Pittsburgh & West Virginia Railway showing the major industries it served. Given its lack of direct access to major cities, the railroad's purpose as a bridge line is readily apparent. (Both maps John W. Barriger III Papers, John W. Barriger III National Railroad Library, University of Missouri, St. Louis.)

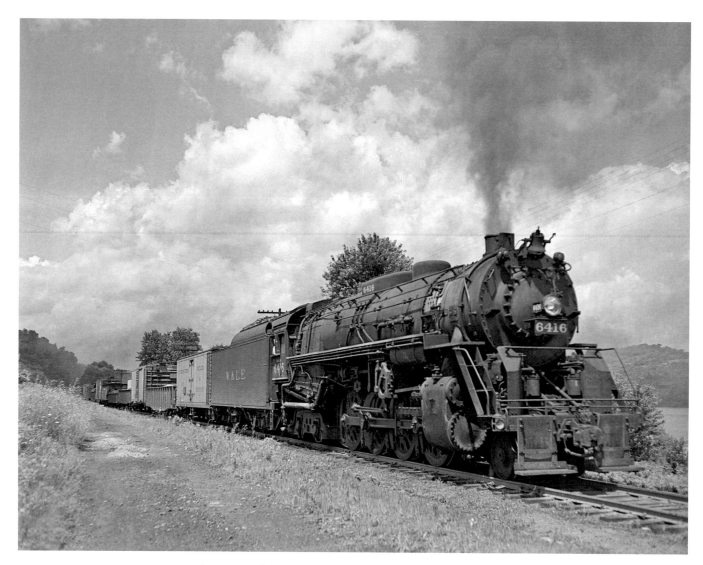

W&LE class K-1 Berkshire #6416 along the Ohio River headed southbound.

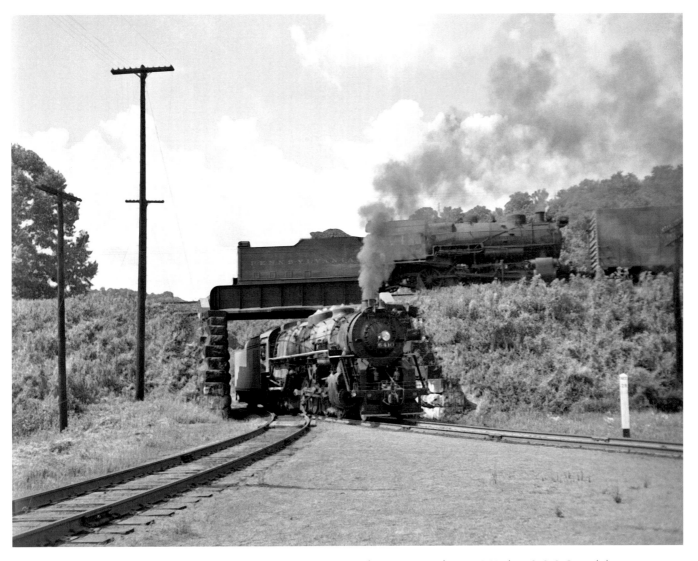

The W&LE K-1 Berkshire #6410 is near Warrenton, OH, and is passing under a PRR H-class 2-8-0 Consolidation.
The PRR locomotive is on the Cleveland & Pittsburgh, which was leased to the PRR in 1871 and later became part
of the PRR system.

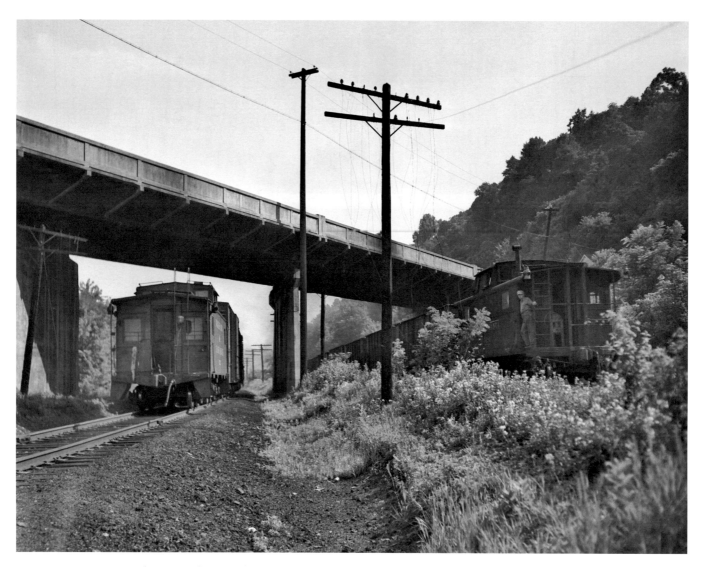

A series 200 caboose on the W&LE is a 1948 product of the railroads shops. The caboose is a modified version from New Haven plans. In this scene, the W&LE and PRR are racing southbound on the west bank of the Ohio River.

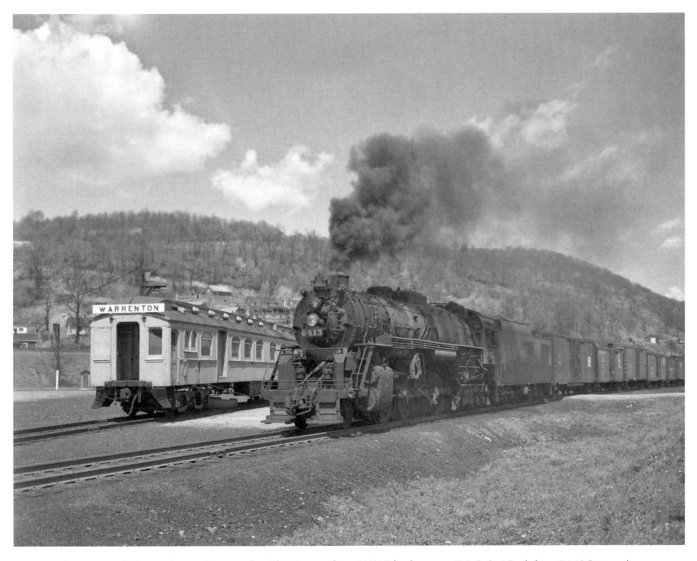

Warrenton, OH, was located next to the Ohio River where W&LE had a wye. K-1 2-8-4 Berkshire #6415 is on the river line. Two legs of the wye bear west through a PRR bridge and head toward north central Ohio. The combine car replaced a small two-story station that was destroyed in 1945.

152

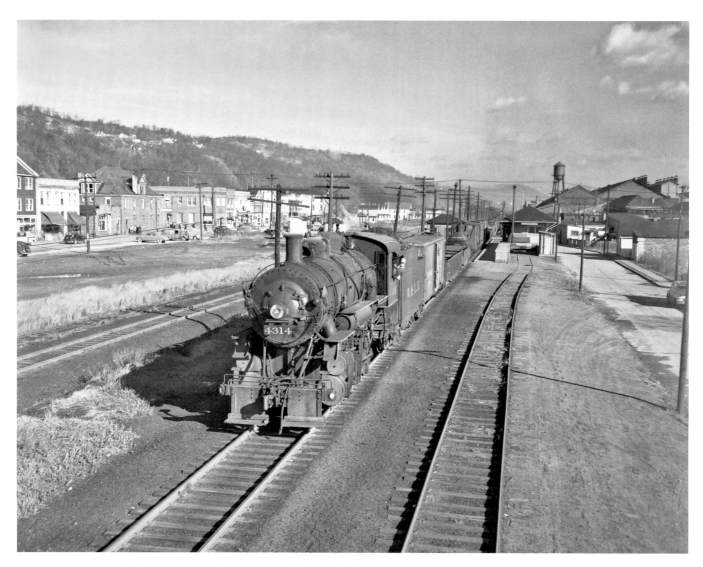

Locomotive #4314 is a W&LE class G-2 Consolidation. This locomotive was assigned #926 but was never renumbered and was retired in 1951. Now working in Yorkville, OH, the 2-8-0 is hauling a way-freight past the town's depot. The PRR tracks parallel the W&LE on the far left; the PRR passenger station sits between the two railroads.

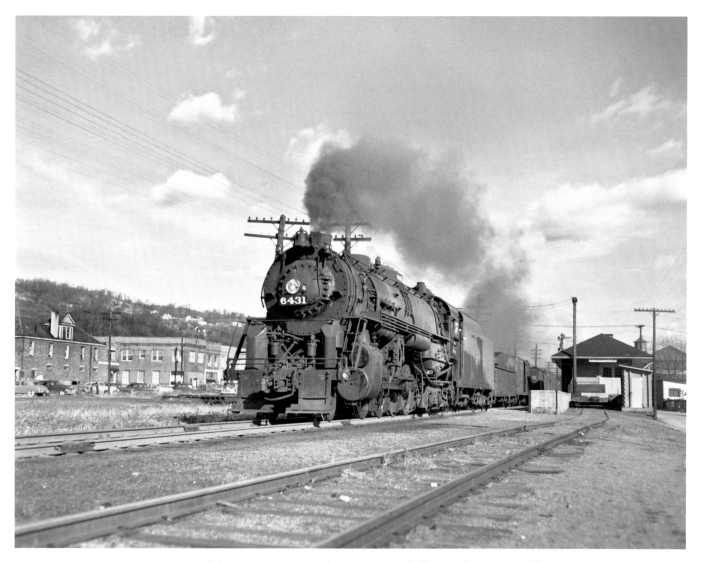

Here is K-1 Berkshire #6431 passing the station at Yorkville, OH, heading southbound.

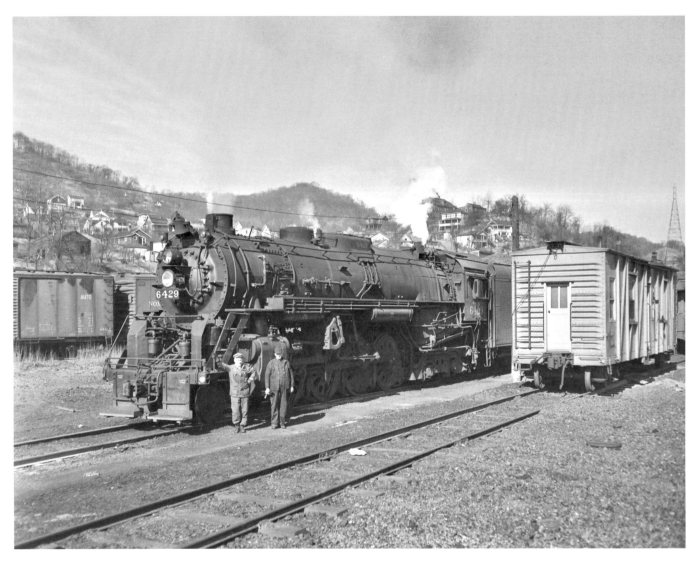

The crew of K-1 2-8-4 Berkshire #6429 poses for J. J. at Yorkville, OH. Note the maintenance of way (MOW) car on the right. It appears to be an outside braced boxcar that has been converted into MOW service by the railroad.

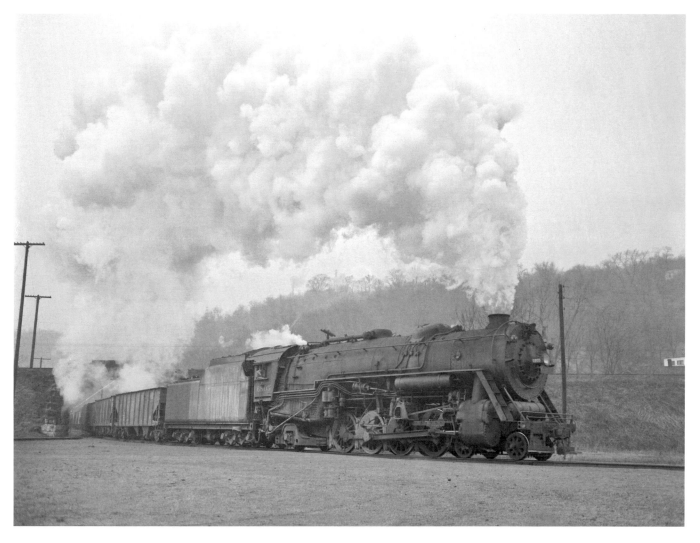

The Norfolk & Western Railway (N&W) built these 4-8-2 Mountains in 1926 as class K-3. Not loved by the N&W, they were sold to the power hungry Denver & Rio Grande Western and Richmond, Fredericksburg & Potomac during World War II. After the war, they were sold by both railroads to the W&LE where they became class J-1. The only ones of this wheel arrangement on the W&LE, the 4-8-2 Mountains were not liked by the crews: they were slow, rough riding, and hard on the rails.

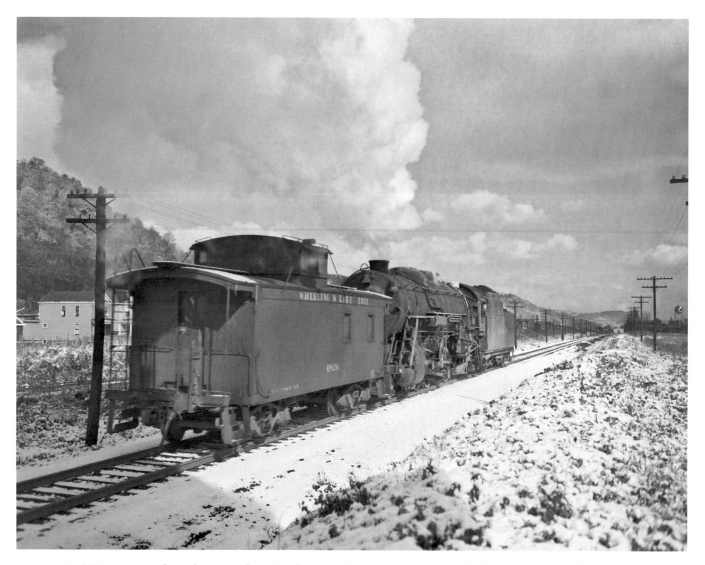

An 800-series wooden caboose on the W&LE being pushed by a class J-1 4-8-2 Mountain, another of the class of
N&W built and cast-off locomotives that made their way to the W&LE.

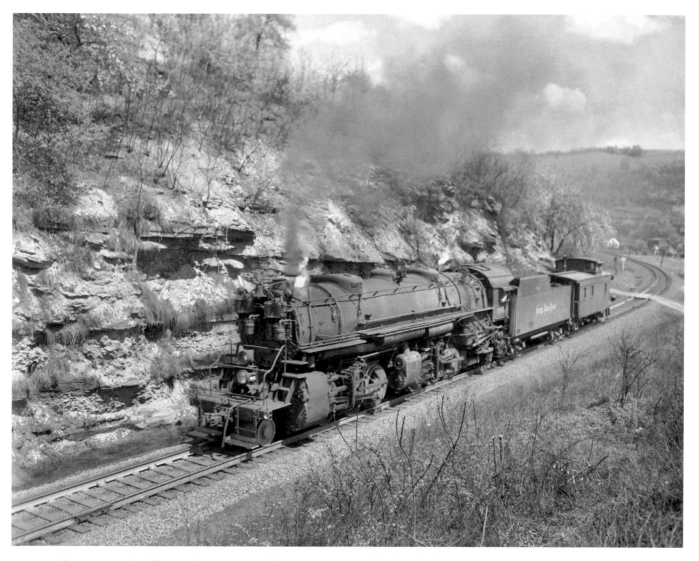

This compound mallet is a class I-3. Formerly W&LE #8002 and reclassified as #941, it is one of only four articulates operated at the time J. J. was photographing the W&LE. There is an 800-series caboose on the rear of the power move. This locomotive was retired by February 1955.

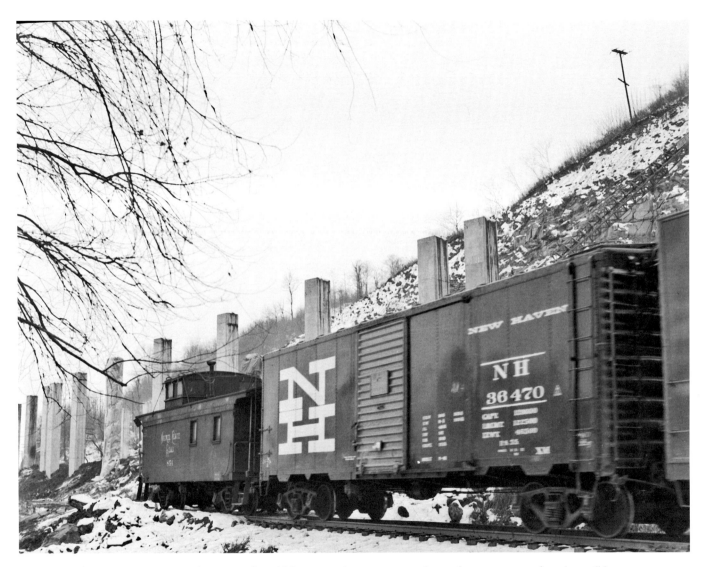

A clean, new New Haven boxcar and an 800-series caboose pass a column of concrete piers for what will become Interstate 70.

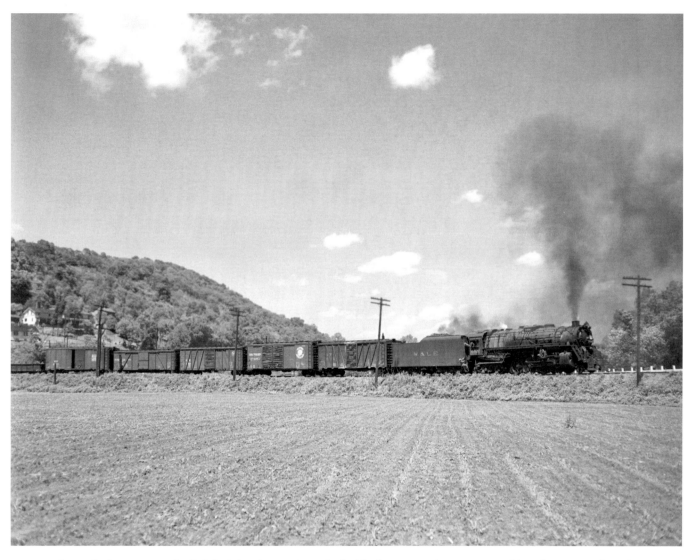

A stop in the country—the K-1 Berkshire's crew is on the ladder for some unknown reason. Note the variety of single sheathed boxcars in the front of the train.

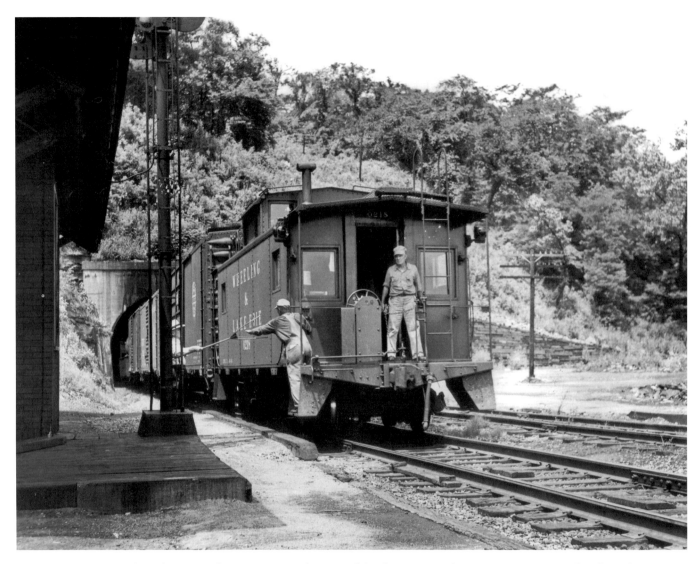

Crewman on board W&LE caboose #218 on the rear of the first section of train no. 91 snags orders from the operator at Mingo, OH.

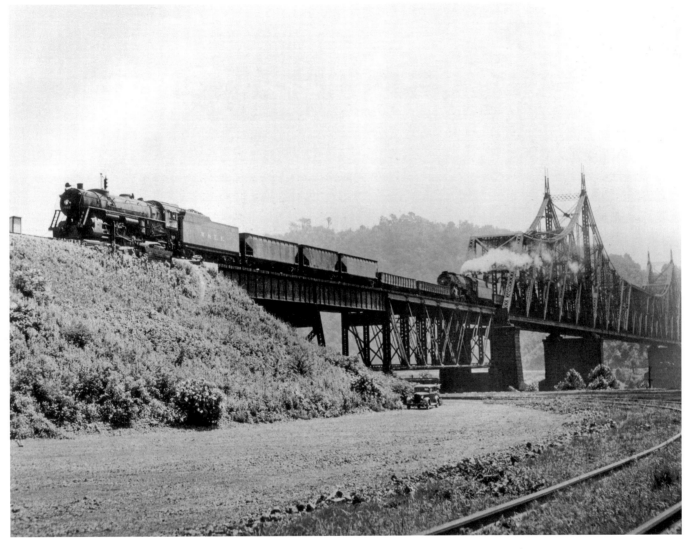

P&WV train no. 91 crosses the Ohio River between Wellsburg Tunnel in West Virginia and Mingo, OH, in 1947 behind a W&LE 2-8-2 Mikado and, five cars back, a P&WV 2-8-2 Mikado.

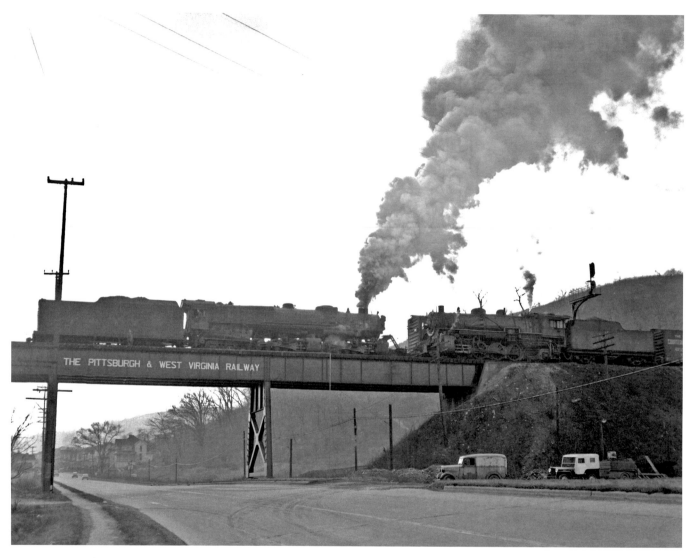

J. J. is shooting south along Ohio Route 7 as two trains meet just east of Coen's Tunnel near the station for Mingo, OH.

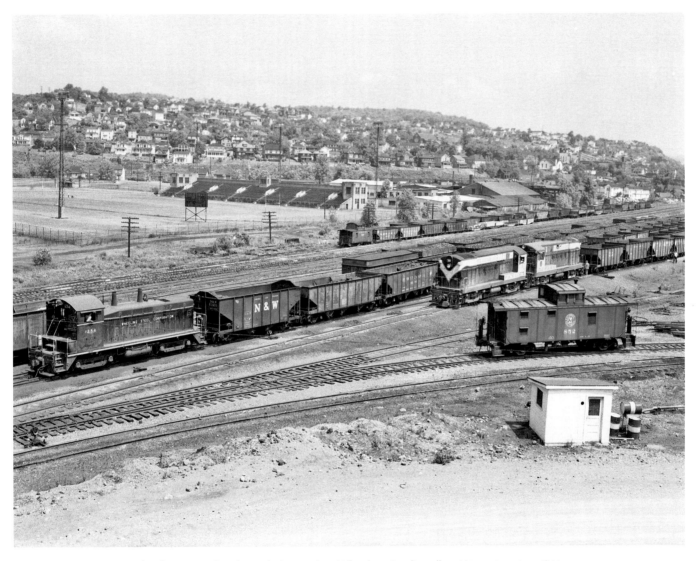

Two P&WV Fairbanks Morse diesels work the yard at Wheeling Steel's mill in Mingo Junction, OH, as a company switcher moves a string of hoppers.

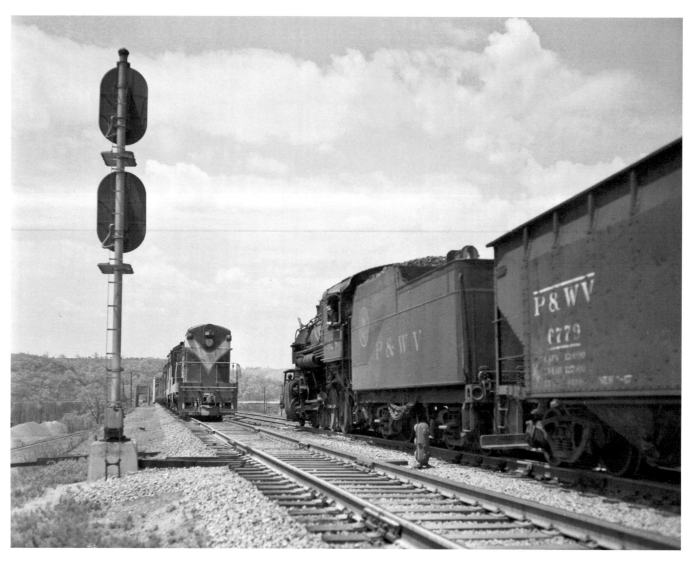

New meets old as a pair of the iconic P&WV Fairbanks Morse units meet up with a Mikado in the vicinity of Mingo Junction, OH.

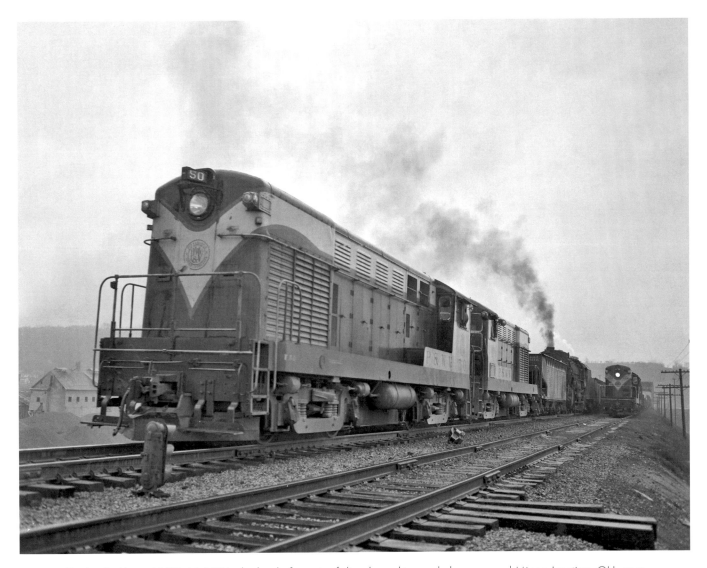

Fairbanks Morse H-20-44 #50 is the lead of a pair of diesels working as helpers around Mingo Junction, OH, as a drag of hoppers pulled by a Mikado works up the grade.

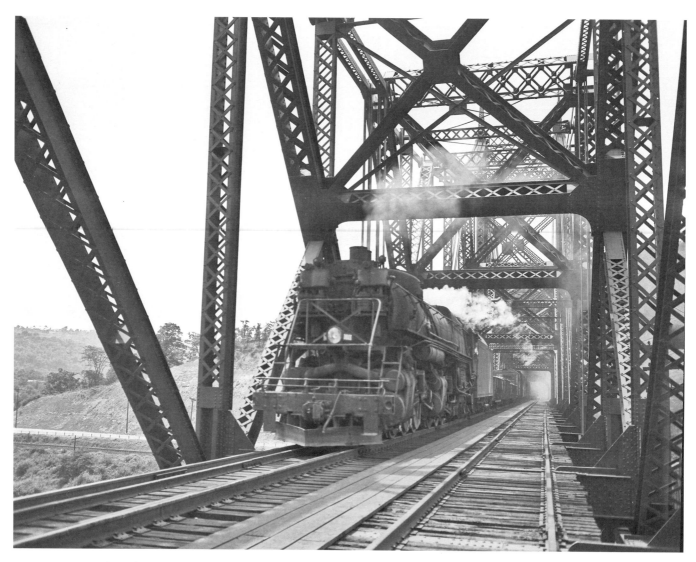

Eastbound P&WV class J-1 2-6-6-4 is one of three engines built by Baldwin Locomotive Works in 1934.

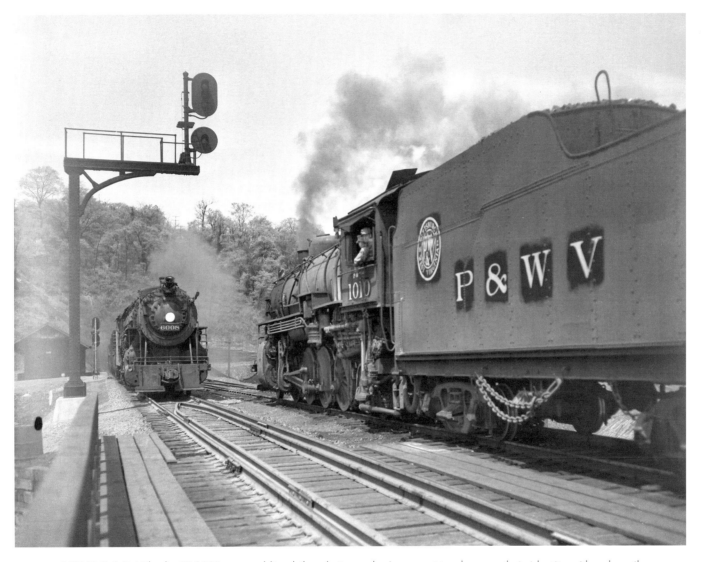

P&WV 2-8-2 Mikado #1010's crew obliged the photographer's request to clean up their identity with valve oil applied to cotton waste while awaiting the arrival of the first train no. 92 of the day at Mingo, OH, behind W&LE M-1 2-8-2 Mikado #6008. The P&WV #1010 was purchased from the Monon Railroad. It was a one of a kind and was P&WV class H-7.

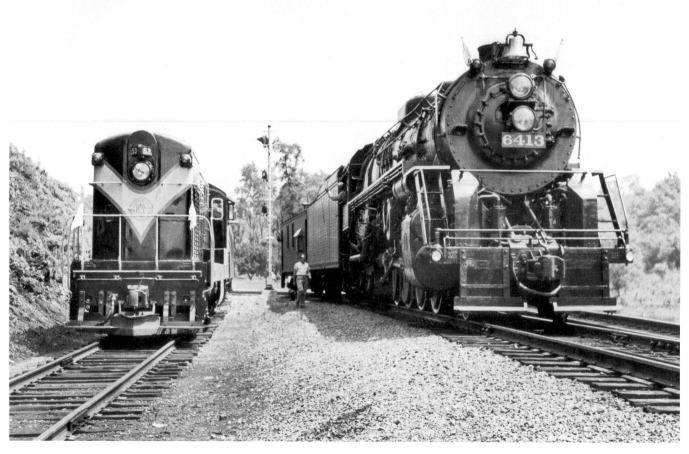

Pittsburgh Junction, OH, in 1949 with P&VW Fairbanks Morse unit #53 and W&LE 2-8-4 Mountain #6413.

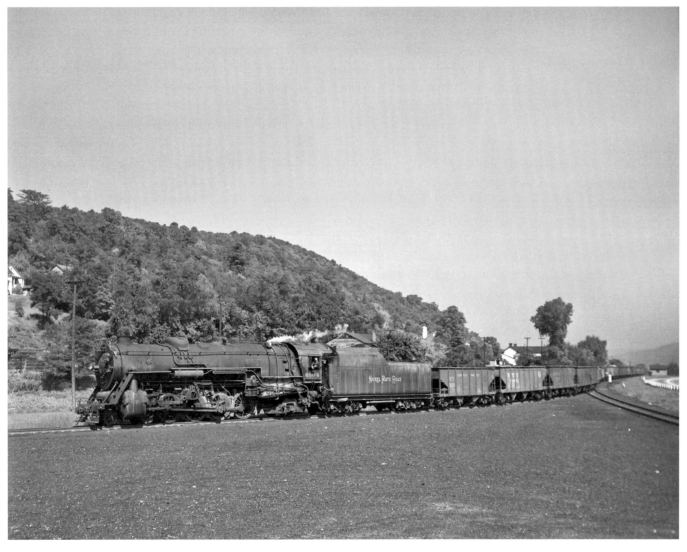

Locomotive #6804, a J-1 4-8-2 Mountain, on the leg of the wye at Warrenton, OH. Note the PRR tracks in the background.

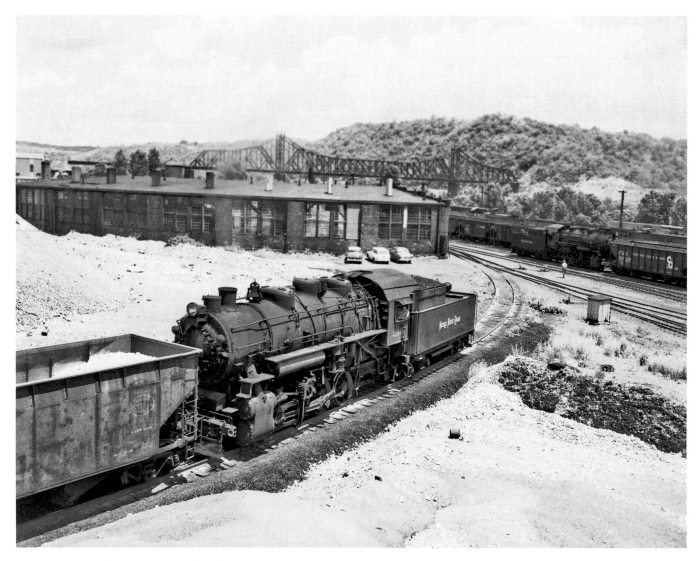

A pair of 0-8-0s are working the yard at Mingo Junction, OH, circa the mid-1950s. Note the Pittsburgh & West Virginia bridge in the distance.

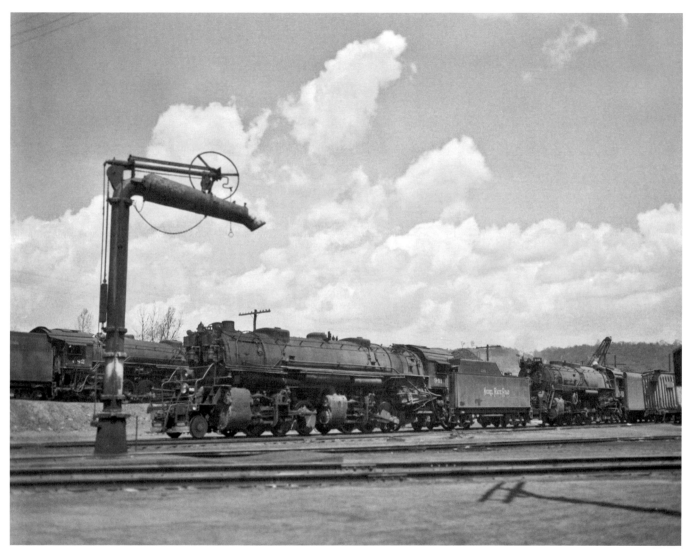

Terminal action with a class M-1 2-8-2 Mikado, #682, and an I-3 2-6-6-2, #941, with a K-1 behind #941.

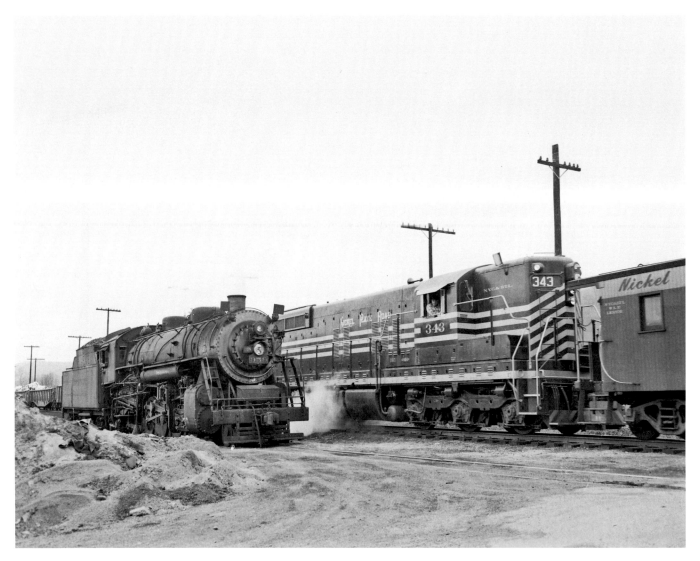

The Nickel Plate Road (NKP) is now showing its influence on the W&LE. Between 1950 and 1952, operable equipment was being lettered into the NKP system. The 2-8-2 Mikado is under steam and awaiting orders while a new EMD SD-9, #343, is giving a shove on the end of a train. Diesel #343 is a product of EMD's LaGrange plant in 1957.

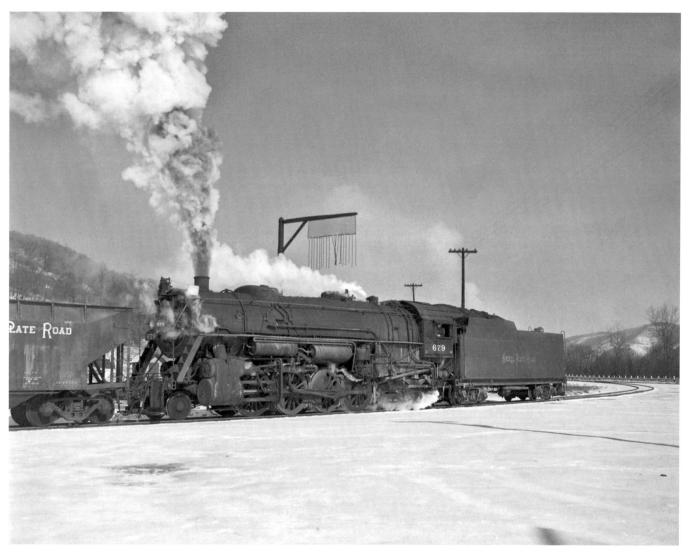

An ex-W&LE 2-8-2 Mikado, now Nickel Plate #679, moves loaded hopper cars at Warrenton, OH.

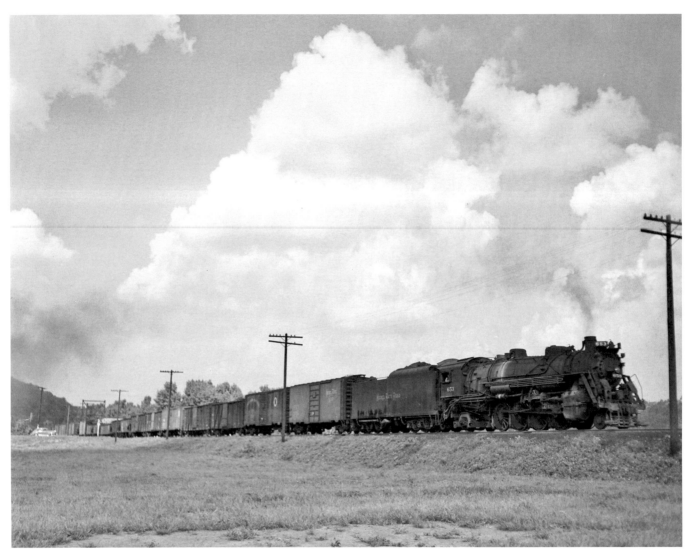

NKP H-6d Mikado #623 pulling a freight. This locomotive was retired in 1954 and scrapped in 1955.

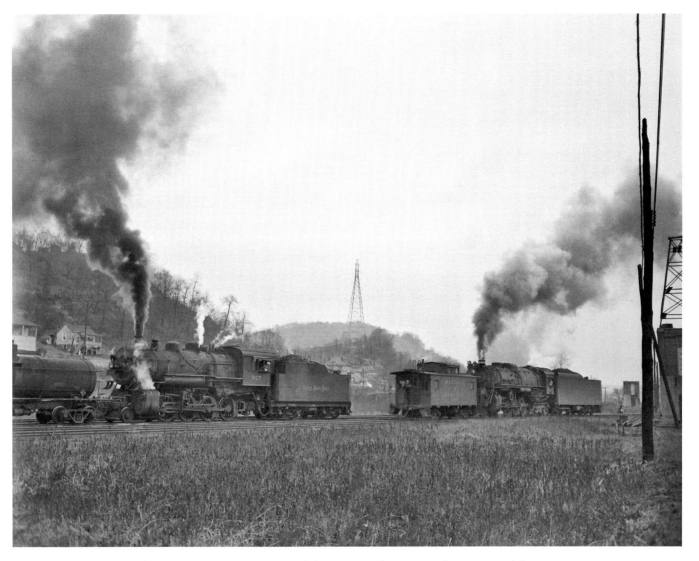

On the left, NKP #927, a 2-8-0 Consolidation, is making a switching move while W&LE #6405 is waiting with a 200-series caboose. It appears to be near Warrenton, OH.

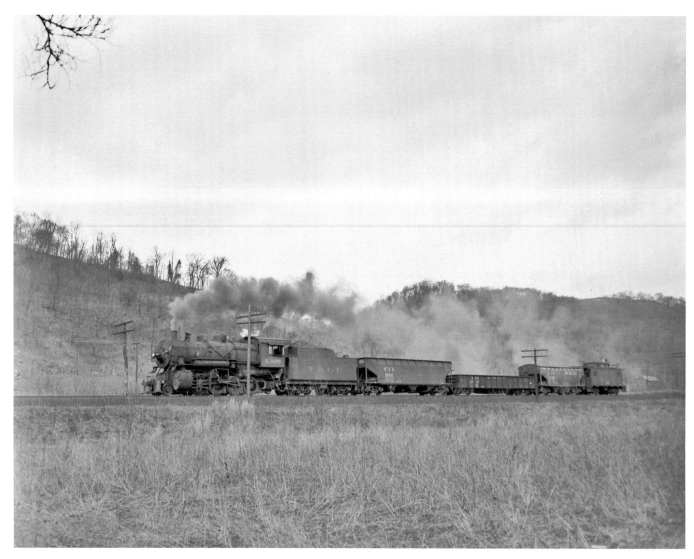

Local freight at work with G-2 class 2-8-0 Consolidation #4308 with a 200-series caboose.

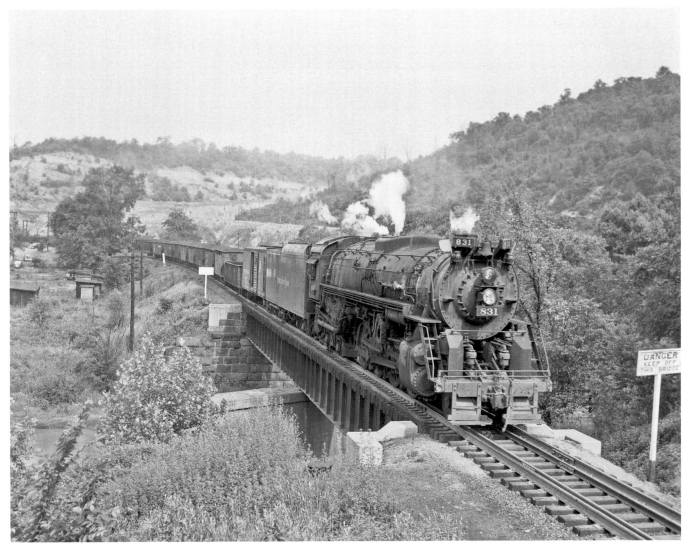

Nickel Plate renumbered W&LE class K-1 #6431 to NKP class S-4 #831 in April 1952. It was retired in 1957.

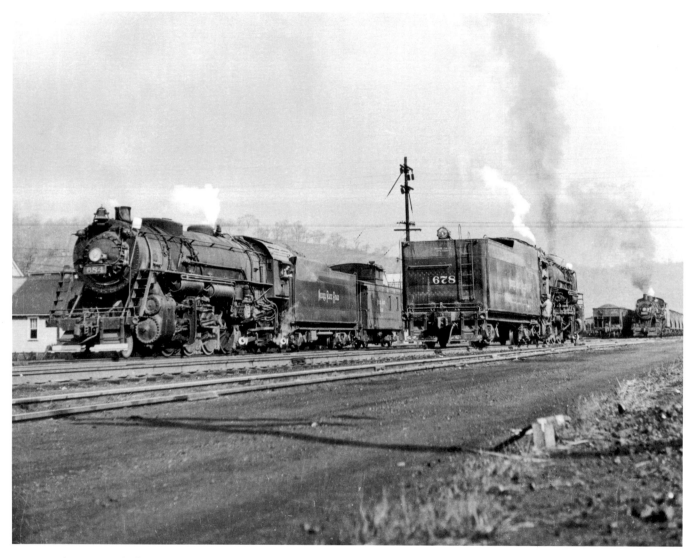

The west end of Pine Valley Yard in Dillonvale, OH, in 1955, with a pair of ex-W&LE 2-8-2 Mikados (#684 and #678) in the foreground and a 2-8-0 Consolidation in the background.

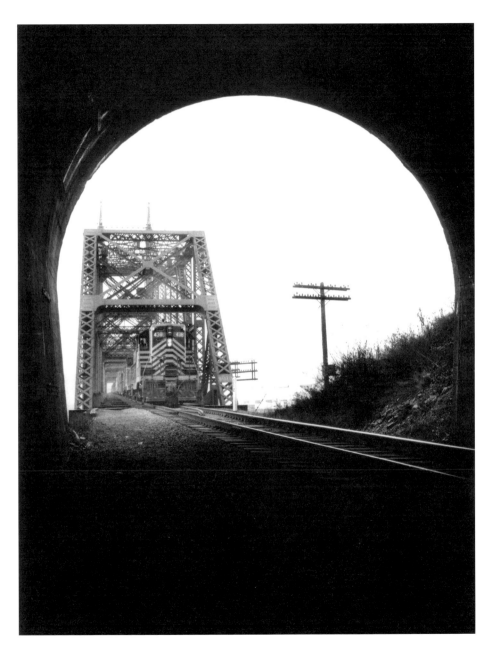

NKP GP-7s with engine #438 in the lead bring train no. 92 across the Ohio River into Wellsburg Tunnel, WV.

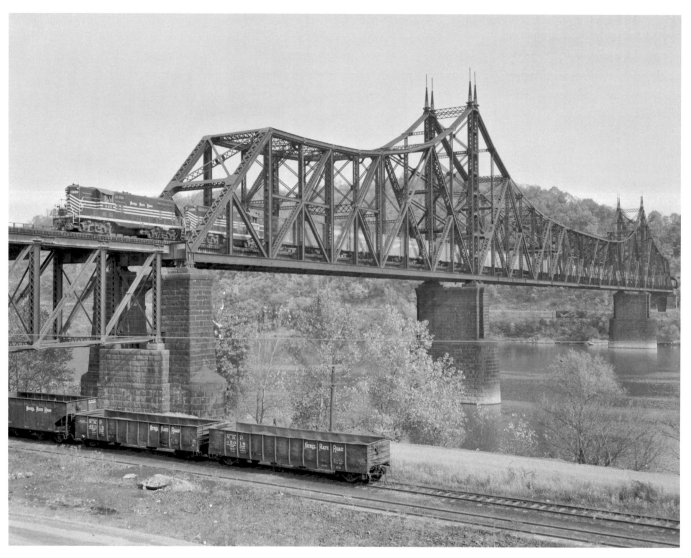

A Nickel Plate train crosses the Ohio over the P&WV Ohio River Bridge near Mingo Junction, OH. Going westbound, the train is about to cross over the Ohio River lines of the PRR and the NKP.

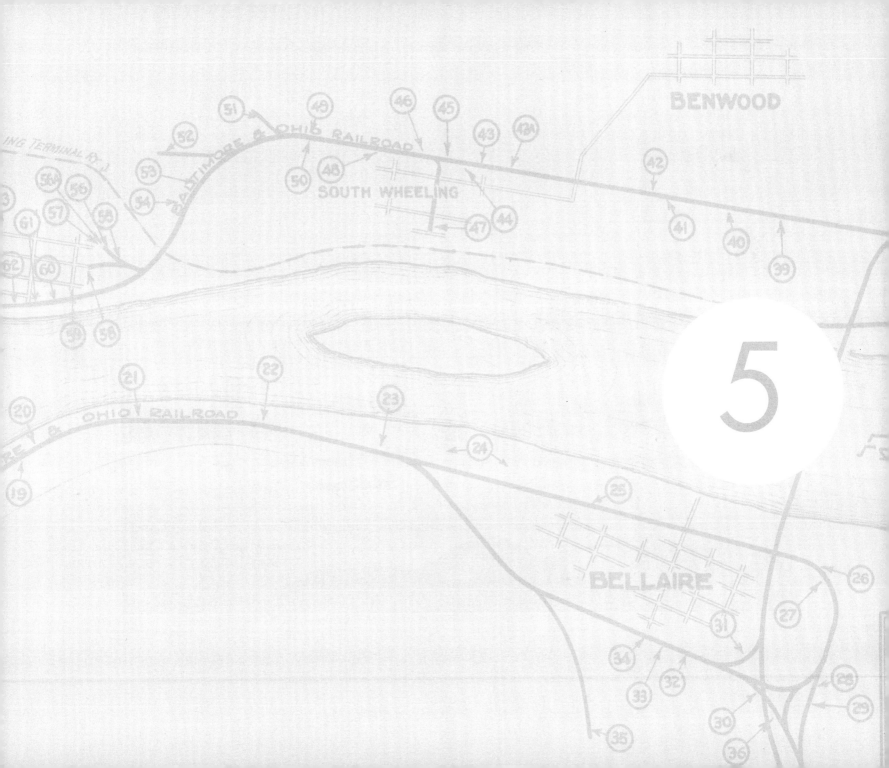

THE NEW YORK CENTRAL AND THE WHEELING AREA

In the spirit of competition that was visible throughout the history of railroading in the nineteenth and twentieth centuries, the New York Central Railroad (NYC) wanted to get into the lucrative Appalachian coal market. Unfortunately, its main line ran along the shores of the Great Lakes, and other railroads had already made significant inroads to the major coal veins in the area. But, for a well-heeled railroad like the New York Central, it was merely a question of money to either buy or lease a railroad or buy a charter for a line that would give it access to the No. 8 coalfield of Ohio.[1]

The geographic disadvantage of the existing location of NYC's main lines made little difference: Using its Lake Shore & Michigan Southern subsidiary, the New York Central took control of the Lake Erie, Alliance & Wheeling Railroad (LEA&W) in 1903. The LEA&W road, like others in the mountainous region of Ohio, was designed to get the coal up to the Lake Erie ports. And like so many others, it was undercapitalized and poorly managed, leading to its acquisition by the New York Central System. Part of the LEA&W line was started in the 1870s during a rush of narrow gauge railroad building in the country. By the time NYC took control, it had been converted to standard gauge (as of November 1883), and the line gradually extended into the coalfields of eastern Ohio near the town of Dillonvale. This made it an interesting target for the New York Central, which had wanted to get into the Appalachian coal market to compete with the Pennsylvania and Baltimore & Ohio Railroads. Amazingly, despite the health of the New York Central at the time, they made no effort to connect the LEA&W track to the main line, relying instead on trackage rights via the Erie Railroad at Phalanx, Ohio, and later via the Lake Erie & Pittsburgh and PRR trackage from Brady Lake, Ohio, to Alliance, Ohio.[2]

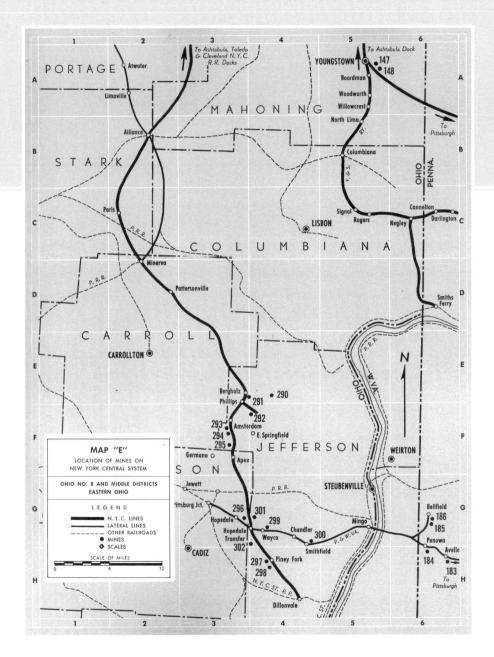

This map is from the New York Central System's *Coal Directory Book of 1961* and shows the company's lines and access to the Ohio coalfields. The next page lists the mines that were accessible to the New York Central. (John W. Barriger III Papers, John W. Barriger III National Railroad Library, University of Missouri, St. Louis.)

184

This table lists mines that were accessible to the New York Central. (John W. Barriger III Papers, John W. Barrigor III National Railroad Library, University of Missouri, St. Louis.)

GEOGRAPHICAL LIST OF BITUMINOUS COAL MINES SERVED BY THE NEW YORK CENTRAL SYSTEM AND LATERAL LINES

OHIO NO. 8 AND MIDDLE DISTRICTS — EASTERN OHIO
MAP "E"

MINE INDEX NUMBER	MAP "E" LOCATION	NAME OF MINE OR WORKS	LOCATION OF MINE OR WORKS AT OR NEAR	OPERATOR	POST OFFICE ADDRESS	COAL SEAM
P. & L. E. R.R. — YOUNGSTOWN DISTRICT						
147	H-2	Y. S. & T. By-Product Coke Works	Youngstown, Ohio	Y. S. & T. Co.	Youngstown, Ohio	Coke
148	H-2	Republic By-Product Coke Works	Youngstown, Ohio	Republic Steel Corp.	Cleveland, Ohio	Coke
PITTSBURGH & WEST VIRGINIA RAILWAY						
183	H-6	Acme Coal Cleaning Plant	Avella, Pa.	Penowa Coal Co.	Burgettstown, Pa.	Pittsburgh
184	H-6	Waverly	Penowa, Pa.	State Line Coal Co.	Avella, Pa.	Pittsburgh
185	G-6	Sasso No. 1	Bellfield, Pa.	Penowa Coal Co.	Burgettstown, Pa.	Pittsburgh
186	G-6	Sasso No. 16	Bellfield, Pa.	Penowa Coal Co.	Burgettstown, Pa.	Pittsburgh
N. Y. C. R.R. ALLIANCE DIVISION						
290	E-4	Mesmer	Bergholz, Ohio	Ted Mesmer & Sons, Inc.	North Lima, Ohio	No. 5, 6
291	E-4	McLain, Blaske School	Bergholz, Ohio	McLain, Homer Mining Co.	Hammondsville, Ohio Rd. No. 1	No. 6
292	F-4	Jensie (Wolf Run)	East Springfield, Ohio	Warner Collieries Co.	Cleveland, Ohio	No. 5, 6
293	F-3	George	Amsterdam, Ohio	George Fuel Co.	Amsterdam, Ohio	No. 6
294	F-3	G & S	Amsterdam, Ohio	G & S Coal Co.	Amsterdam, Ohio	No. 6
295	F-3	Apex	Amsterdam, Ohio	Germano Coal Co.	Dover, Ohio	No. 8
296	G-3	Dyco No. 2	Hopedale, Ohio	Ruschell Coal Co.	Hopedale, Ohio	No. 8
297	H-4	Piney Fork No. 1 (Henderson Run Opening)	Piney Fork, Ohio	Hanna Coal Co. Div. of Consolidation Coal Co.	Cadiz, Ohio	No. 8
297	H-4	Piney Fork Cleaning Plant	Piney Fork, Ohio	Hanna Coal Co. Div. of Consolidation Coal Co.	Cadiz, Ohio	No. 8
298	H-4	Pine Valley	Smithfield, Ohio	Robert Coal Co.	Smithfield, Ohio	No. 8
299	G-4	Hopedale	Wayco, Ohio	Polen Coal Co.	Hopedale, Ohio	No. 8
300	G-4	Betsy	Smithfield, Ohio	North American Coal Company	Cleveland, Ohio	No. 8
301	G-4	Polen	Pan, Ohio	Polen Coal Co.	Hopedale, Ohio	No. 8
302	H-4	Piney Fork Strip Mine	Piney Fork, Ohio	Hanna Coal Co. Div. of Consolidation Coal Co.	Cadiz, Ohio	No. 8

Because of its isolation from the main lines of the New York Central and the late arrival of that railroad, the track around Dillonvale and into the mines of southeastern Ohio never developed into a major access point into the Wheeling industrial area. Passenger traffic was negligible. As one will see in the photos in this section, J. J. was able to catch some heavy freight locomotives, mainly NE class 2-6-6-2 Mallets and H-10 class 2-8-2 Mikados at Dillonvale, Ohio, with their coal drags or empty hoppers going to and from the mines. Dillonvale itself was home to the Pine Valley Yard, an interchange point with the Wheeling & Lake Erie and a collection point for coal coming out of the various mines in the area for both railroads.

Copeland traffic maps show that the line from Bradley, Ohio, to Piney Fork, Ohio (passing through Dillonvale), was producing 690,000 revenue tons of coal going west and 400,000 tons of freight, mainly coal, going east per year as of 1951. Additional freight was added on to the trains as they proceeded west to Minerva, Ohio, where they would use trackage rights on the Pennsylvania Railroad to proceed to Alliance, Ohio, and thence over rights on either the PRR or B&O to the lake ports and the NYC's main line in northern Ohio.[3]

This area is something of an anomaly for the New York Central System. Although the railroad promoted its low-grade high capacity "water-level" route between New York and the Midwest, the region saw significant mountain crossings that required locomotives that provided greater amounts of power but at lower speeds. J. J.'s photographs help provide some much-needed visual history of this area of operations that tended to get overshadowed by the passenger and freight main lines that ran through northern Ohio and saw a much higher frequency of trains at speed.

The NYC line through Dillonvale was eventually abandoned as the economics of the coal business began to decline. By 1976, Conrail, the successor to the New York Central and Penn Central Railroads, had abandoned the line. Today some parts of the right-of-way are visible, but no tracks remain. The W&LE tracks are still in place in Dillonvale and are used by the successor to the original W&LE, which operates under the same name and reporting marks.[4]

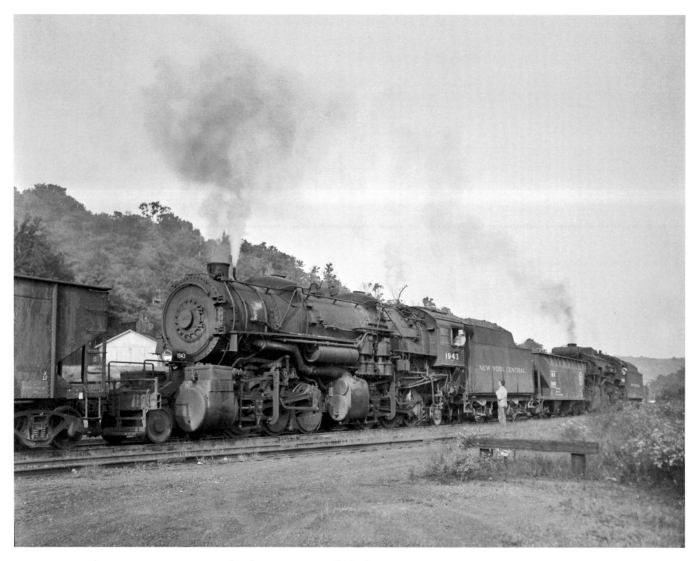

NYC class NE-2g 2-6-6-2 Articulated #1943 (originally built as #1343) works in conjunction with H-10a #2196
in Dillonvale, OH, before pulling a run of hopper cars up the line.

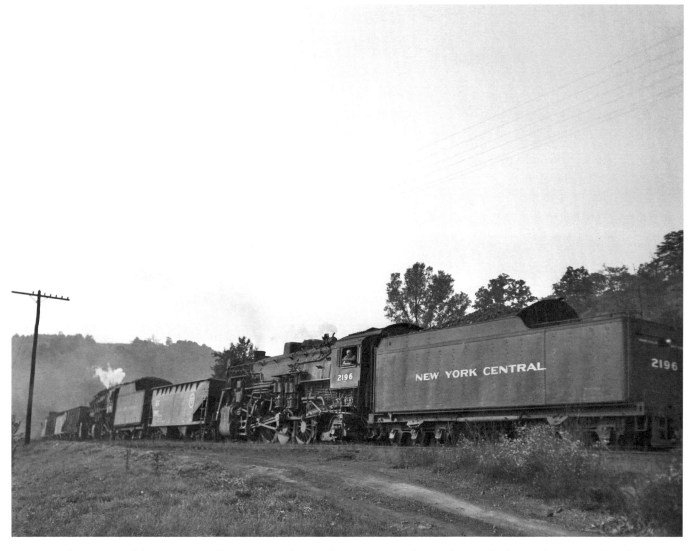

A better view of the same pair of locomotives, this time focusing on H-10a #2196, a Mikado-type locomotive bought by the NYC from ALCO in 1923.

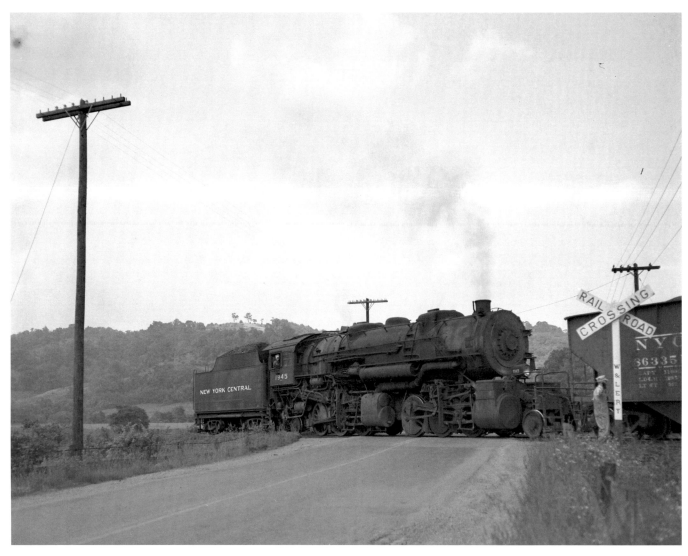

NYC NE-2g #1945 is on the W&LE track in Ohio with another load of hoppers being interchanged.

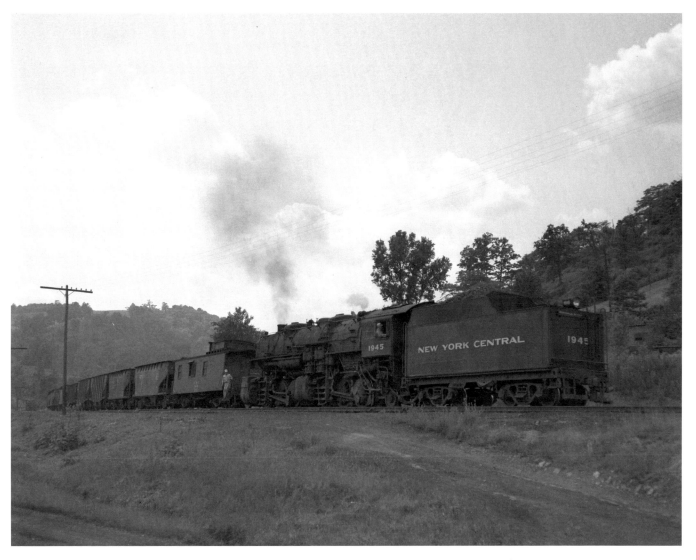

NYC #1945 is acting as a helper in this shot, working on a loaded train of hoppers.

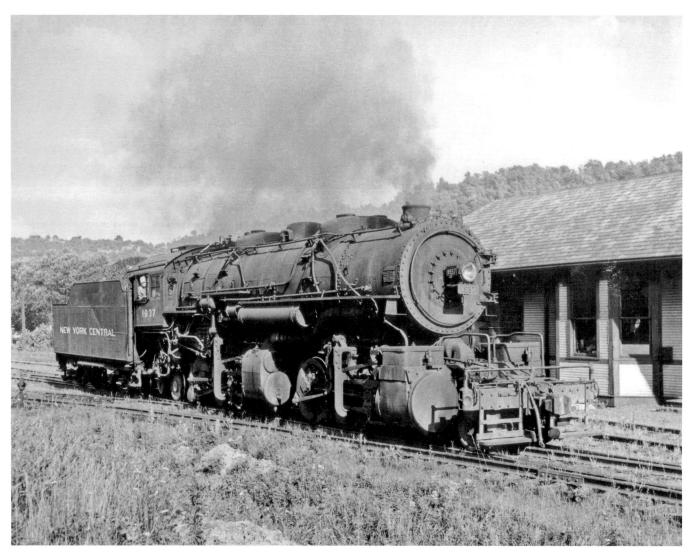

NYC class NE-2d 2-6-6-2 #1937 at Dillonvale, OH, in 1948.

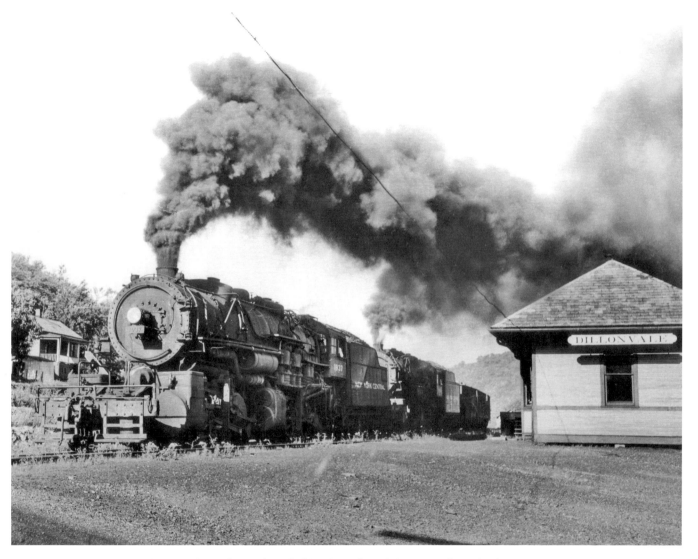

NYC 2-6-6-2s on the north end of NYC yards and depot at Dillonvale, OH, in 1949.

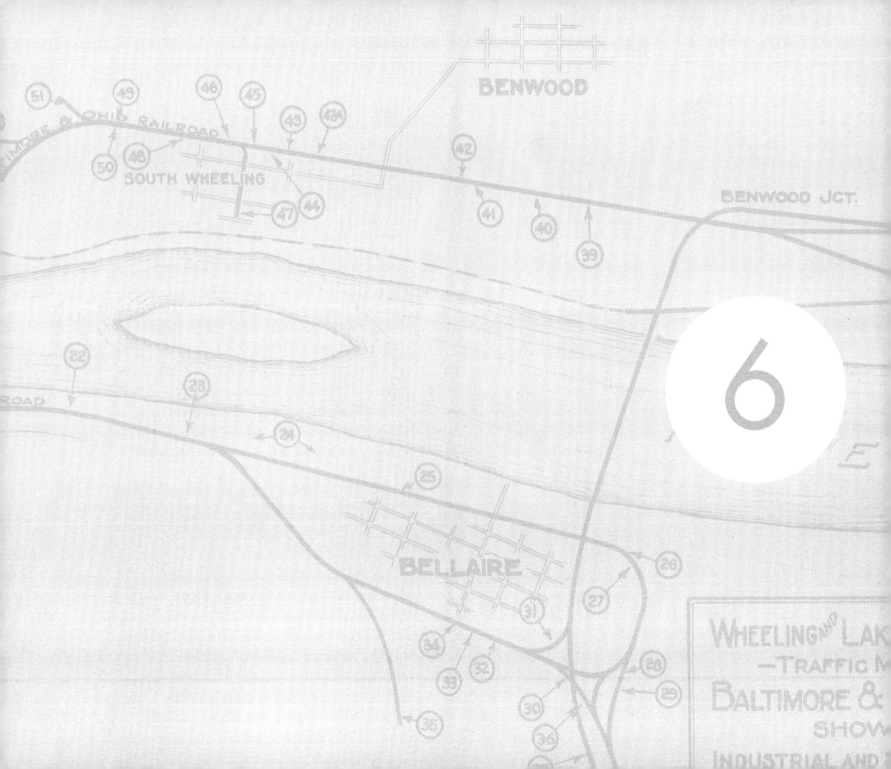

THE INDUSTRIAL AND INTERURBAN LINES OF WHEELING

Wheeling began to develop as an industrial center in the middle of the nineteenth century. Because of the city's location along the Ohio River, and with Fish Creek providing a possible source of water power, the potential for industrial mills made it a natural center for development. When coal and iron ore deposits were discovered in the region, the city's location on the natural highway of the Ohio River helped the steel industry to develop and flourish.

By the 1930s and onward, Wheeling's industrial base had been well developed, and several railroads were bringing in raw materials for processing and bringing out finished goods. J. J. was able to photograph two of the major heavy industries in the city during his time in Wheeling: one was Wheeling Steel and the other was Ohio River Sand & Gravel.

J. J. was able to use Wheeling Steel as an impressive backdrop for several of his photographs of B&O trains that passed by the plant. In this section, some of his more detailed images show operations within the plant. Wheeling Steel was created in 1920 when three other steel-making operations in Wheeling were combined. The company had plants along a thirty-mile stretch of the Ohio River from Steubenville, Ohio, to Benwood, West Virginia. J. J. shot several images at the Wheeling No. 2 plant during his time in Wheeling. Wheeling Steel merged with Pittsburgh Steel in 1968 to form Wheeling-Pittsburgh Steel. As the industry declined, the company continued to be merged and consolidated. Today only three of the plants are still in existence, and of those, only two are currently in operation.

Wheeling Steel's switchers weren't the only industrial locomotives operating in town: National Tube Company, part of US Steel, owned the Benwood & Wheeling Connecting Railroad. National Tube Company was incorporated in 1900 to provide switching service on fourteen miles of track in the plant that connected the tube works to the coke works of the Semet-Solvay Process Company and the

tracks that connected the works to the other railroads in Ben-wood. The line survived a challenge by the B&O to the West Virginia Public Utilities Commission to shut it down in 1918 as well as the decline of the steel industry long enough for J. J. to photograph its Whitcomb diesel switching locomotives.[1]

Ohio River Sand & Gravel was a major aggregate concern in multiple states along the Ohio River. It made use of the sand deposits that had built up over the eons to provide aggregate and other materials for the building and cement industries. When state and municipal governments began to pave streets and roads with concrete and asphalt in the 1920s, Ohio River Sand & Gravel saw a significant increase in business, and it still exists today, serving the construction industry. J. J. only shot a limited number of images featuring this company, and the best of these are showcased in this section.[2]

The streetcars and interurban railroads of the Wheeling area also saw time as subjects of J. J.'s camera. While their days were numbered due to the unstoppable march of the automobile, the interurban system was an important part of J. J.'s life in Wheeling. As a non-driver, J. J. relied on these

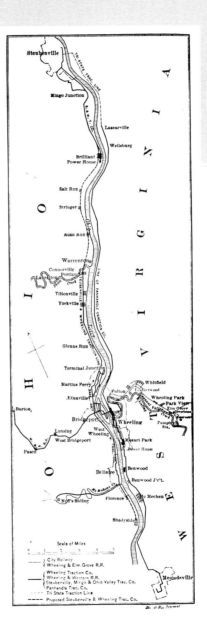

This map from *The Street Railway Journal* shows the extent of the Wheeling Traction Company.

195

electrically powered rail vehicles as an important means of transportation in the Wheeling area. His interest in the interurban cars of the Wheeling area was not long-lasting, as he seems to have only shot them for one session of in-depth photography over a winter's day in 1946. His subject during this session was the Wheeling-based Co-operative Transit Company. It was formerly known as the Wheeling Traction Company until 1933 when the line's employees purchased it and operated the company under the new name. The Co-operative Transit Company remained in existence until 1947 when buses finally took over all transit routes in the area. Given the timing of the photos, J. J. probably knew the end was coming and wanted to document the streetcars in his hometown before they disappeared.[3]

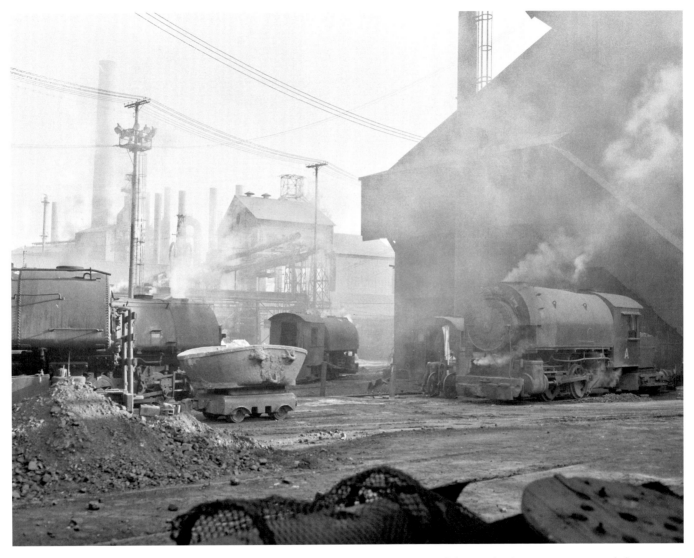

A collection of tank engines used to move steel and other components of the steelmaking process around the Wheeling Steel plant.

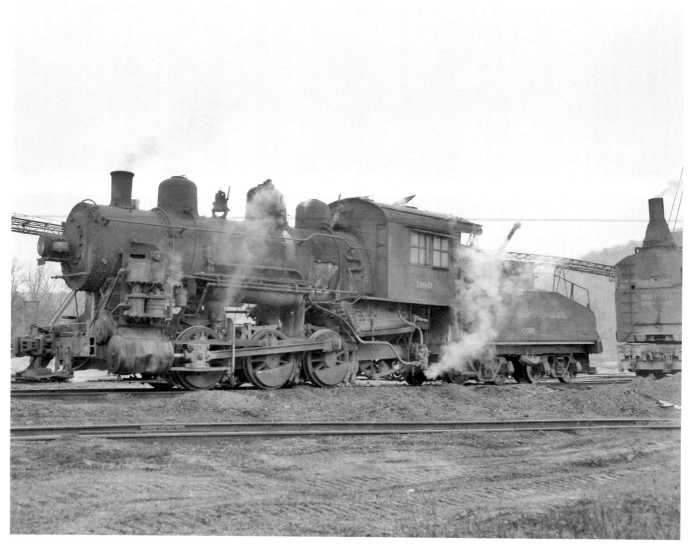

Ohio River Sand & Gravel 0-6-0 #1190 at the company's facility near Wheeling. Note the steam-powered shovel to the right and the overhead conveyor system behind the locomotive to move aggregates to a loading point.

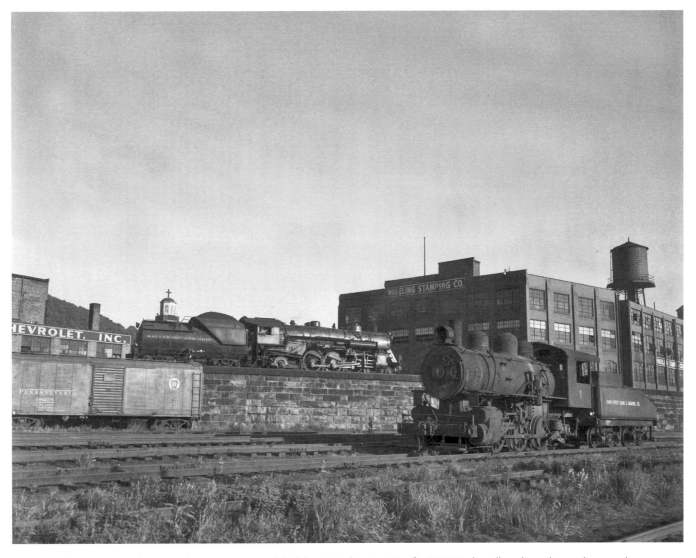

Ohio River Sand & Gravel 0-6-0 #1 sits cold while B&O class P-6 Pacific #5239 also idles along the tracks near the mouth of Wheeling Creek between the Ohio River and the Wheeling Warehouse District. The Wheeling Stamping Co. building still stands as of 2015 and has been converted to other uses.

With a tongue of flame coming from the works, a Wheeling Steel 0-4-0 waits to enter the plant with what appears to be a slag car.

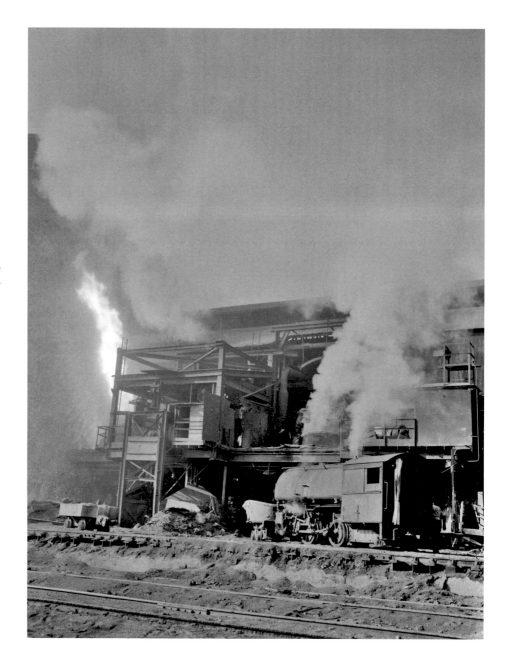

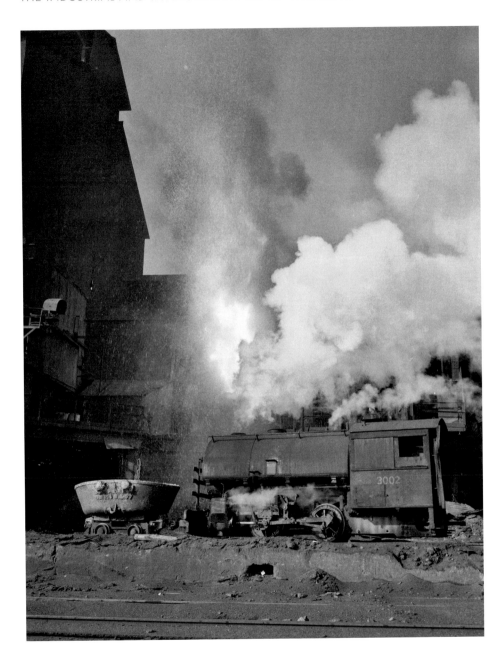

Another view from the ground level of Wheeling Steel, switch engine #3002 at work.

Wheeling Steel 0-4-0T letter B with steel ingot mold cars at a plant in Mingo, OH, 1950.

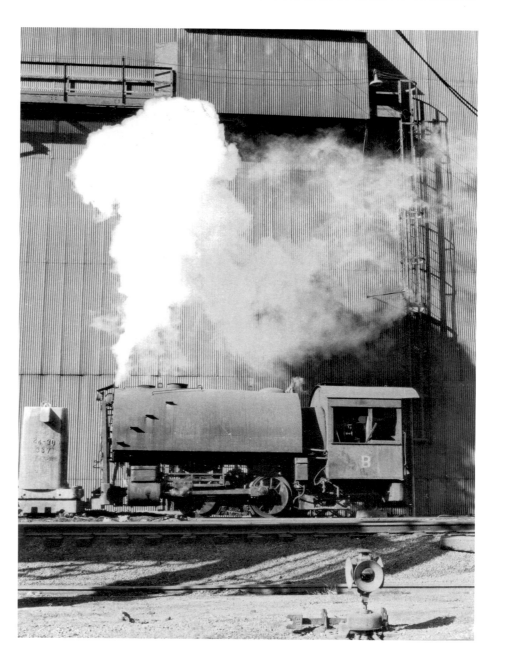

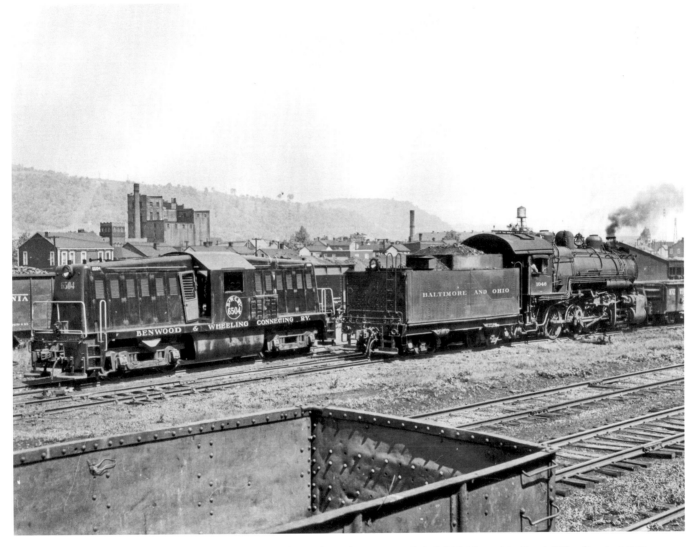

Benwood & Wheeling Connecting Railway Whitcomb and B&O L-1a 0-8-0 #1048 work in South Wheeling in 1949.

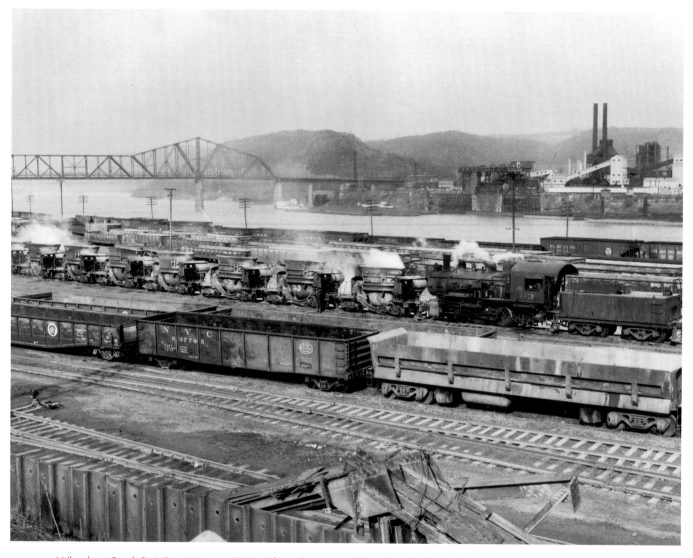

Wheeling Steel 0-6-0 at Mingo, OH, with a slag train. Wheeling Steel's bridge over the Ohio River is in the background.

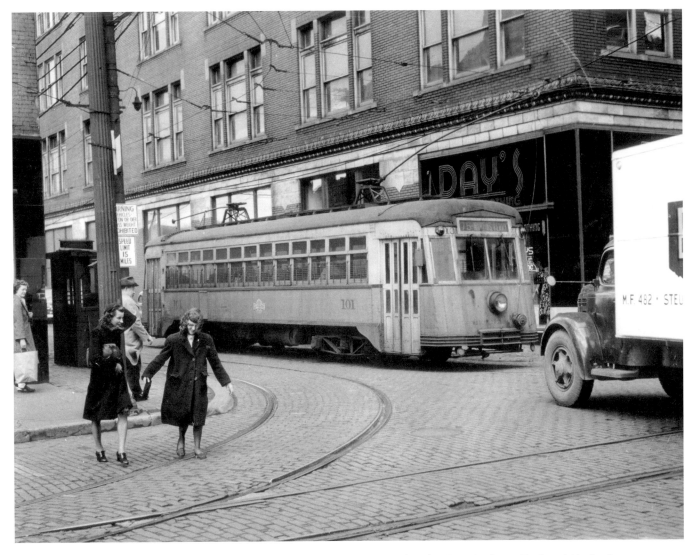

Downtown Wheeling in 1946 as Co-op Transit Car #101 swings onto the Ohio River Bridge at Tenth and Market Streets.

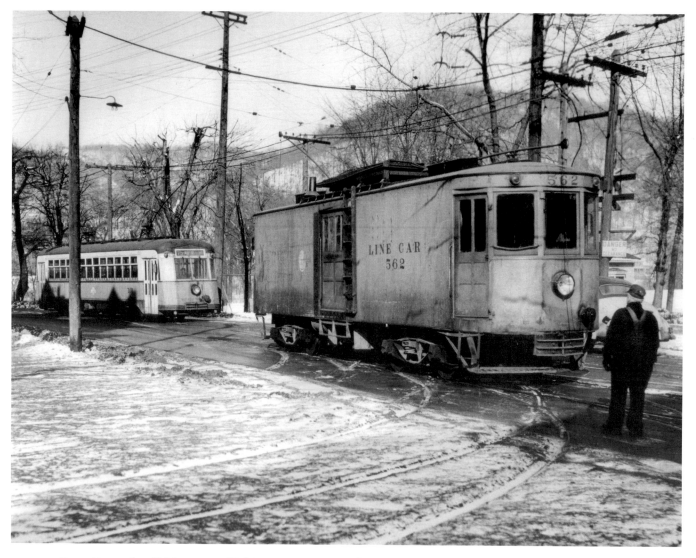

Co-op Transit Car #101 on route 75 (Martins Ferry Run) is about to cross Back River Bridge exiting Wheeling Island as line car #562 exits the Island car barn for overhead work downtown in 1945.

NOTES

INTRODUCTION: WELCOME TO WHEELING, WEST VIRGINIA

1. The Ohio County (WV) Public Library maintains an excellent internet resource of Wheeling's history. For those wishing to learn more about the city and the surrounding area, please use the following web address: http://www.ohiocountylibrary.org/wheeling-history.

1. J. J. YOUNG JR.

1. The information in this chapter is from J. J. himself and the Young family as related to Elizabeth Davis-Young.
2. Additional information from Jay Potter, "'I Did My Thing My Way': John Young Leaves B&O Fans a Trove of Stories, Photographs," *Sentinel* 27, no. 2 (2005): 3–14.

2. THE BALTIMORE & OHIO RAILROAD

1. Gary W. Schlerf, "Wheeling: B&O Crossroads," *Sentinel* 20, no. 2 (1998): 5–33.
2. Jay Potter, "'I Did My Thing My Way': John Young Leaves B&O Fans a Trove of Stories, Photographs," *Sentinel* 27, no. 2 (2005): 14.
3. Schlerf, "Wheeling: B&O Crossroads," *Sentinel* 20, no. 2 (1998): 5–33.

3. THE PENNSYLVANIA RAILROAD IN WHEELING

1. George Heckman Burgess and Miles C. Kennedy, *Centennial History of the Pennsylvania Railroad Company, 1846–1946* (Philadelphia, PA: Pennsylvania Railroad, 1949), 377. (A more detailed chronology can be found in Coverdale and Colpitts, *The Pennsylvania Railroad Company: Corporate Financial and Construction History of Lines Owned, Operated and Controlled to December 21, 1945*, 4 vols [New York: Coverdale and Coplitts, 1947].)
2. National Railway Publication Co., *The Official Guide of the Railways and Steam Navigation Lines of the United States, Porto Rico, Canada, Mexico and Cuba* (Philadelphia: National Railway Publication Co.: July 1950); and National Railway Publication Co., *The Official Guide of the Railways and Steam Navigation Lines of the United States, Porto Rico, Canada, Mexico and Cuba* (Philadelphia: National Railway Publication Co.: July 1964).
3. "Historic Wheeling: Wheeling Terminal Railway Bridge," accessed March 1, 2015, http://historic-wheeling.wikispaces.com/Wheeling+Terminal+Railway+Bridge.
4. Stuart J. Little, "The Freedom Train: Citizenship and Postwar Political Culture," *American Studies* 34, no. 1 (Spring 1993): 36.

4. THE WHEELING & LAKE ERIE RAILWAY, THE PITTSBURGH & WEST VIRGINIA RAILWAY, AND THE NICKEL PLATE ROAD

1. Herbert Harwood, *Invisible Giants: The Empires of Cleveland's Van Sweringen Brothers* (Bloomington, IN: University of Indiana Press, 2003), 142–150.
2. John A. Rehor, *The Nickel Plate Story* (Milwaukee, WI: Kalmbach, 1965), 196–199.
3. Harwood, *Invisible Giants*, 185–186.
4. The collapse of the Van Sweringen Empire is covered in Harwood, *Invisible Giants*, 234–310.
5. Harwood, *Invisible Giants*, 295–301.
6. For a complete history of the Pittsburgh & West Virginia, the best source available is Howard V. Worley Jr. and Wiliam N. Poellot Jr, *The Pittsburgh and West Virginia Railway: The Story of the High and Dry* (Halifax, PA: Withers Publishing, 1989).
7. The definitive history of the Nickel Plate and the source of the Nickel Plate information in this chapter is John A. Rehor, *The Nickel Plate Story* (Milwaukee, WI: Kalmbach Publishing, 1965).

5. THE NEW YORK CENTRAL AND THE WHEELING AREA

1. George W. Hilton, *American Narrow Gauge Railroads* (Stanford: Stanford University Press, 1990), 470.
2. J. C. Morris, compiler, *Ohio Railway Report 1902* (Columbus, OH: State of Ohio, 1902), http://www.railsandtrails.com/ohiorailwayreport/1902/1900.html#LakeErie; and Hilton, *American Narrow Gauge Railroads*, 470.
3. Copeland Traffic Maps-New York Central Railroad; John W. Barriger III Papers, John W. Barriger III National Railroad Library, UMSL.
4. "Abandoned Rails: Ohio: Phalanx Station to Minerva," accessed March 1, 2015, http://www.abandonedrails.com/Phalanx_Station_to_Minerva.

6. THE INDUSTRIAL AND INTERURBAN LINES OF WHEELING

1. Wheeling Steel, "Wheeling Steel, 1956," Ohio County Public Library, accessed March 17, 2015, http://www.ohiocountylibrary.org/wheeling-history/wheeling-steel-1956/3050.
2. Stone Publishing Company, *Stone: Monthly Publication Devoted to the Stone Industry In All of Its Branches* 53, no. 3 (March 1922): 143.
3. "Notes on the Wheeling Traction Company," *Electric Railway Journal* 39, no. 4 (January 27, 1912): 136–141.

BIBLIOGRAPHY

ARCHIVAL SOURCES

John W. Barriger III National Railroad Library, University of Missouri, St. Louis
 Barriger, John W., III. Papers.
 Robert Lewis Collection
 Bruhn, Fred. "Cooperative Transit Company (Wheeling West Virginia) The Post-War Years."
 Research notebook.
 Rupp Timetable Collection.
 Isabel Benham Collection.
 Wheeling, West Virginia, File.
Baltimore and Ohio Railroad Historical Society Collection, Baltimore, MD
 Young, J. J. Jr. Recording of presentation given to Clarksburg, WV, convention.
City of Martins Ferry, Ohio.
 Office of the City Clerk Files
 "Wheeling Terminal Railroad in Martins Ferry Map."

BOOKS

Burgess, George H., and Miles C. Kennedy. *Centennial History of the Pennsylvania Railroad Company.*
 Philadelphia: The Pennsylvania Railroad Company, 1949.

Canfield, Joseph M. *West Penn Traction*. Chicago: Central Electric Railfans Association. 1968.

Corns, John B. *The Wheeling & Lake Erie Railway*. Vol. 2. Lynchburg, VA: TLC Publishing, 2002.

Douglas, Kenneth L., and Peter C. Weiglin. *Pennsy Diesels 1924–1968: A-6 to EF-36*. Mukilteo, WA: Hundman Publishing, 2002.

Edson, William D. *Steam Locomotives of the Baltimore & Ohio: An All-Time Roster*. Potomac, MD: Edson Publications, 1992.

Edson, William D., and H. L. Vail Jr. *Steam Locomotives of the New York Central Lines*. Vol 2, Parts 1–7, *Lake Shore & Michigan Southern; Lake Erie & Western; Indiana Harbor Belt; Chicago River & Indiana; Chicago Junction; Ohio Central Lines; Big Four; Michigan Central; Pittsburgh & Lake Erie*. NP, New York Central System Historical Society, 2002.

Frizzi, Daniel L., Jr. *An American Railroad Portrait: People Places and Pultney*. Bellaire, OH: D. L. Frizzi Jr., 1993.

Hilton, George W. *American Narrow Gauge Railroads*. Stanford: Stanford University Press, 1990.

Hipes, Steve, and David P. Oroszi. *Pennsylvania Railroad Lines West*. Vol. 1, *Pittsburgh to St. Louis, 1960–1999*. Hanover, PA: The Railroad Press, 2004.

Moody, John. *Moody's Analyses of Investments: Steam Railroads, 1917*. New York: Moody's Investors Service, 1917.

New York Central System. *Coal Service Directory*. New York Central System, 1960.

The Pennsylvania Railroad Company; Coverdale & Colpitts. *The Pennsylvania Railroad Company: Corporate, Financial and Construction History of Lines Owned, Operated and Controlled to December 31, 1945*. 4 vols. New York: Philadelphia, Allen, Lane & Scott, 1946.

Public Utilities Reports, Incorporated. *Public Utilities Reports: Annotated*. Rochester, NY: The Lawyers Cooperative Publishing Company, 1918.

Railroad Commission of Ohio. *Report of the Railroad Commission of Ohio to the Governor of the State of Ohio for the Year 1909*. Springfield, OH: Springfield Publishing Company, 1910.

Rehor, John A. *The Nickel Plate Story*. Milwaukee, WI: Kalmbach Publishing, 1965.

Staufer, Alvin, and Edward L. May. *New York Central's Later Power 1910–1968*. Medina, OH: A. F. Staufer, 1981.

Stegmaier, Harry. *Pennsylvania Railroad Passenger Trains, Consists and Cars—1952*. Vol.1, *East-West Trains*. Lynchburg, VA: TLC Publishing, 2003.

Worley, Howard D., Jr., and William N. Poellot Jr. *The Pittsburgh & West Virginia Railway: The Story of the High and Dry*. Halifax, PA: Withers Publishing, 1989.

Yanosey, Robert J. *Pennsylvania Railroad Facilities in Color.* Vol. 14, *Buckeye Division, East of Columbus Union Depot.* Scotch Plains, NJ: Morning Sun Books, 2011.

ARTICLES

"Barlotti & Son et al. v. Public Utilities Commission et al. (No. 16943)." *The Northeastern Reporter* 134 (1922): 468–471. Google Books, 2007. Accessed March 1, 2015. https://books.google.com/books?id=LfcKAAAAYAAJ.

"Bus Company Will Seek City Authorization." *Electric Railway Journal* 58, no. 18 (October 29, 1921): 801. Google Books, 2014. Accessed March 1, 2015. https://books.google.com/books?id=P0c_AQAAMAAJ.

"Business Brevities." *Stone: Monthly Publication Devoted to the Stone Industry In All of Its Branches* 53, no. 3 (March 1922): 143.

Foss, Charles W. "Wheeling & Lake Erie Watches Cost Factors Closely, Part II." *Railway Age* 72, no. 13 (April 1,1922): 829–832.

Frizzi, Daniel L., Jr. "The Baltimore & Ohio River Crossing at Bellaire, Ohio." *Sentinel* 17, no. 1 (1995): 5–16.

Little, Stuart J. "The Freedom Train: Citizenship and Postwar Political Culture." *American Studies* 34 no. 1 (Spring 1993): 35–67.

"Notes on the Wheeling Traction Company." *Electric Railway Journal* 39, no. 4 (January 27, 1912): 136–141.

Potter, Jay. "'I Did My Thing My Way': John Young Leaves B&O Fans a Trove of Stories, Photographs." *Sentinel* 27, no. 2 (2005): 3–14.

Schlerf, Gary W. "Wheeling: B&O Crossroads." *Sentinel* 20, no. 2 (1998): 5–33.

"Wheeling Traction System." *Street Railway Journal* 28, no. 15 (October 15, 1906): 544–552.

WEBSITES

Britton, Jerry. *PRR Steam Locomotive Roster Database* (blog). Keystone Crossings. Accessed March 14, 2014. http://www.pennsyrr.com/entry/prr-steam-locomotive-roster-database.

Harrison, Greg. "Phalanx Station to Minerva." Abandoned Rails. Accessed March 1, 2015. http://a-r.us/4w9.

Historic Wheeling: Wheeling Terminal Railway Bridge. Accessed March 1, 2015. http://historic-wheeling.wikispaces.com/Wheeling+Terminal+Railway+Bridge.

"Ohio Public Utilities Commission 1914 Map of Ohio." Rails and Trails. Accessed March 1, 2015. http://www.railsandtrails.com/Maps/OhioRRCommission/1914/index.html.

Tanner, Borgon. "Streetcar Lines." e-WV: The West Virginia Encyclopedia. November 5, 2010. Accessed March 17, 2015. http://www.wvencyclopedia.org/articles/612.

Wheeling Steel. "Wheeling Steel, 1956." Ohio County Public Library. Accessed March 17, 2015. http://www.ohiocountylibrary.org/wheeling-history/wheeling-steel-1956/3050.

Elizabeth Davis-Young met J. J. Young while working on a double program of associate of arts degree and interior design certification at Broome Community College in Binghamton, NY, graduating Phi Theta Kappa. She has worked for the West Virginia State Senate since 2001. She wants to express her deep gratitude to Nick, Greg, and the whole crew at WVU Press for helping her bring about John's book.

Nicholas Fry has been the curator of the John W. Barriger III National Railroad Library since 2012. He holds a bachelor of arts degree in history from the University of Maryland-Baltimore County, as well as a masters of arts degree in nineteenth-century US history from the same institution. He also holds a masters degree in library and information sciences from Drexel University. Previously, he has worked at government records facilities, including the NASA Center for Aerospace Information where he was an outreach specialist for their collection of Scientific and Technical Reports. His work has allowed him wide experience with government agencies regarding information management and records management activities, and, most notably, he has by avocation managed the archives of the B&O Railroad Historical Society and its research activities since 2002. He currently lives in St. Louis, MO.

Gregory Smith currently resides in Maryland and is a retired high school special educator. A lifetime railroad modeler and historian, he enjoys the history of all US railroads, but his first love is the Baltimore & Ohio Railroad. He has written a number of articles for the B&O Railroad Historical Society's publication, the *Sentinel*, as well as captions for their annual calendar. Greg is currently serving for the third time as president of the B&O Railroad Historical Society. He also at one time served as superintendent of the Mount Clare Division of the National Model Railroad Association. He has assisted in a number restoration projects at the B&O Museum in Baltimore, MD, and the model railroad display in the freight house in Ellicott City, MD.